THE SECRET MANDALA

A Colouring Book By
Stuart Royce

Copyright © 2016 Stuart Royce

All rights reserved. No part of this work may be reproduced or utilized in any form or by any means, electronic or mechanical (with the notable exception of fair use practices required to share your coloured-in pieces), without the prior written permission of the artist/publisher.

ISBN-10: **1537462636**
ISBN-13: **978-1537462639**

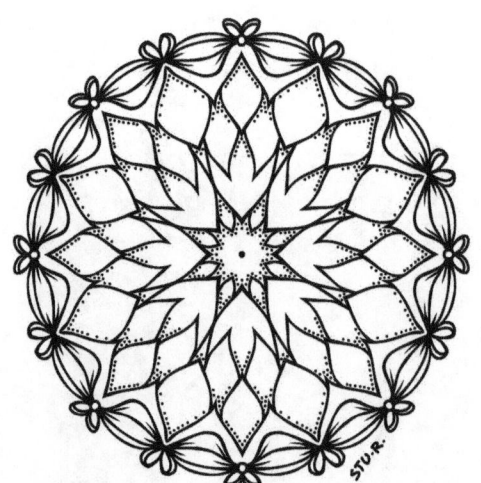

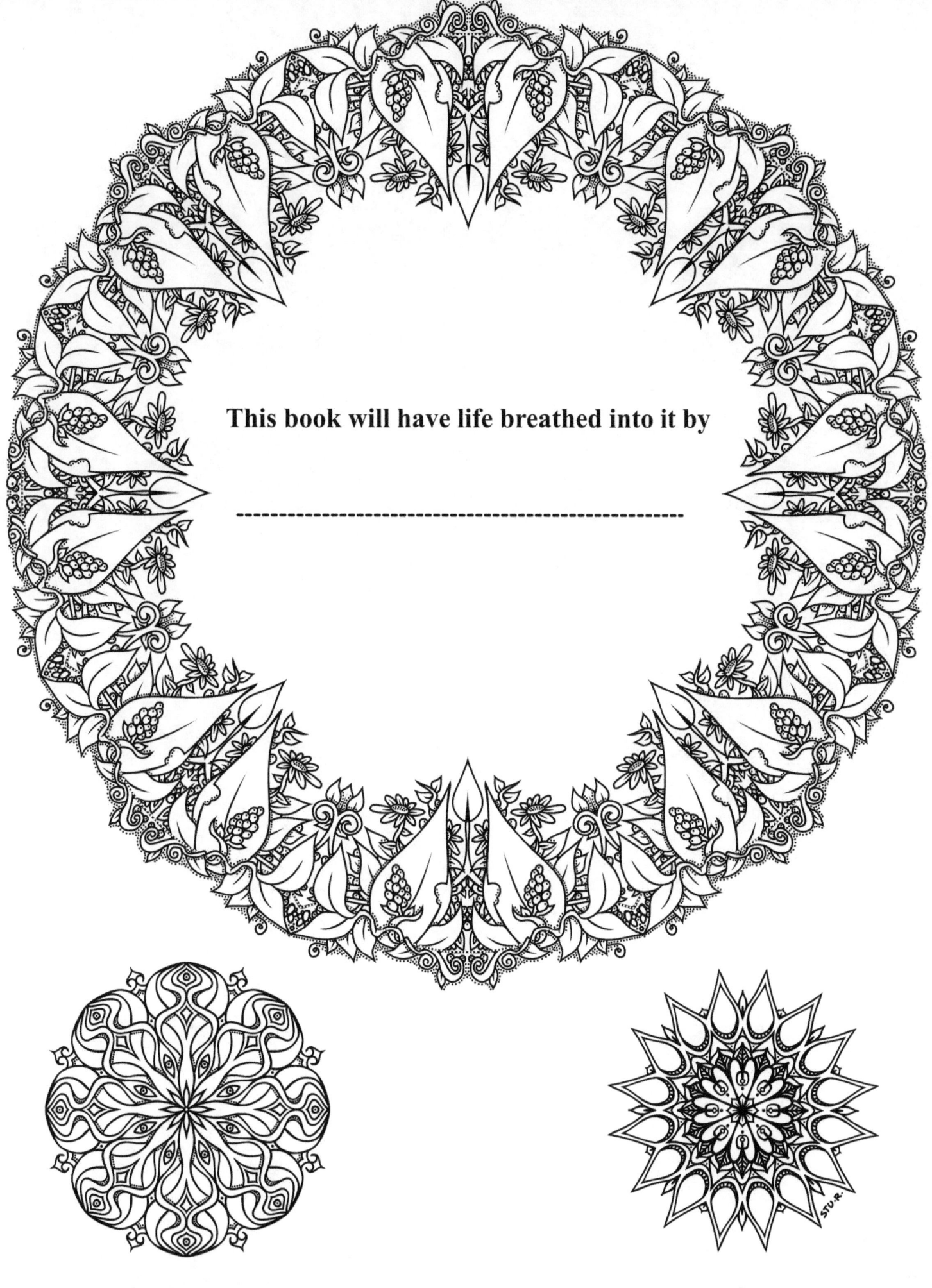

This book will have life breathed into it by

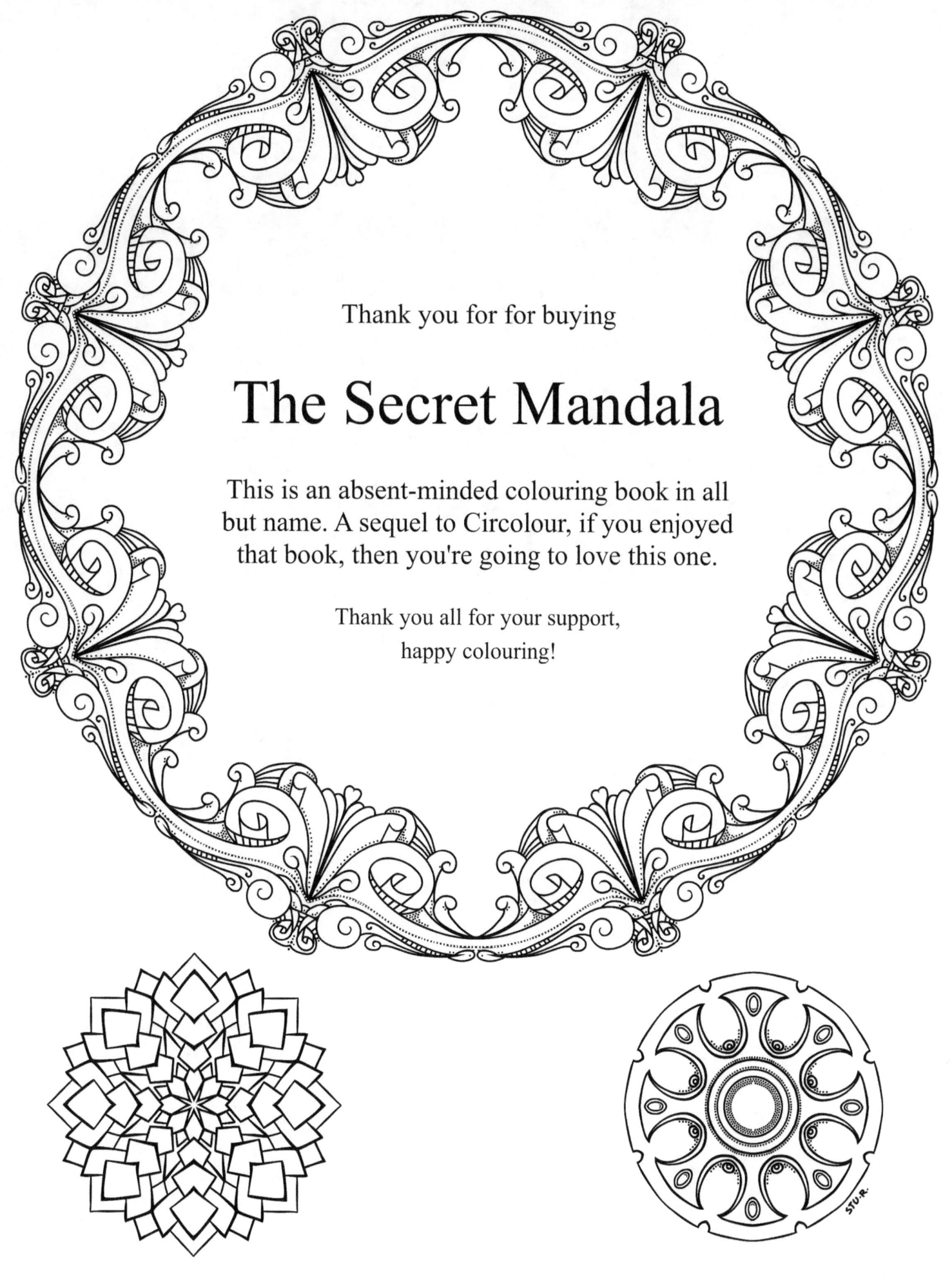

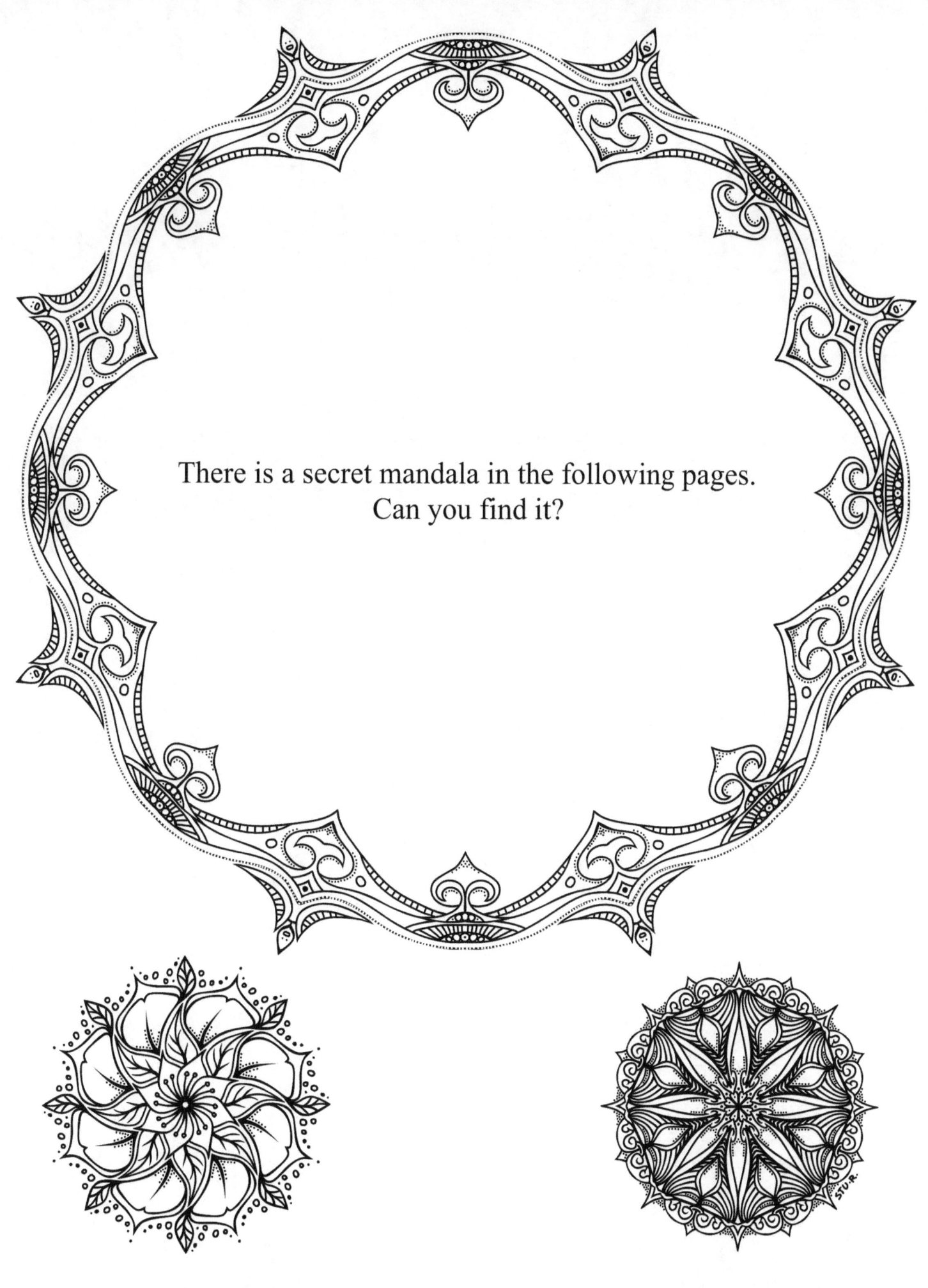

There is a secret mandala in the following pages.
Can you find it?

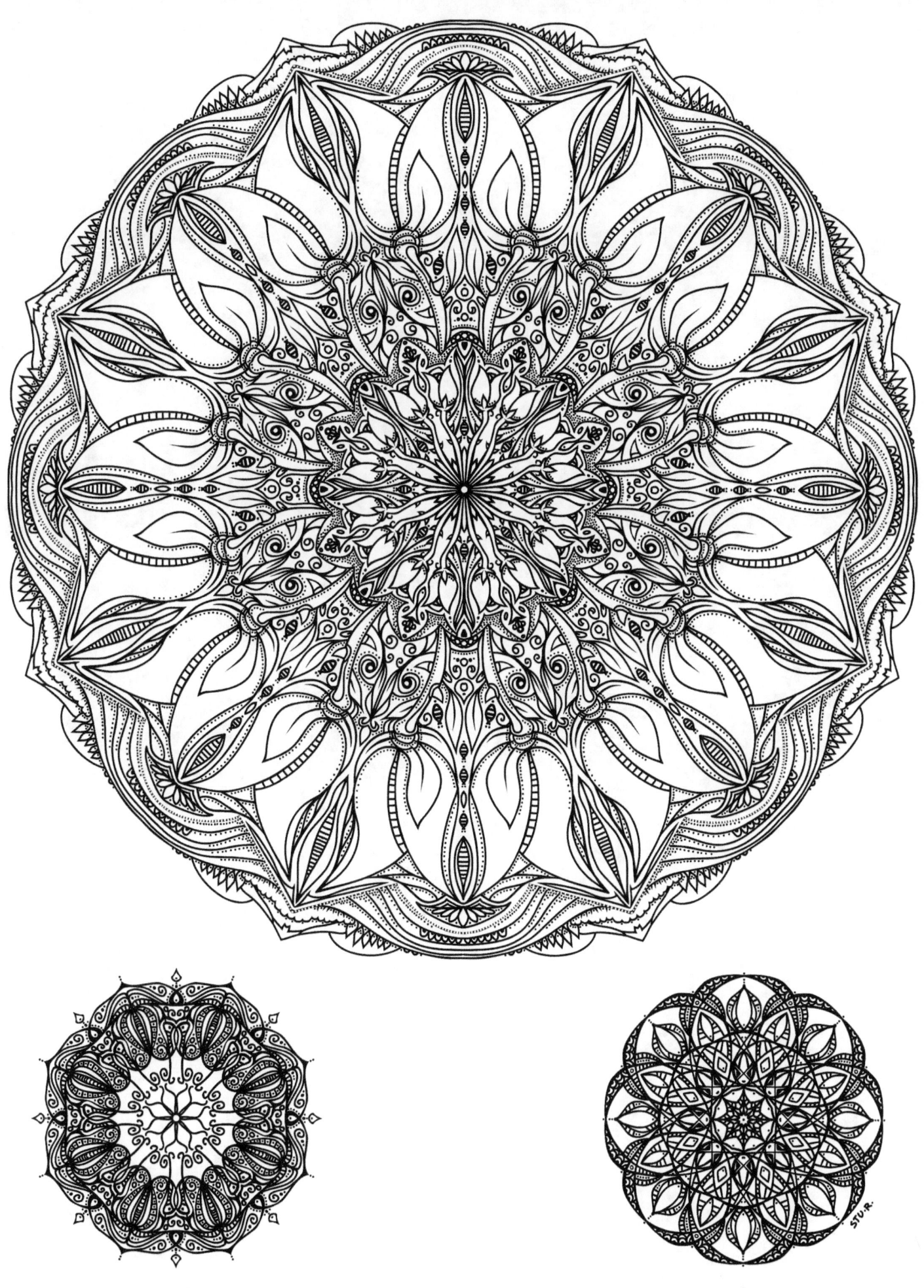

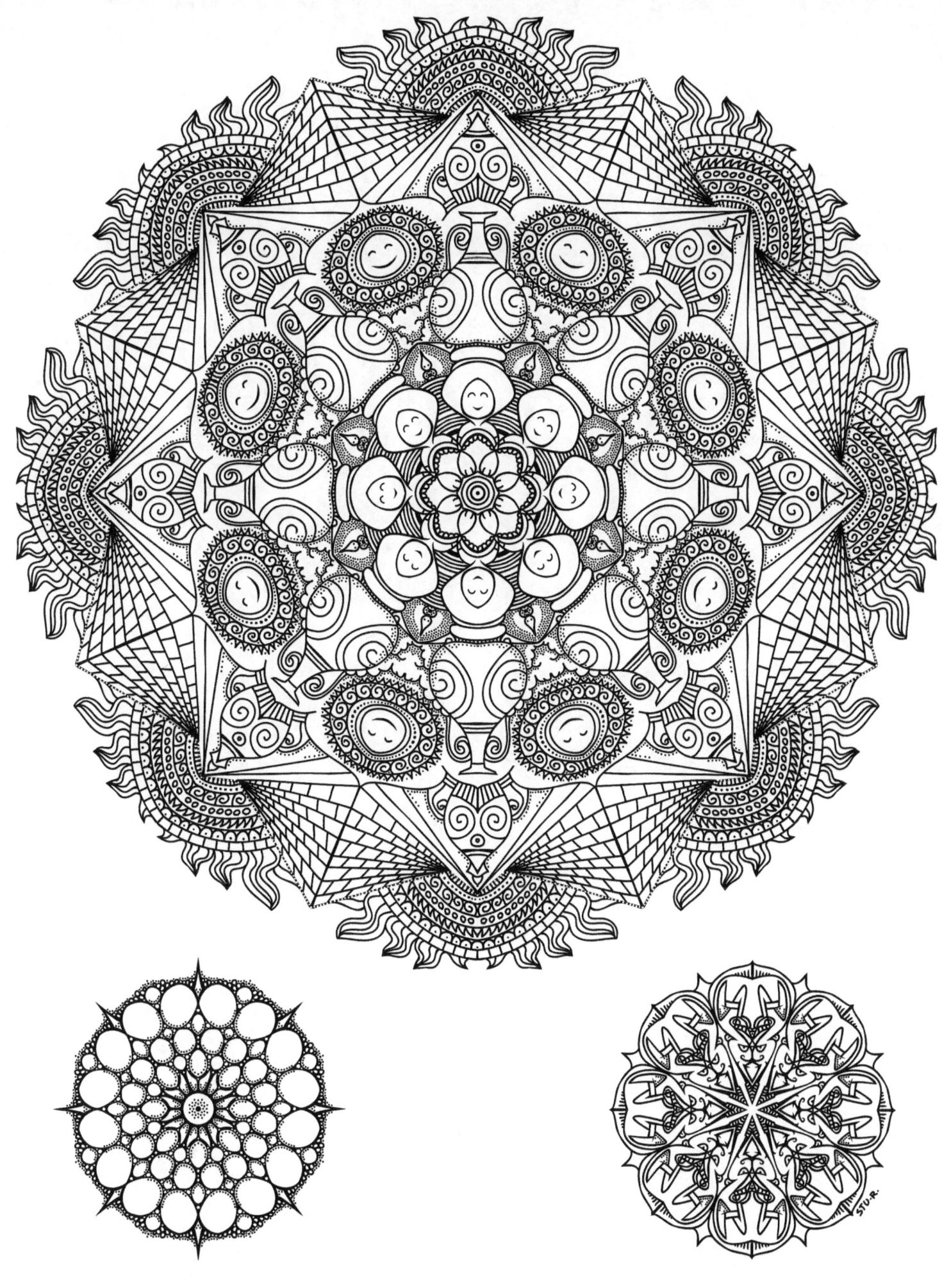

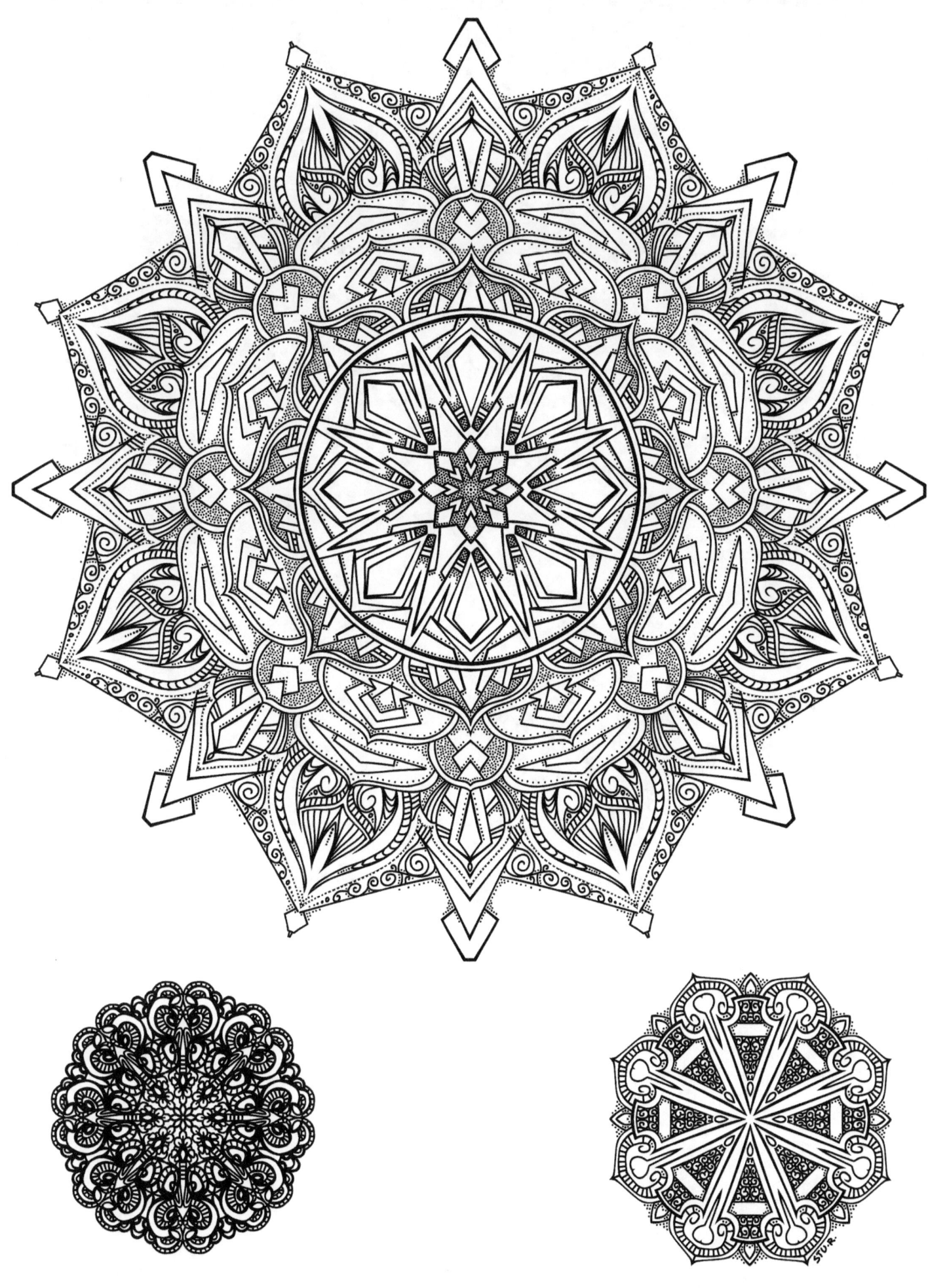

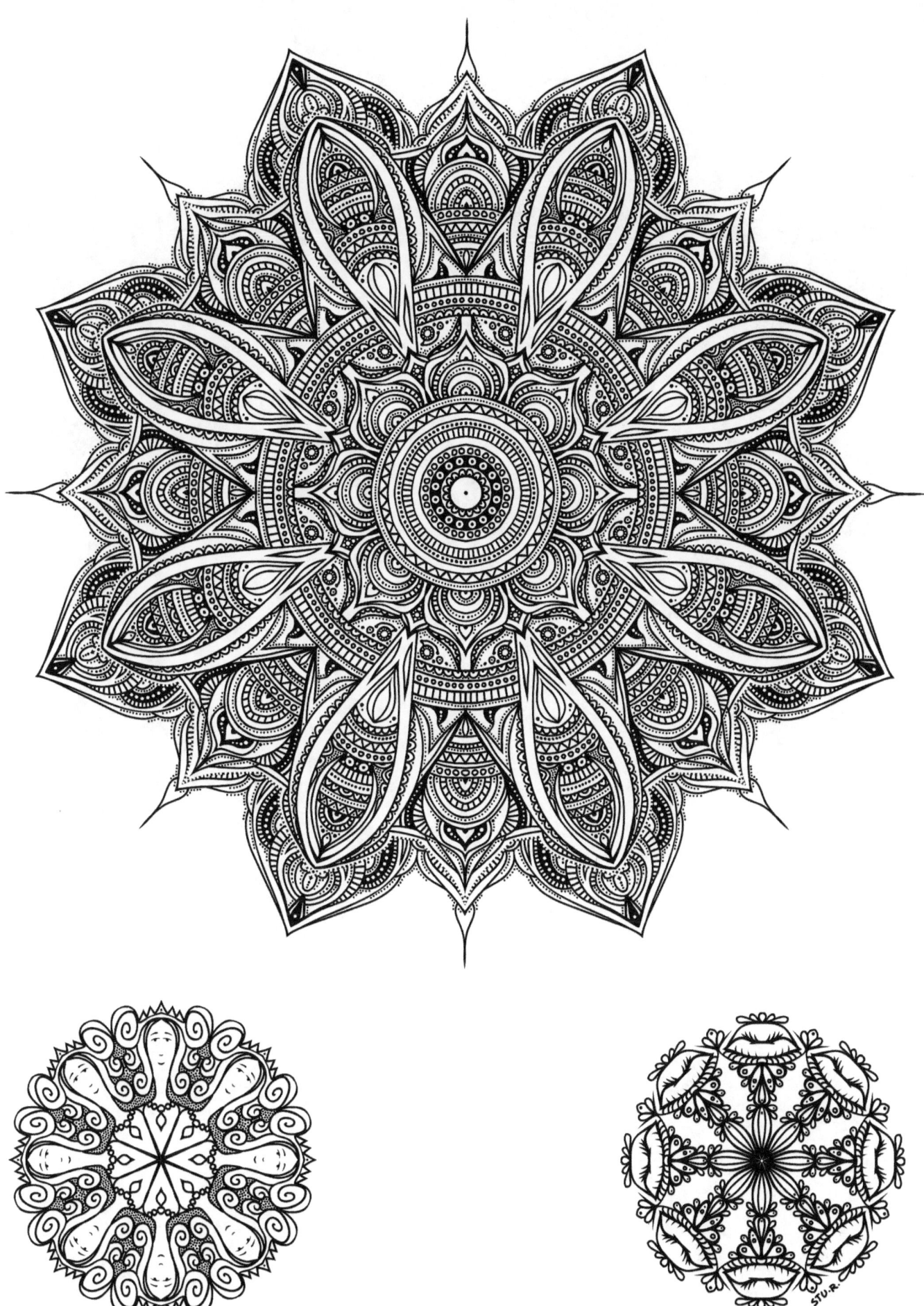

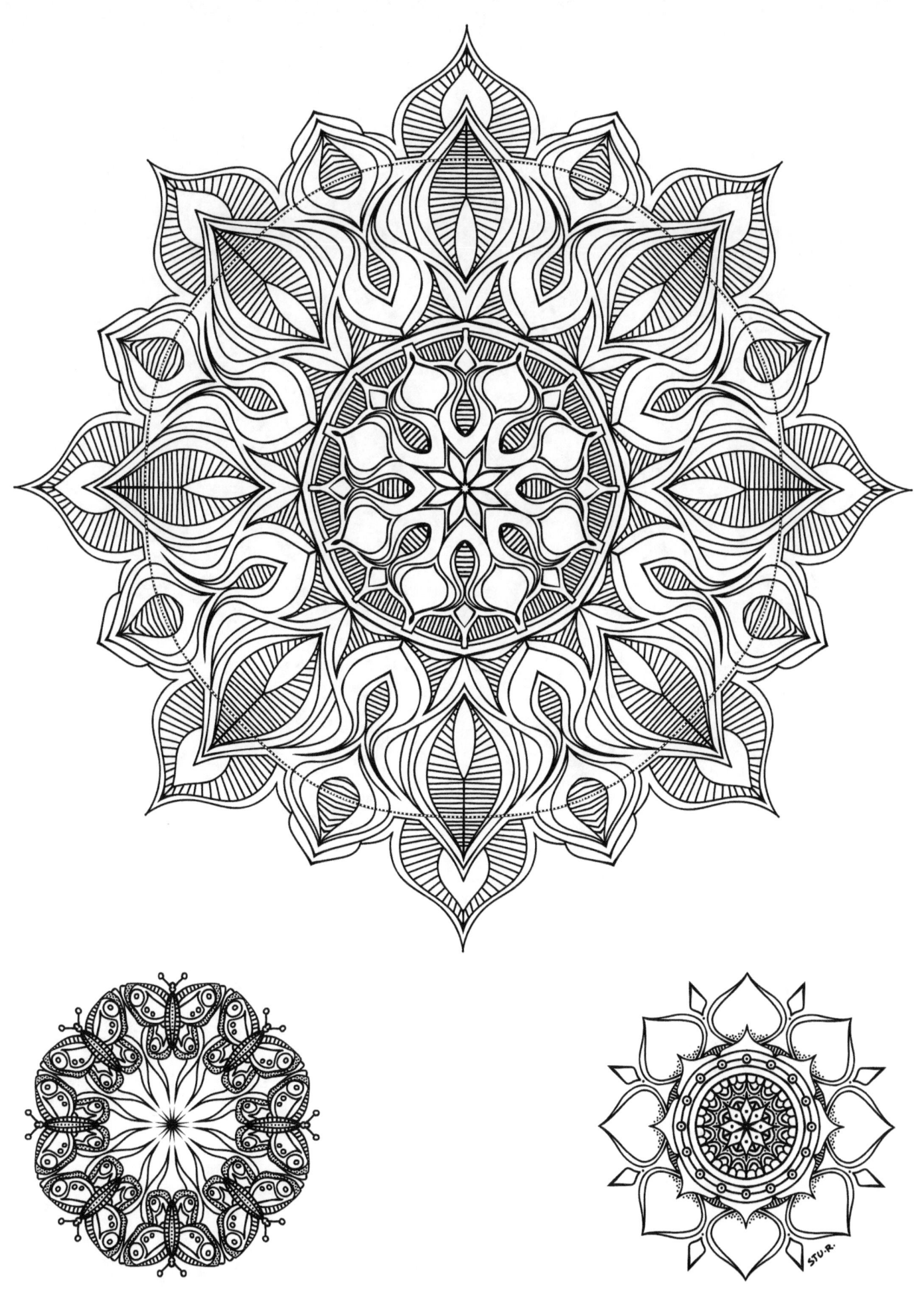

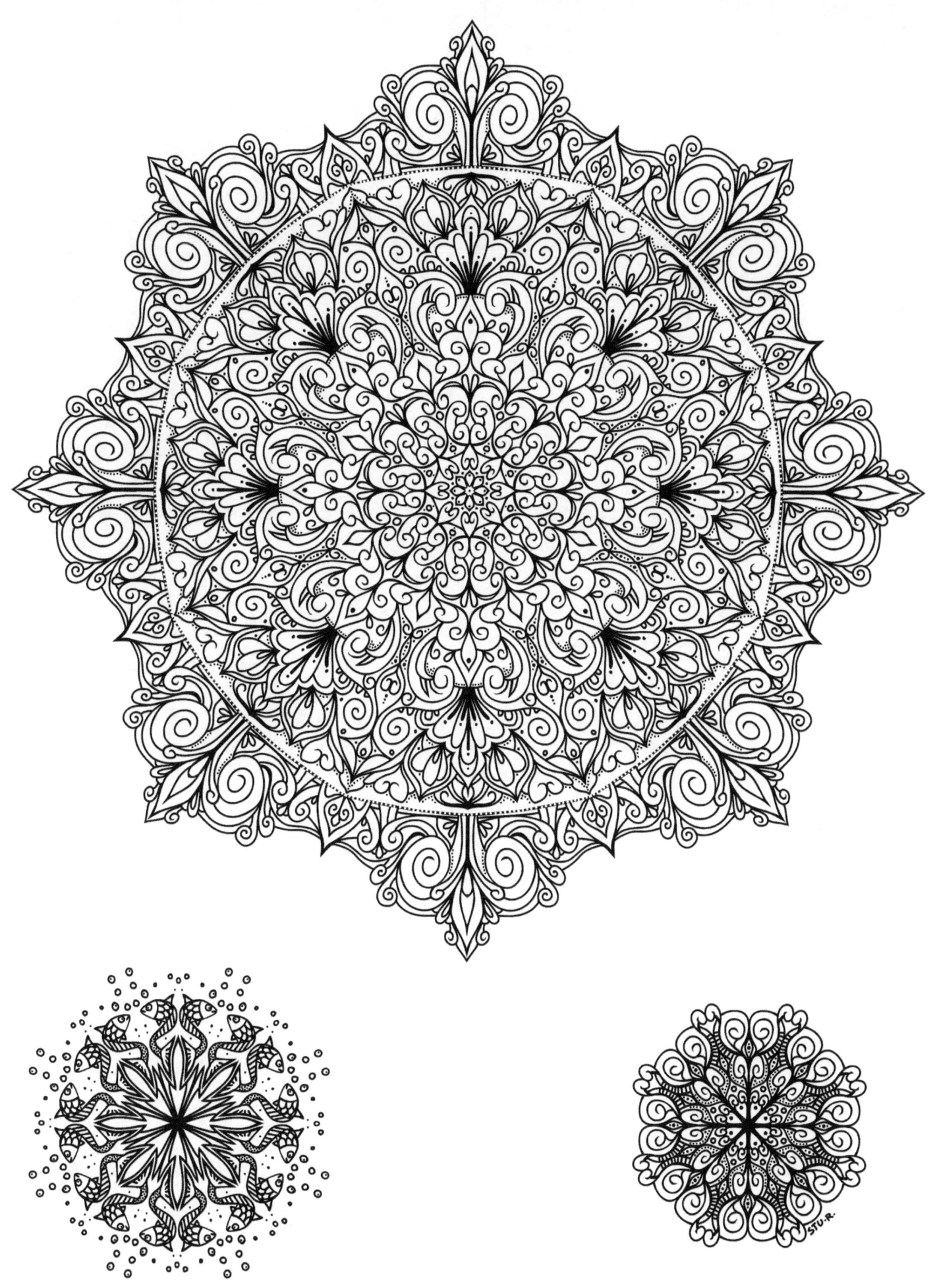

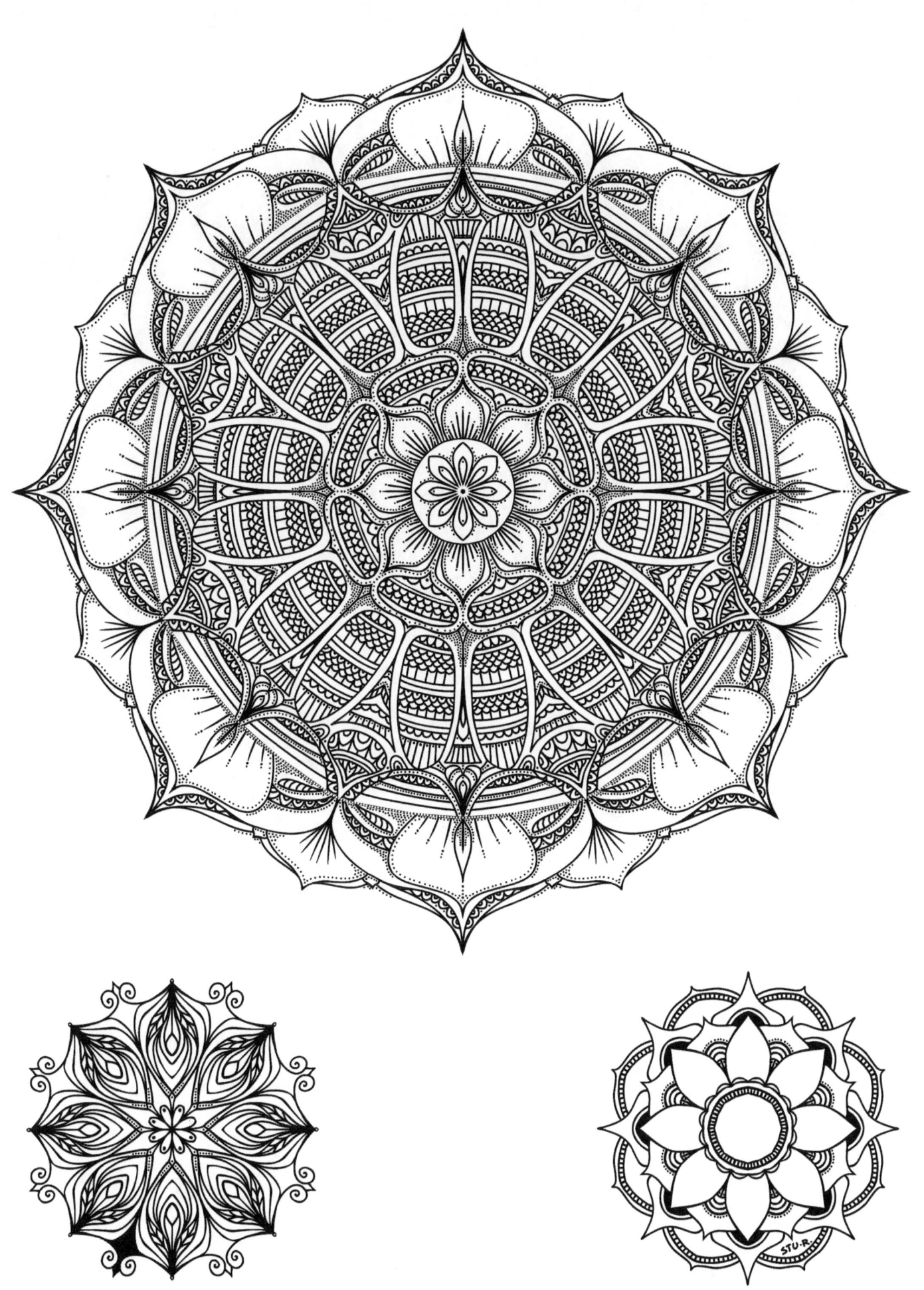

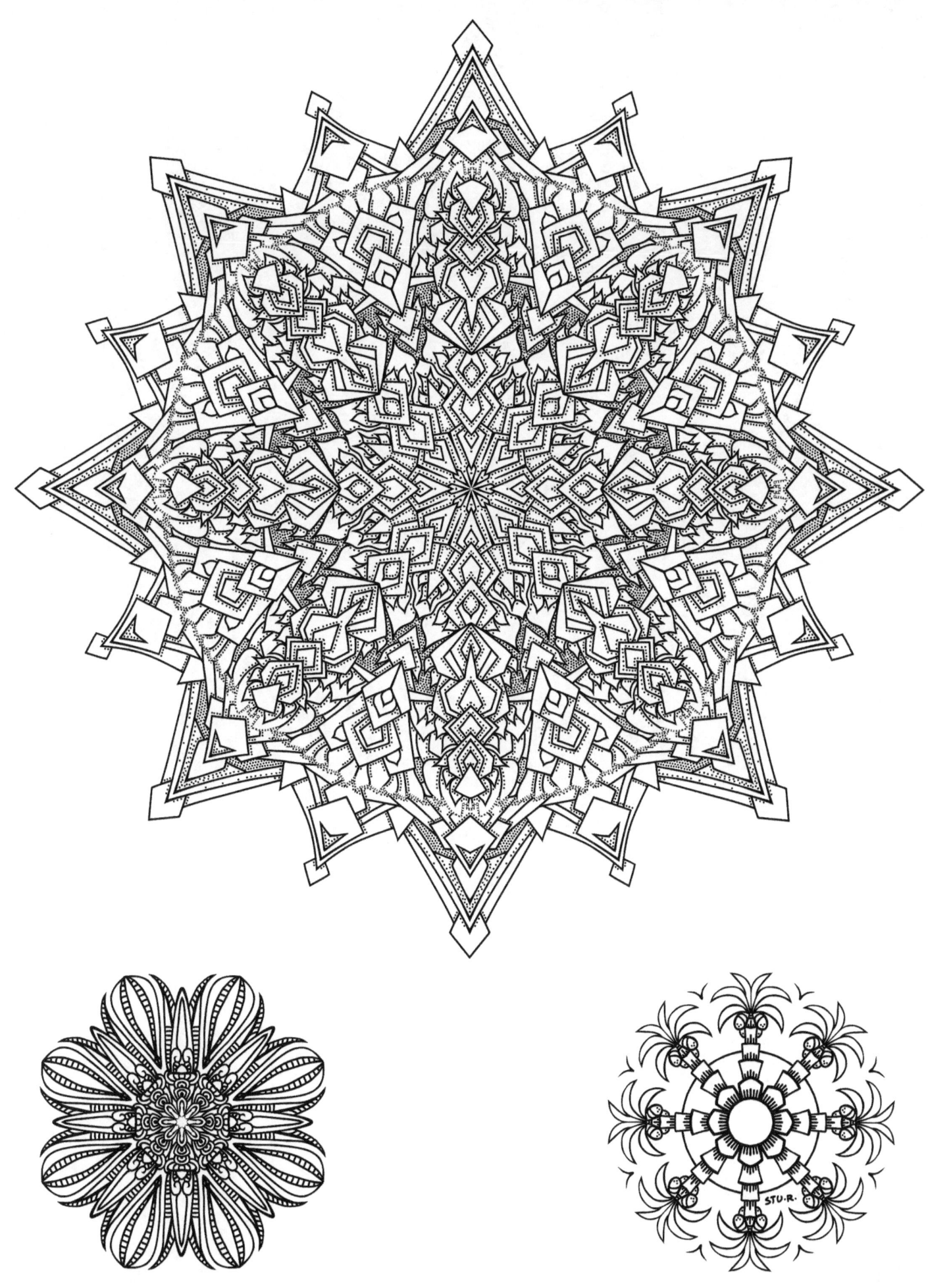

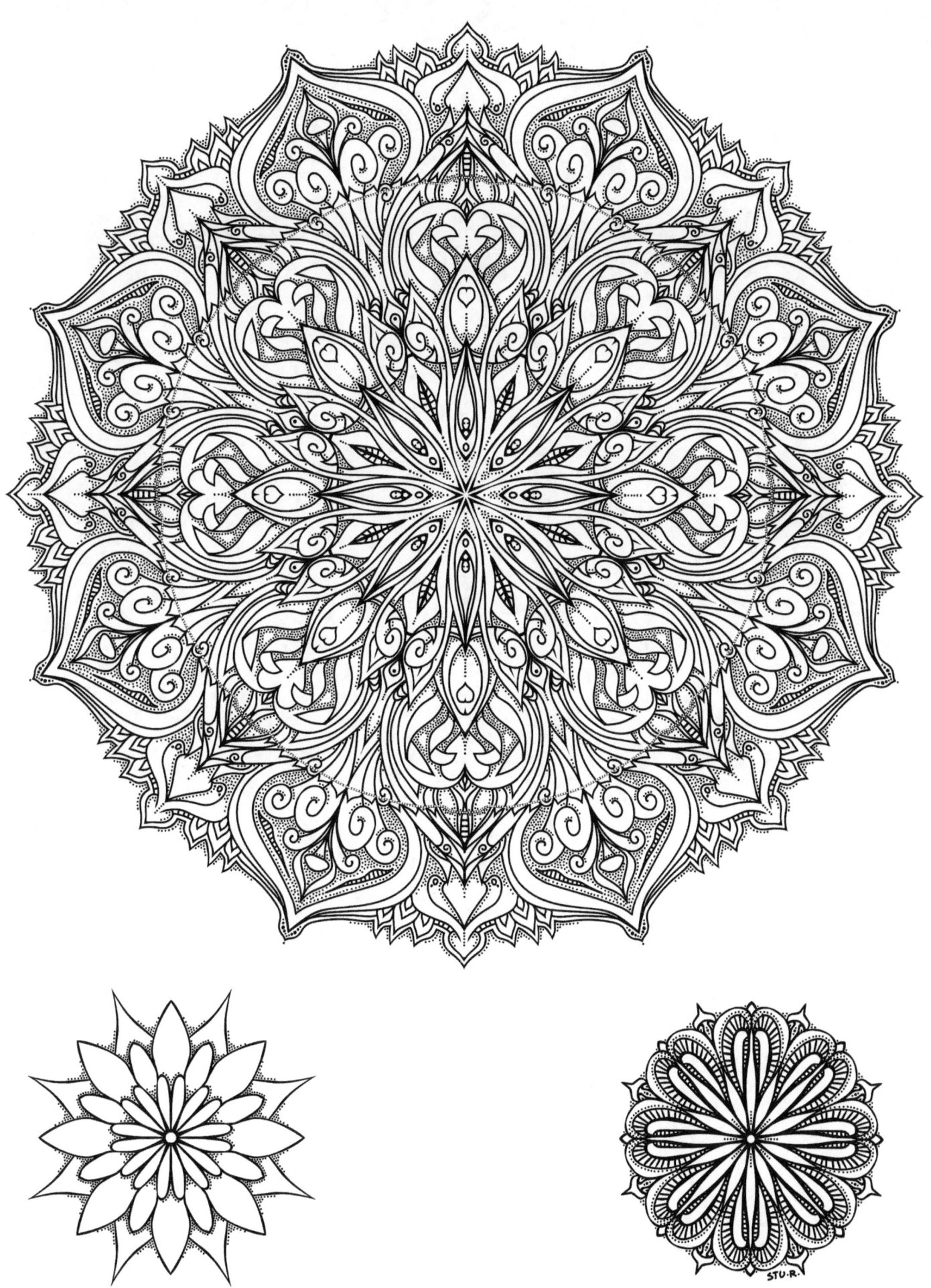

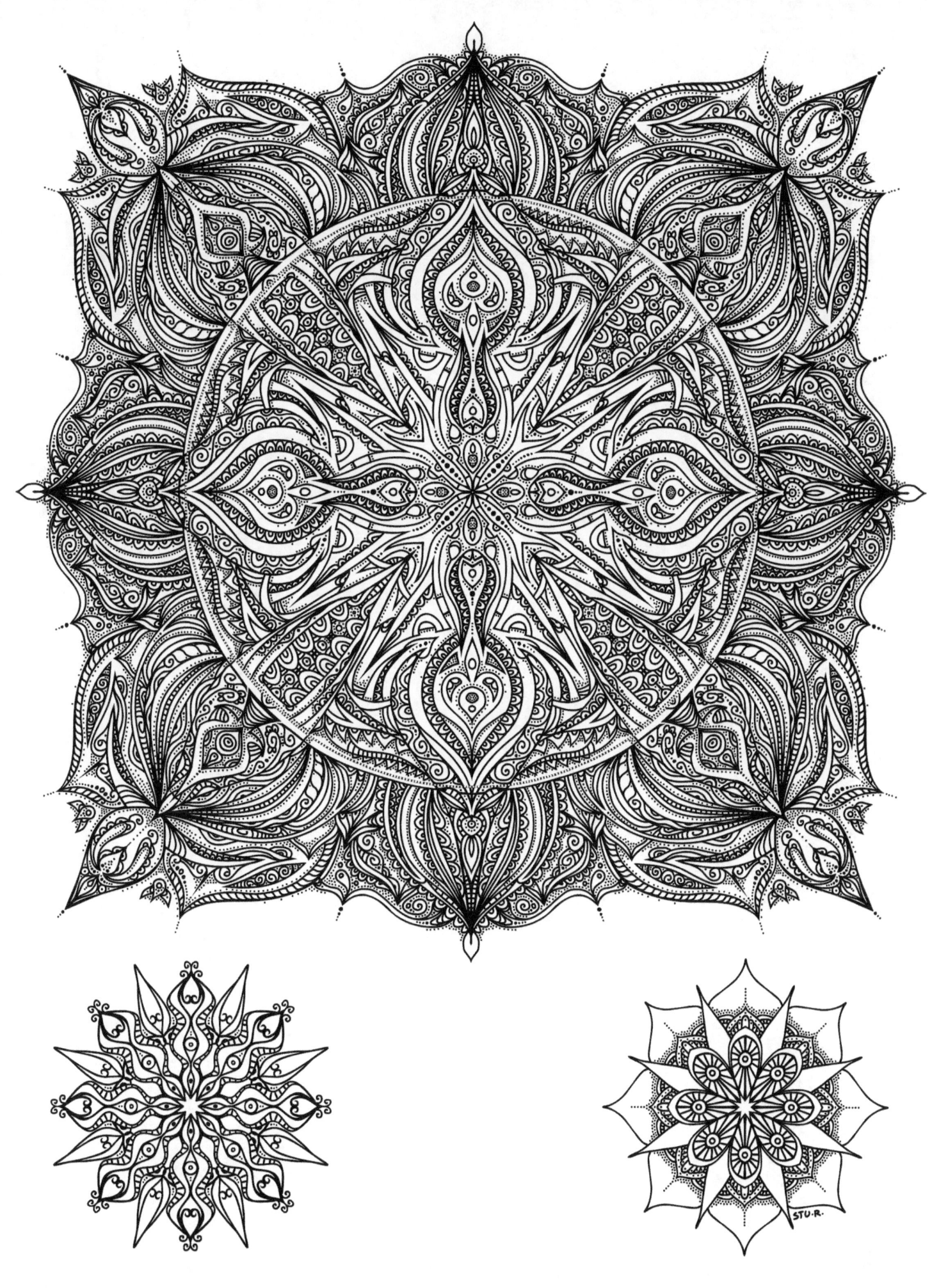

切

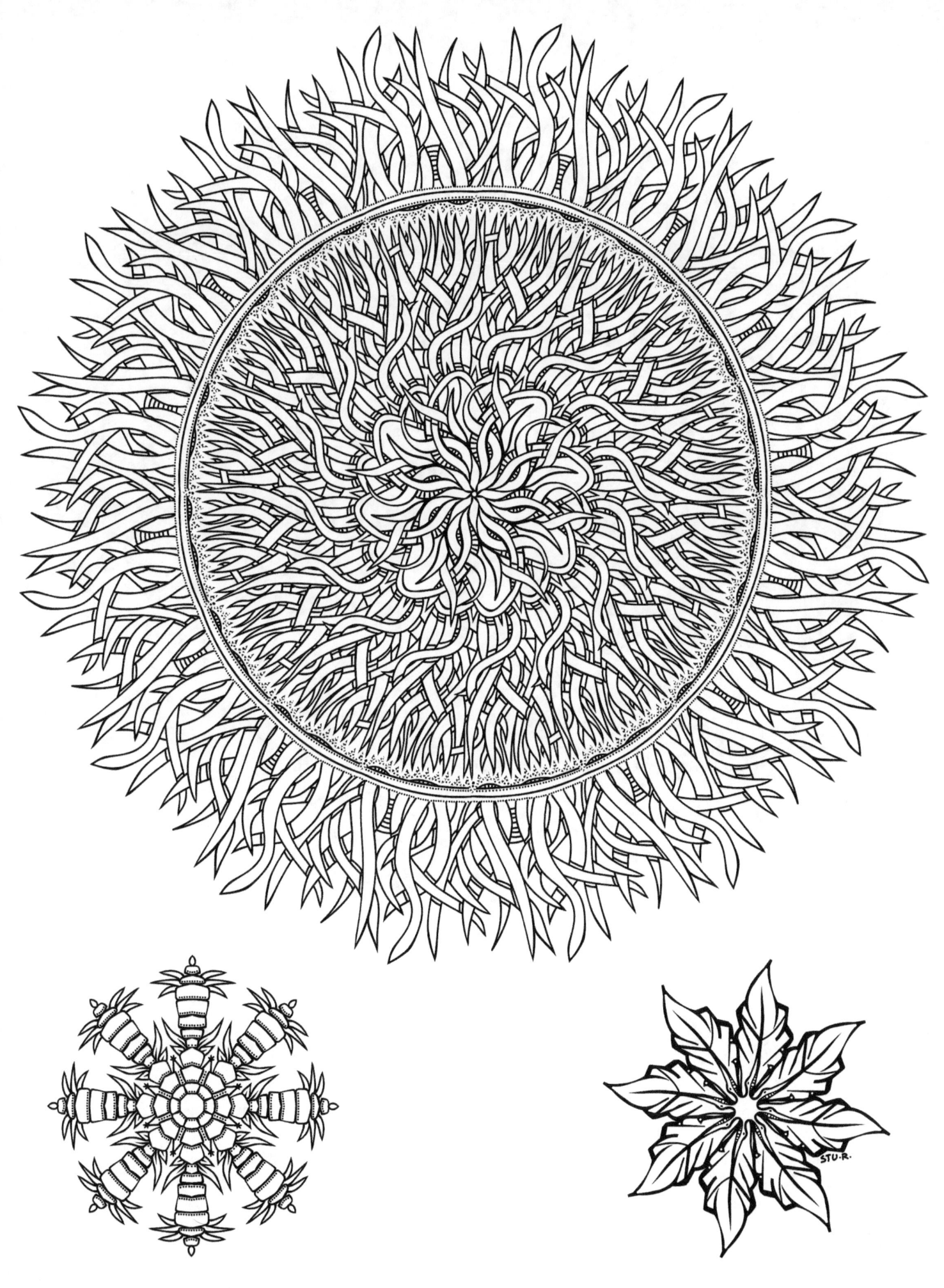

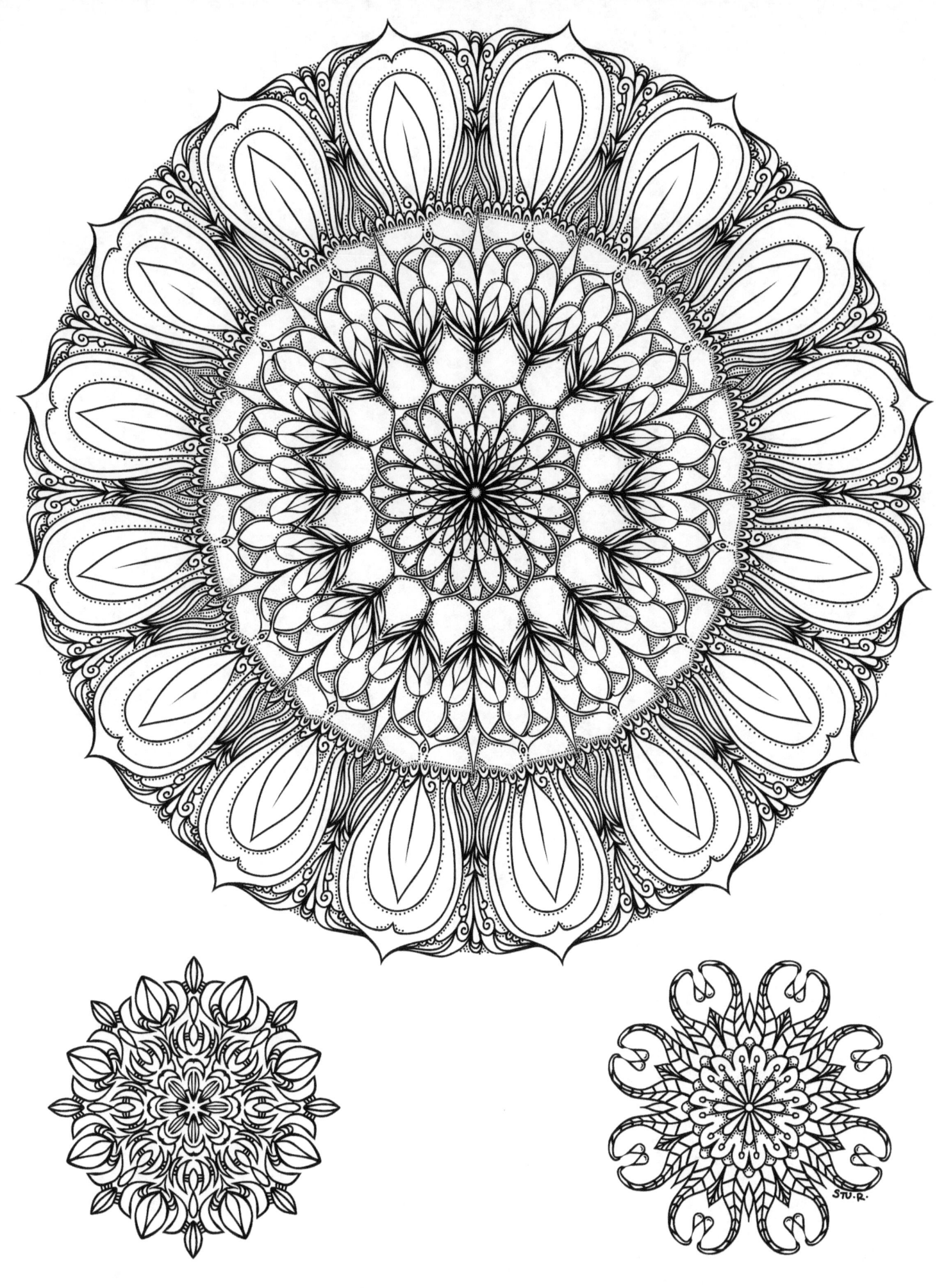

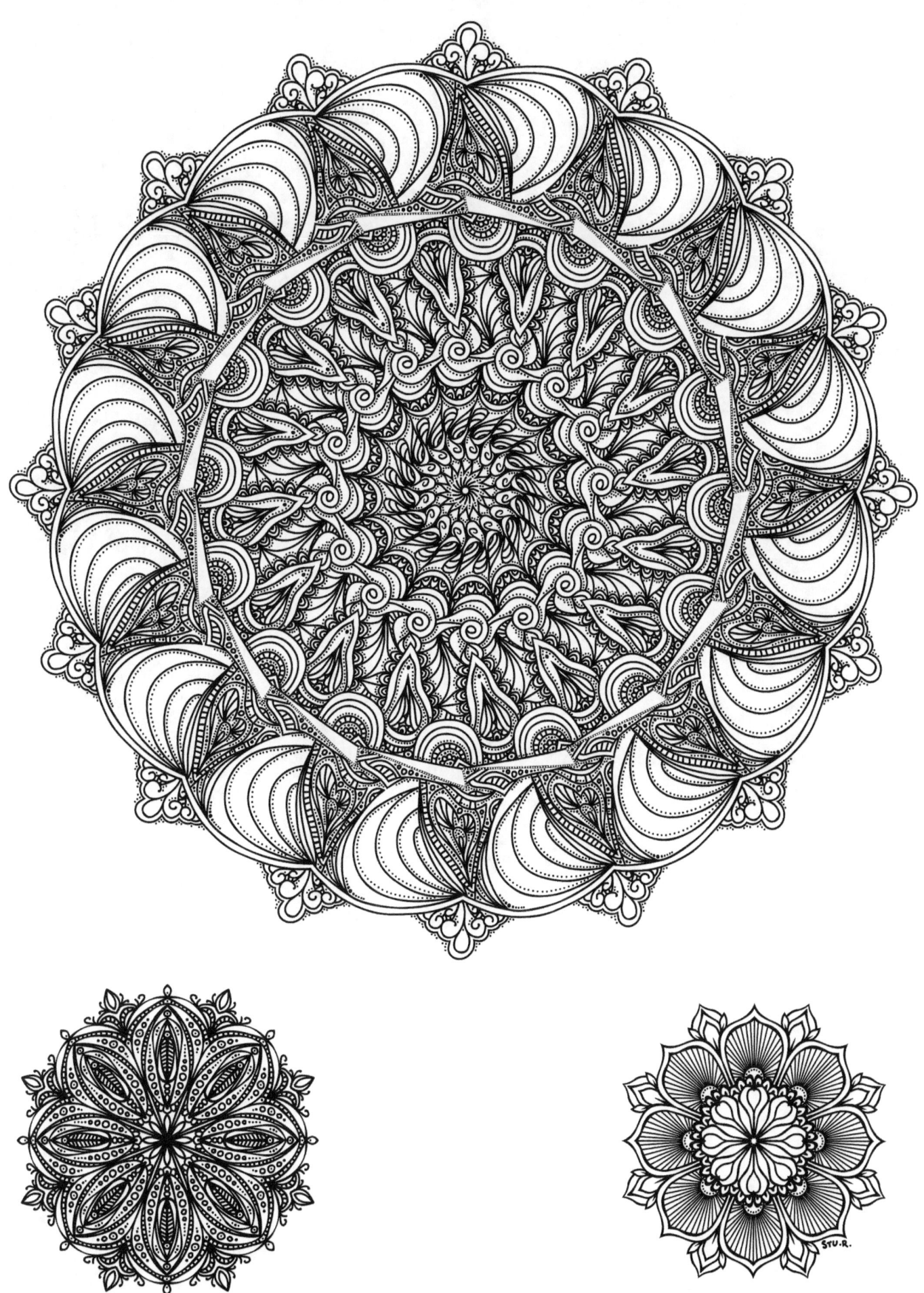

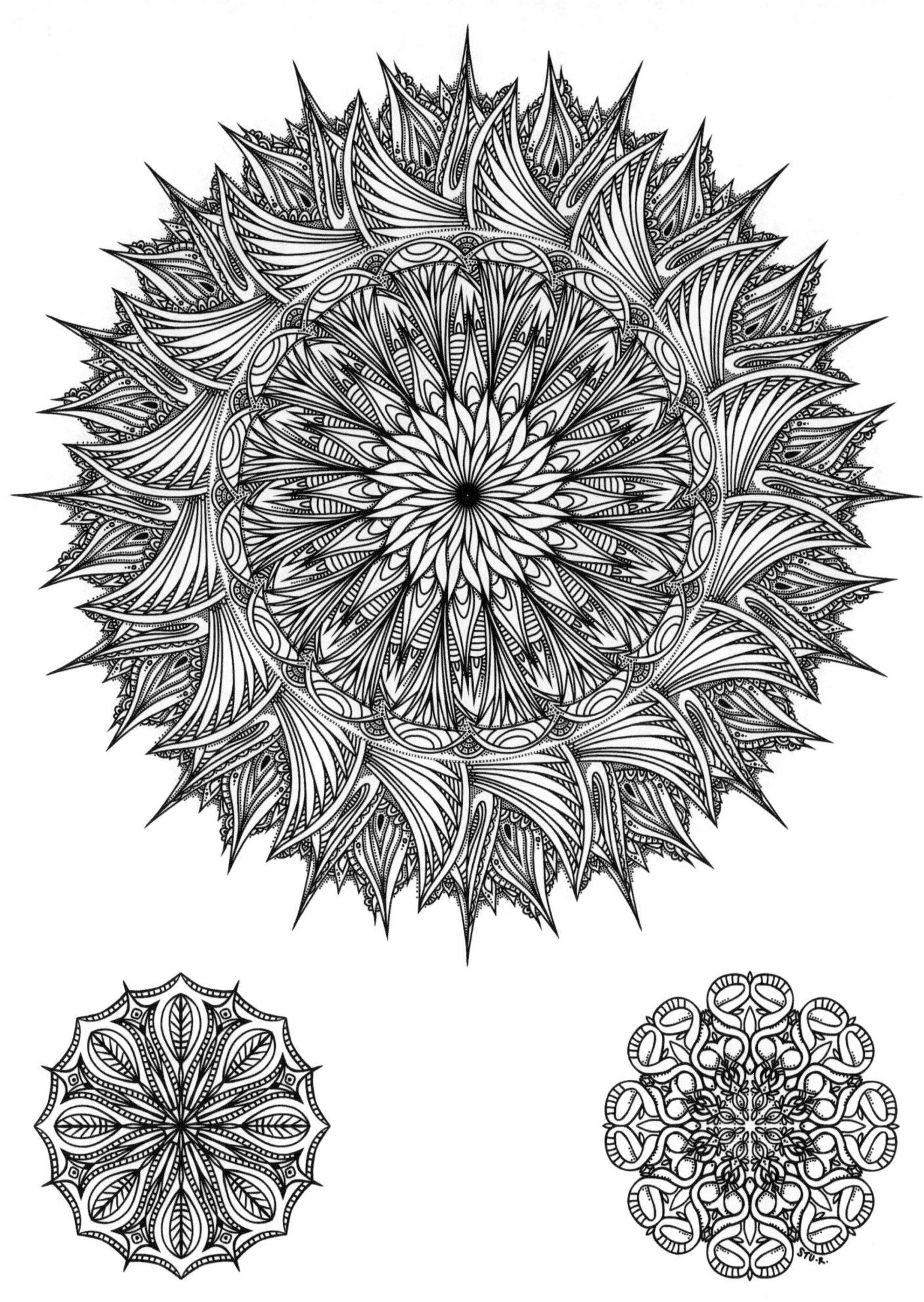

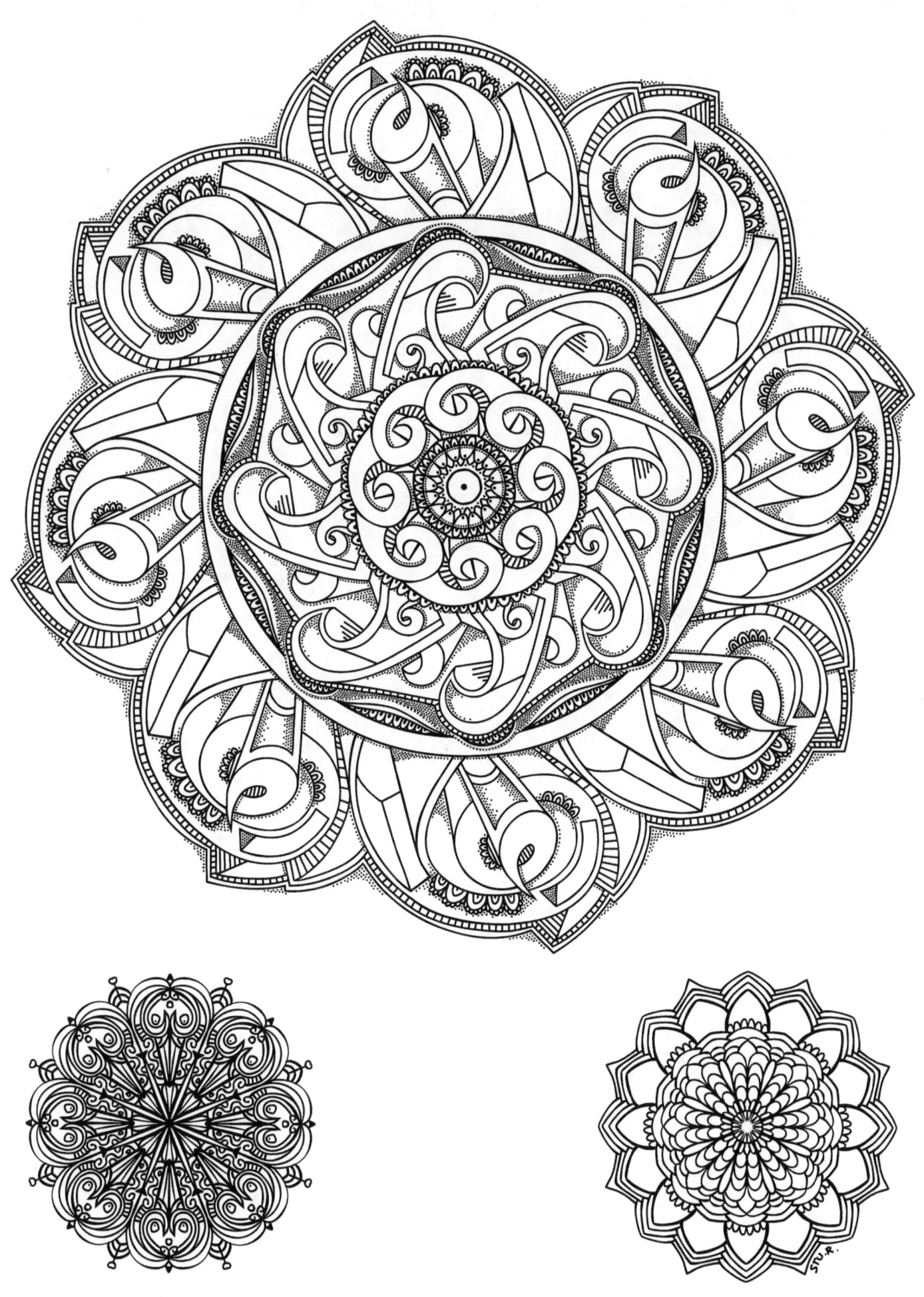

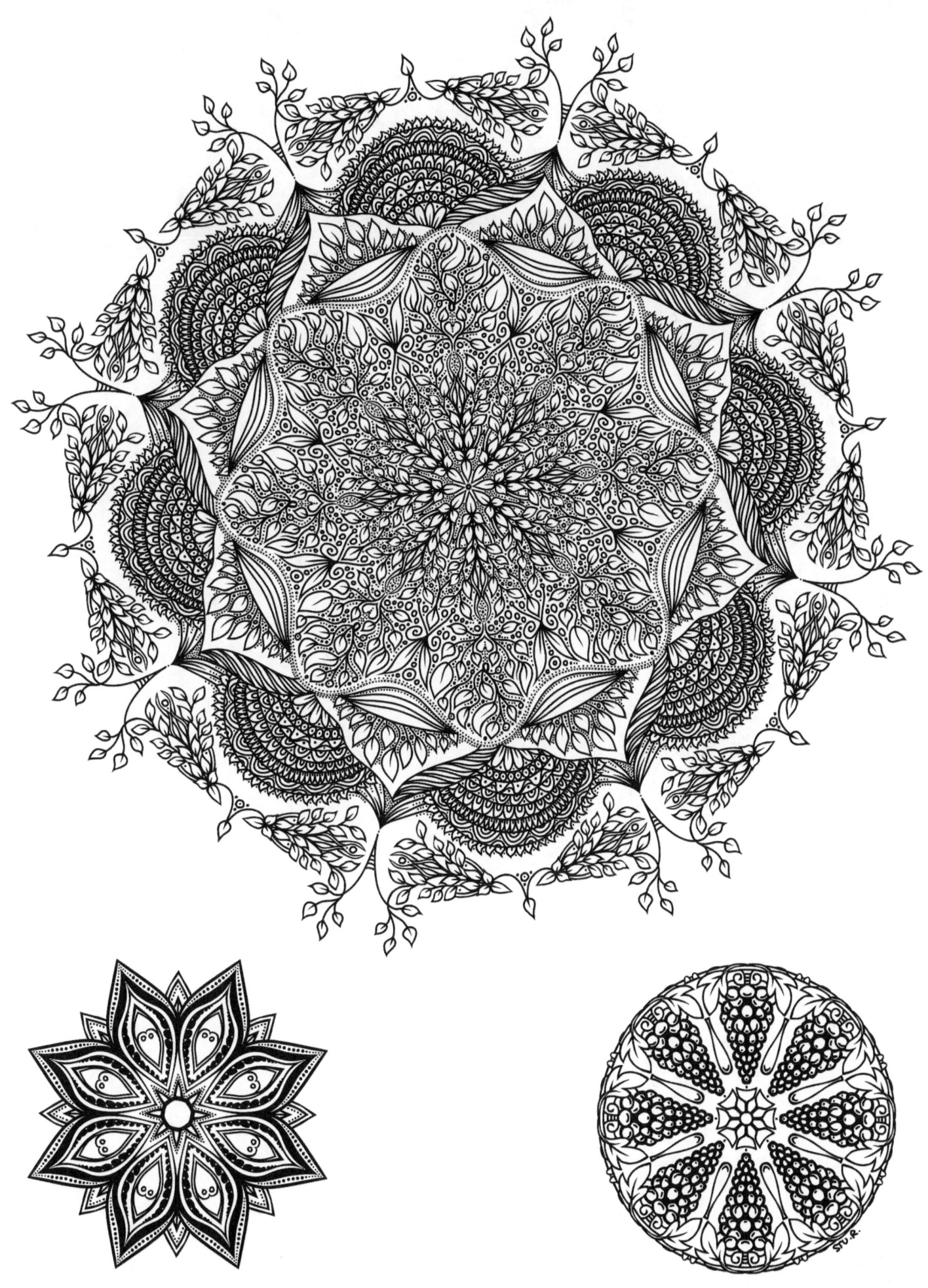

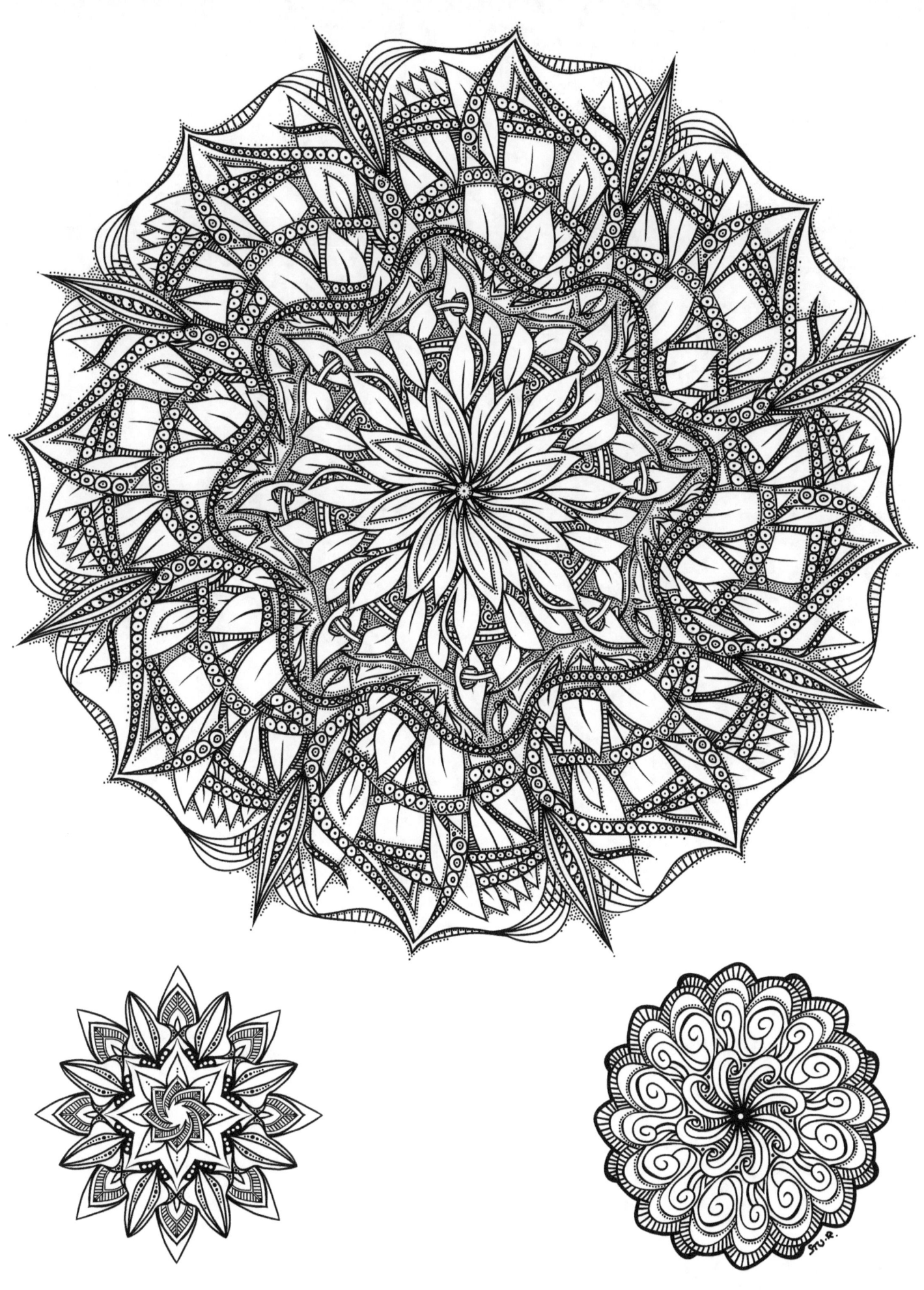

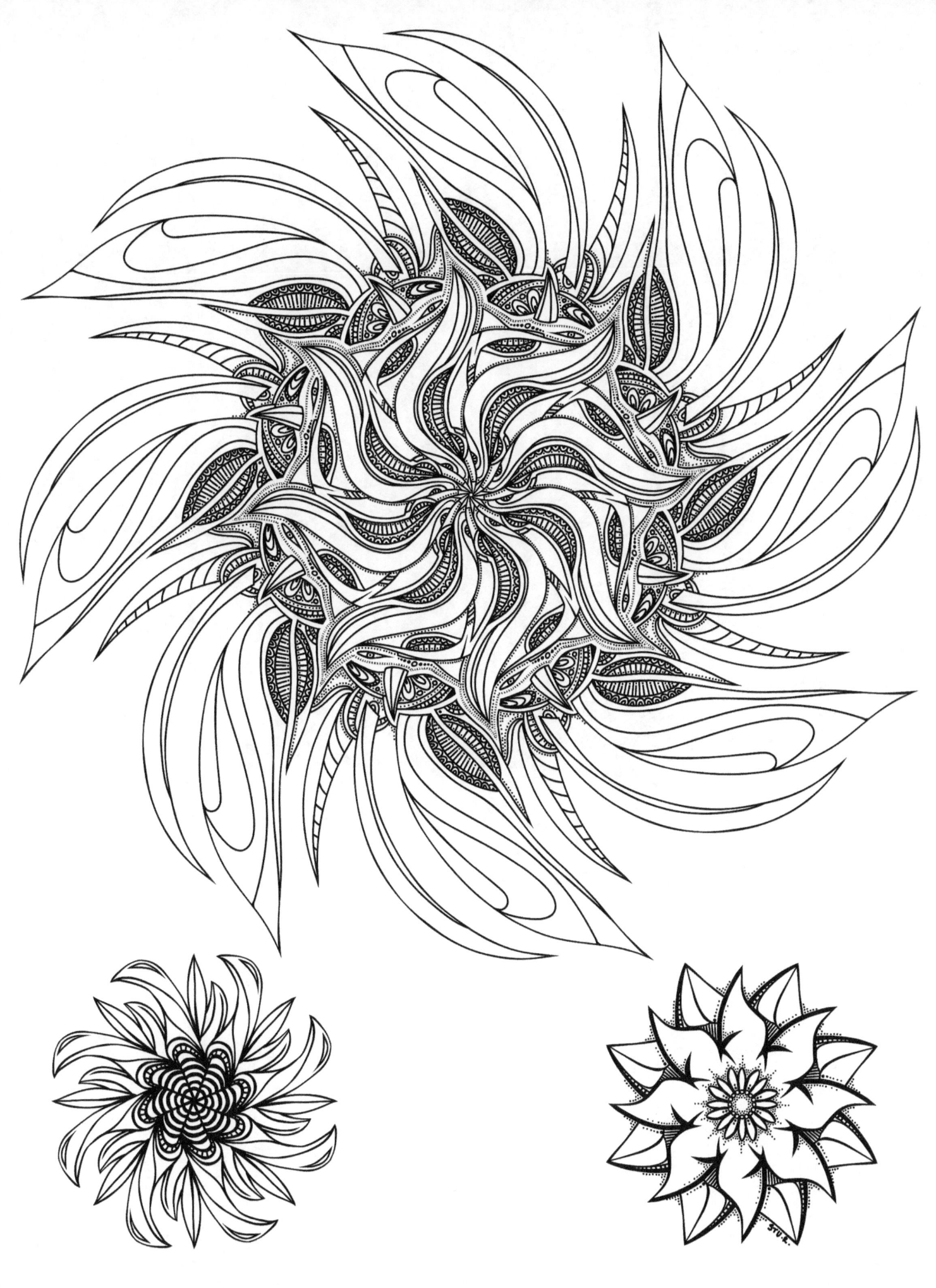

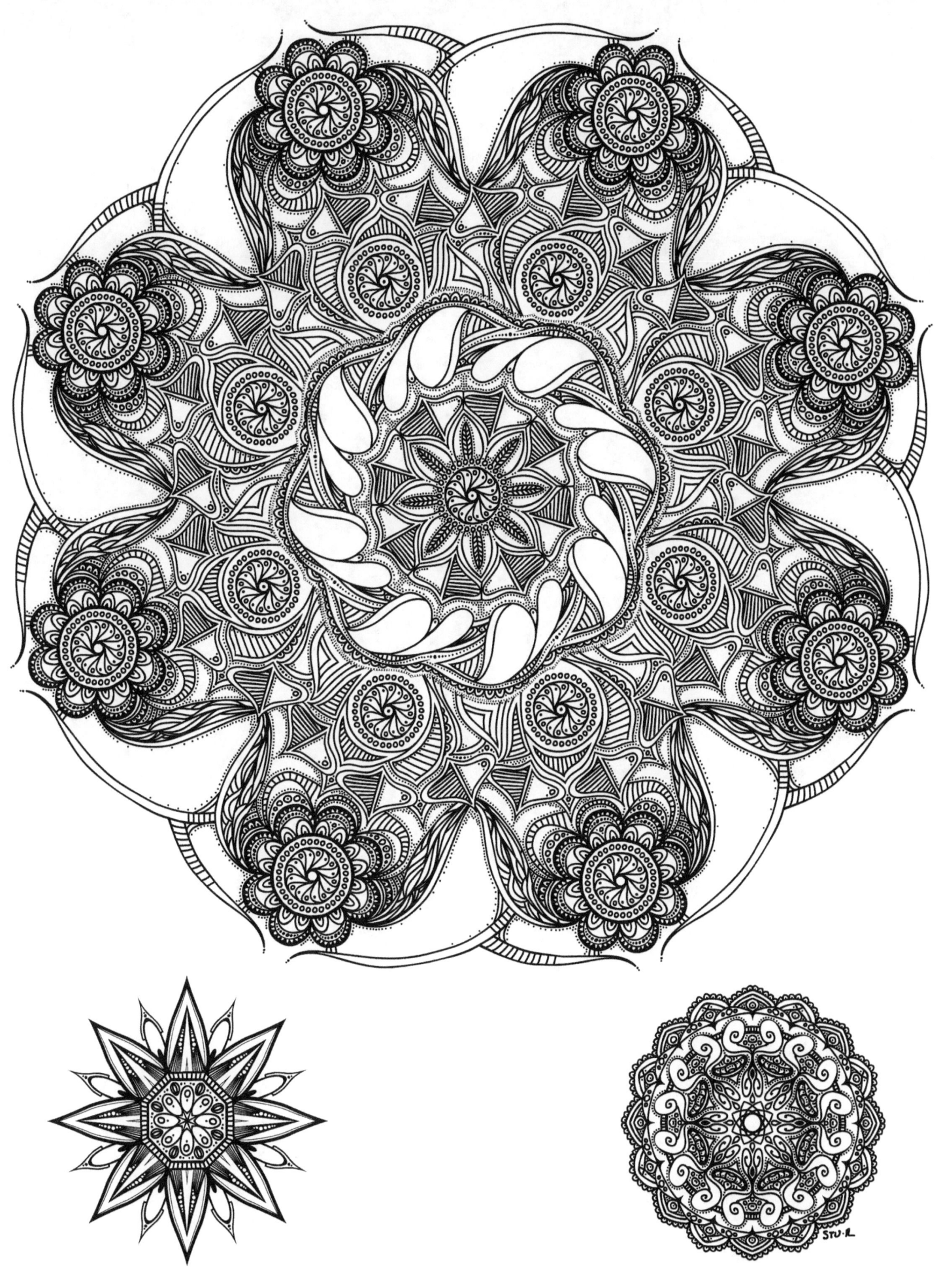

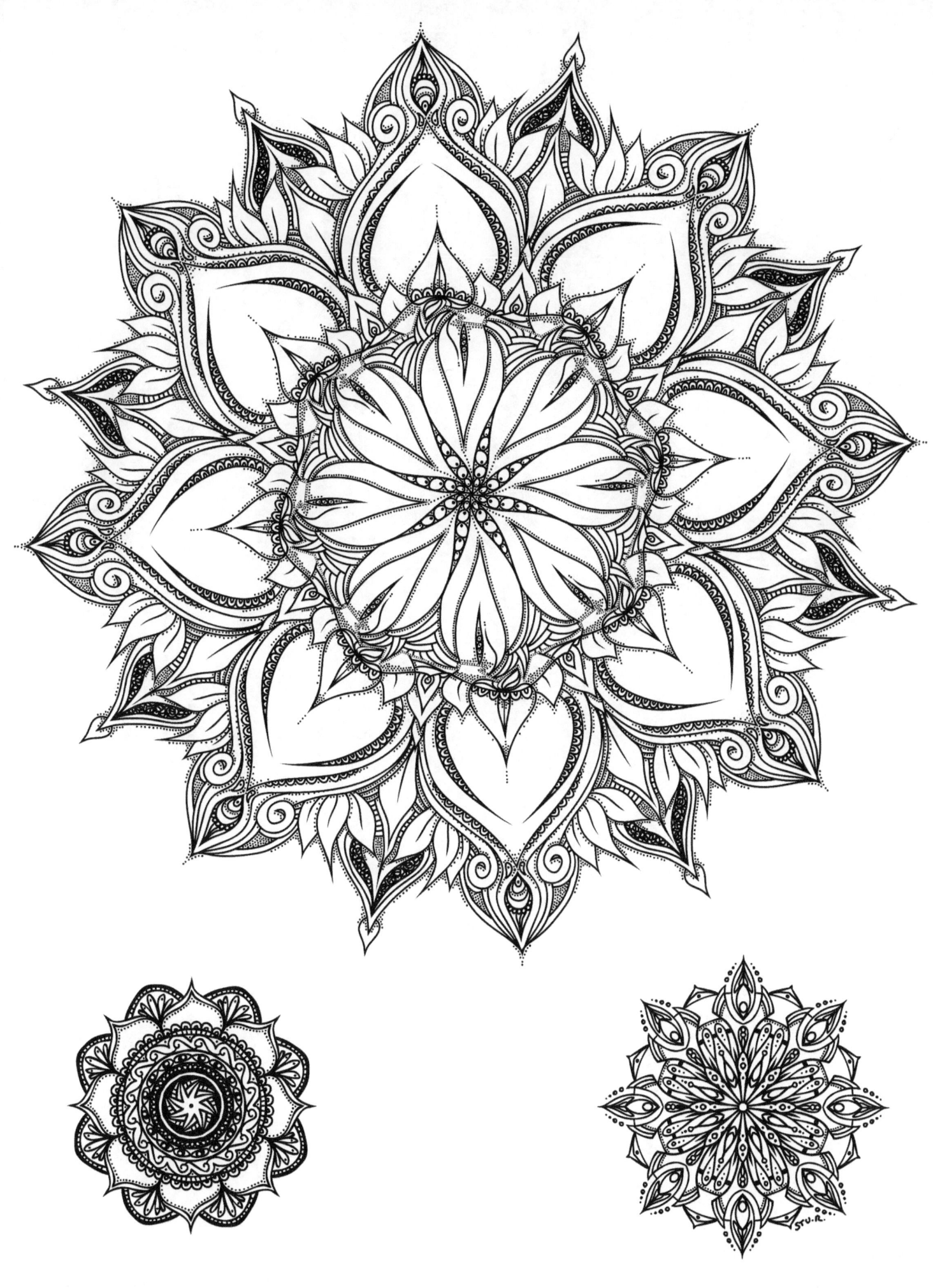

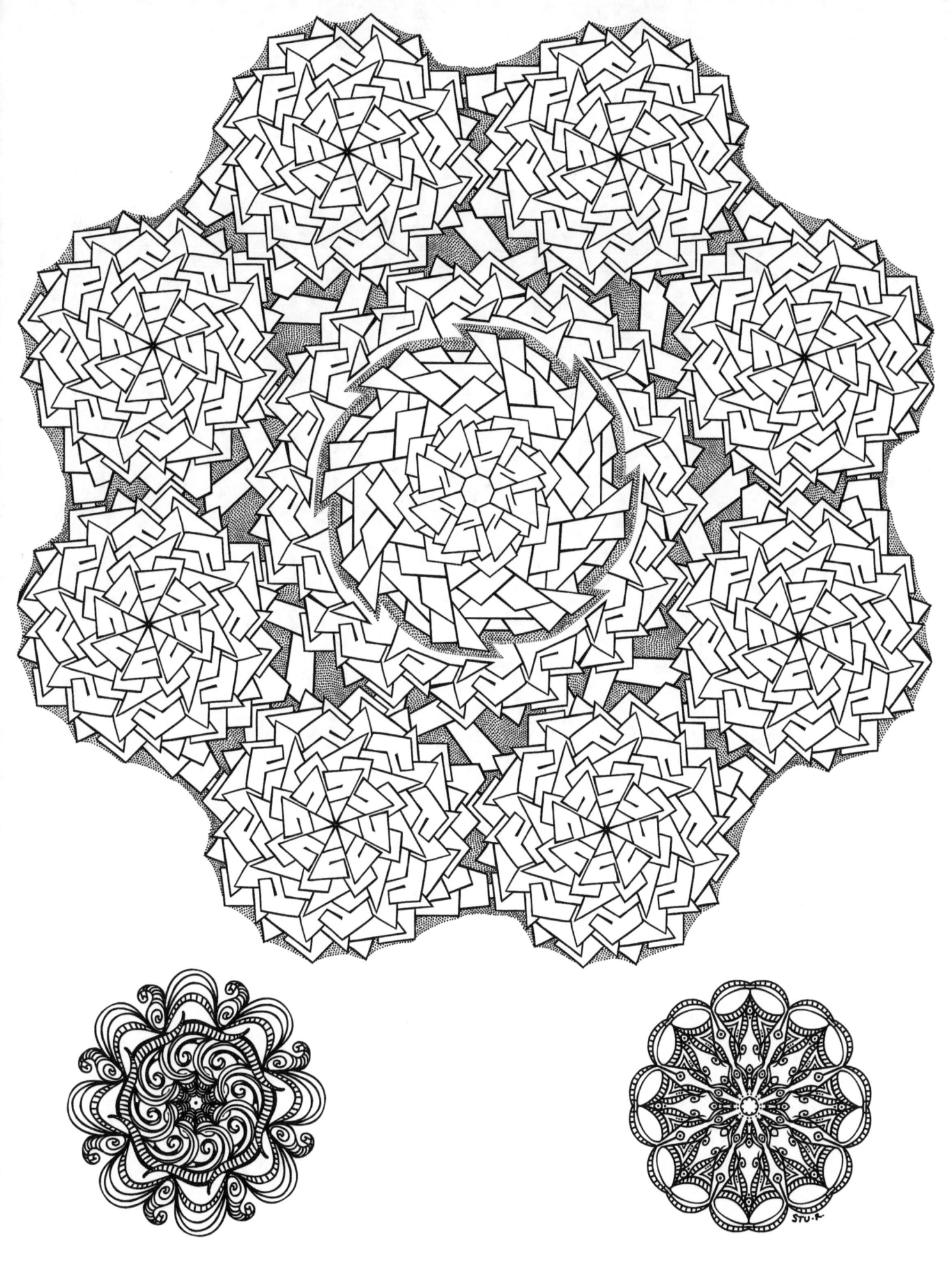

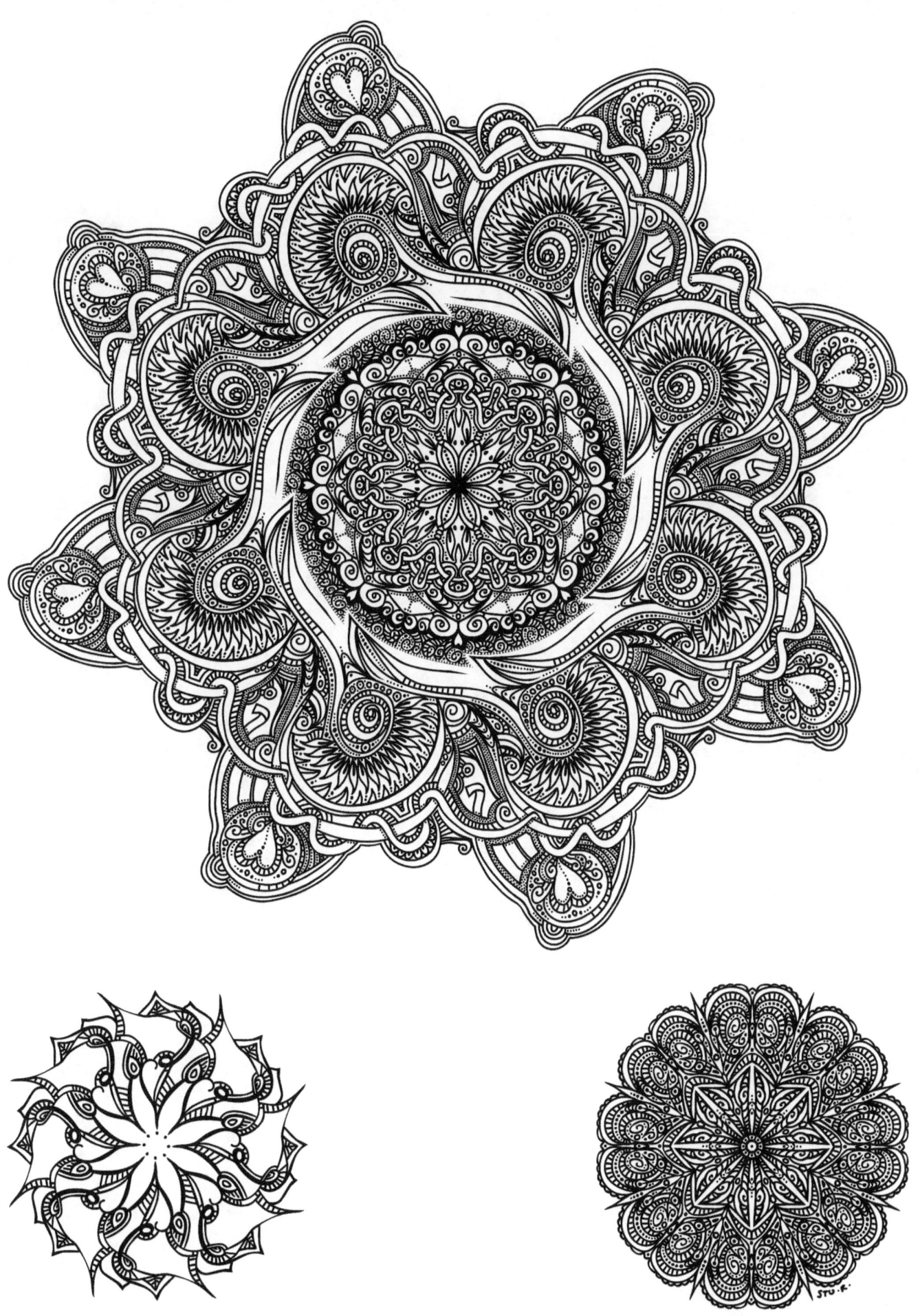

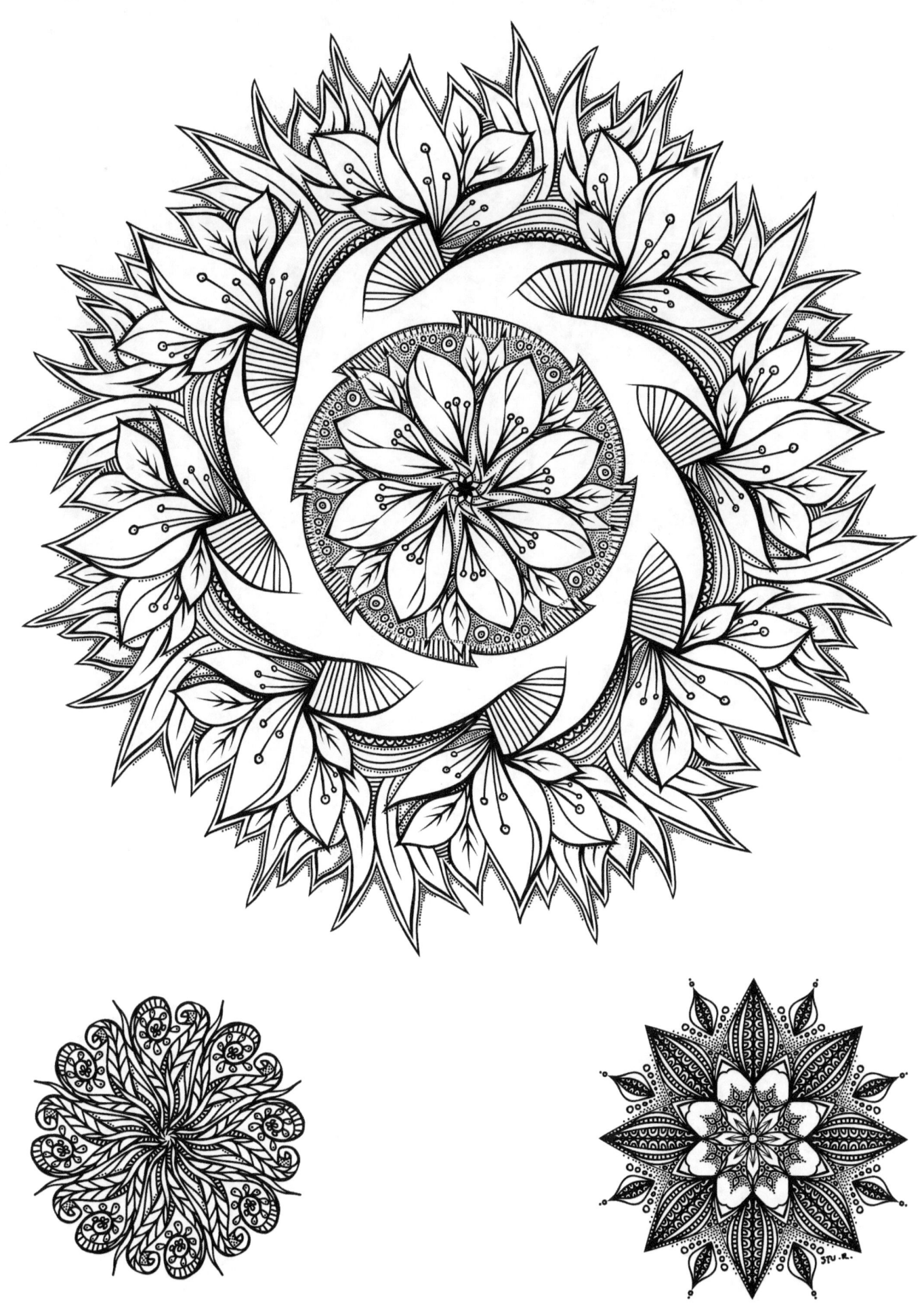

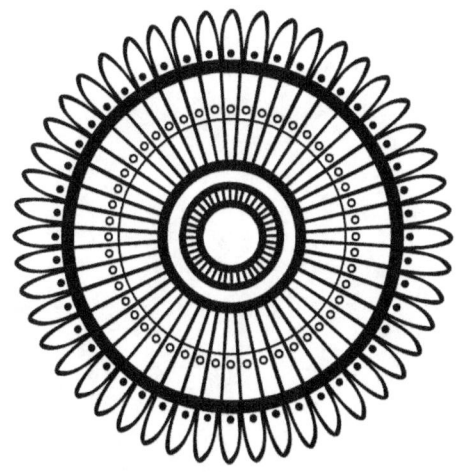
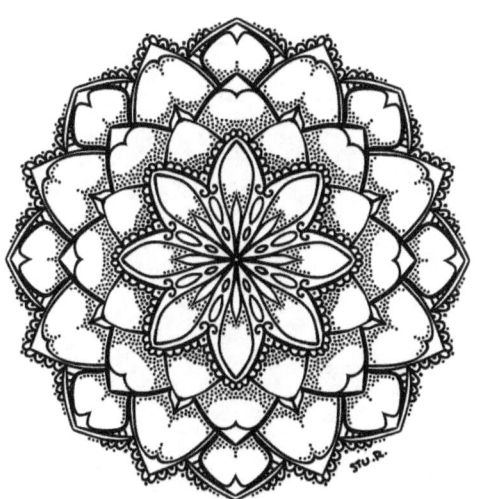

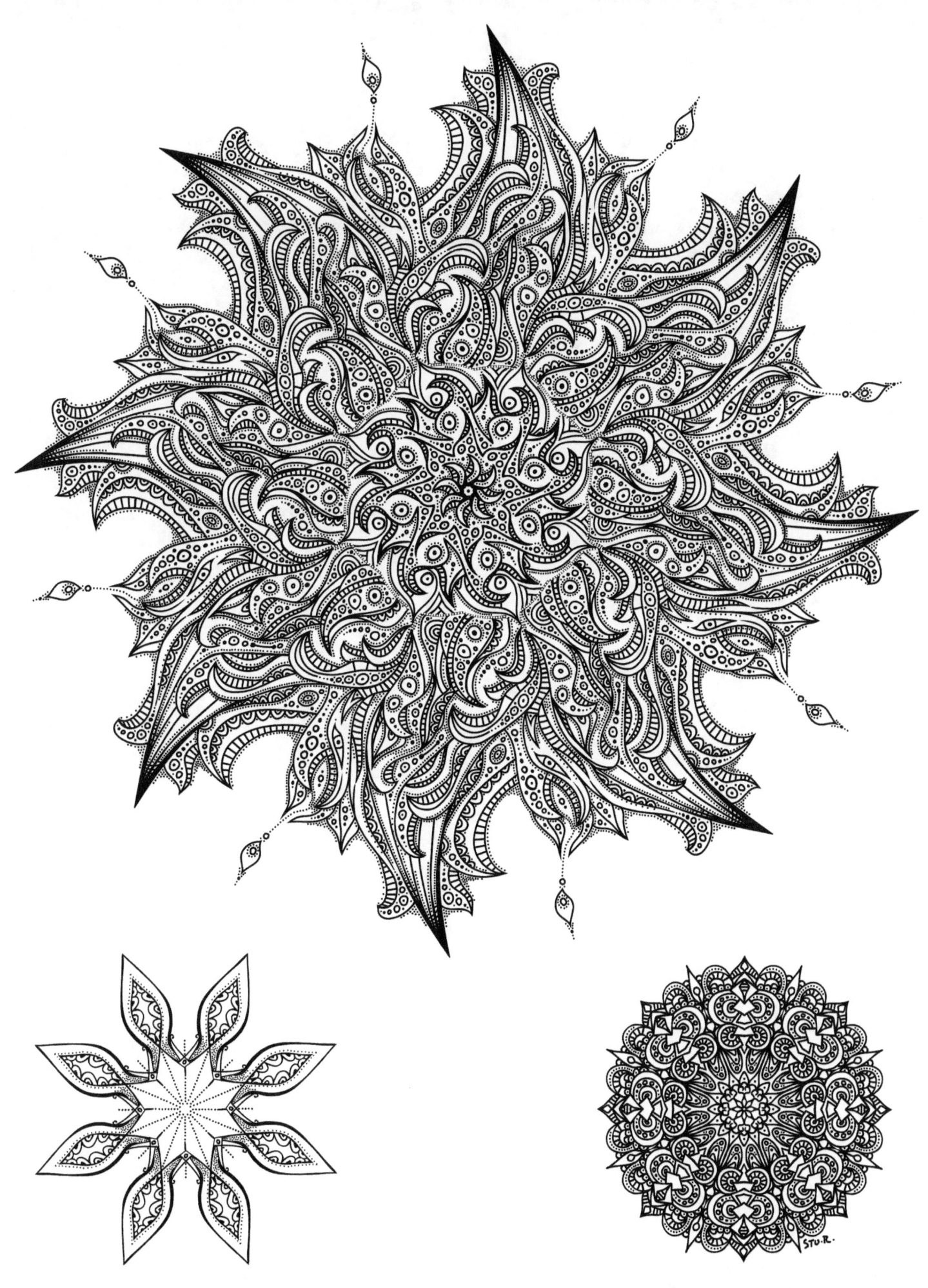

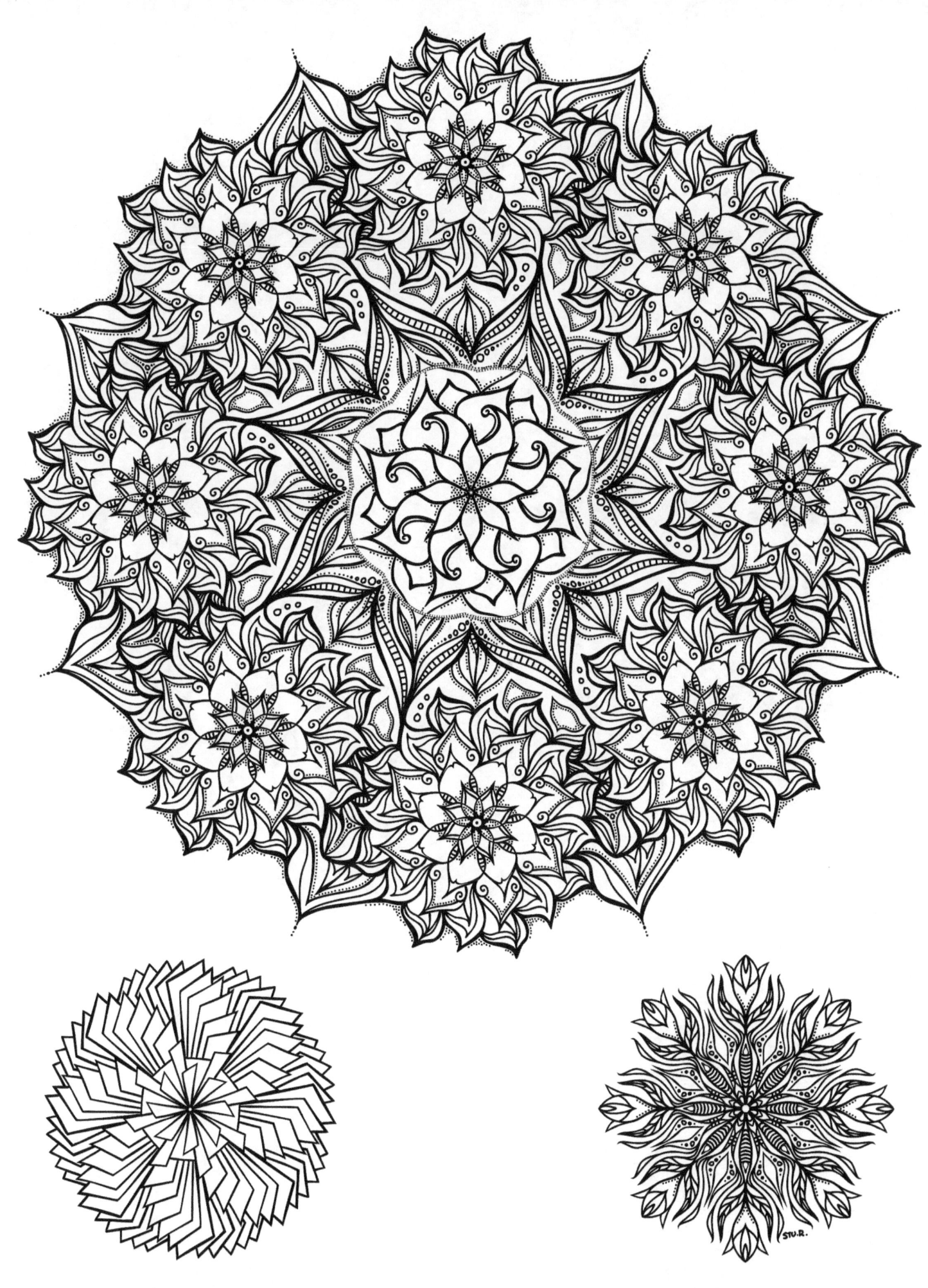

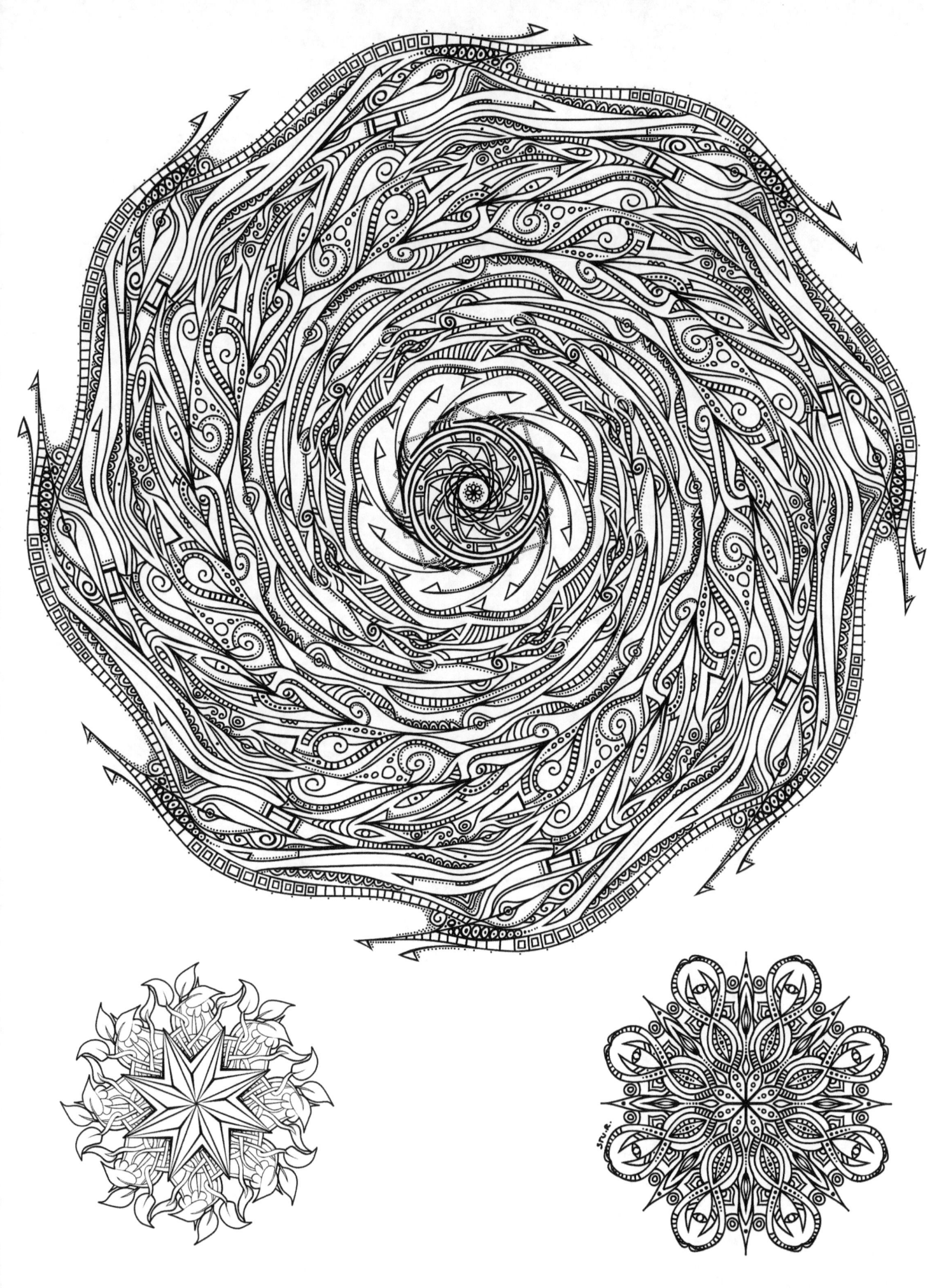

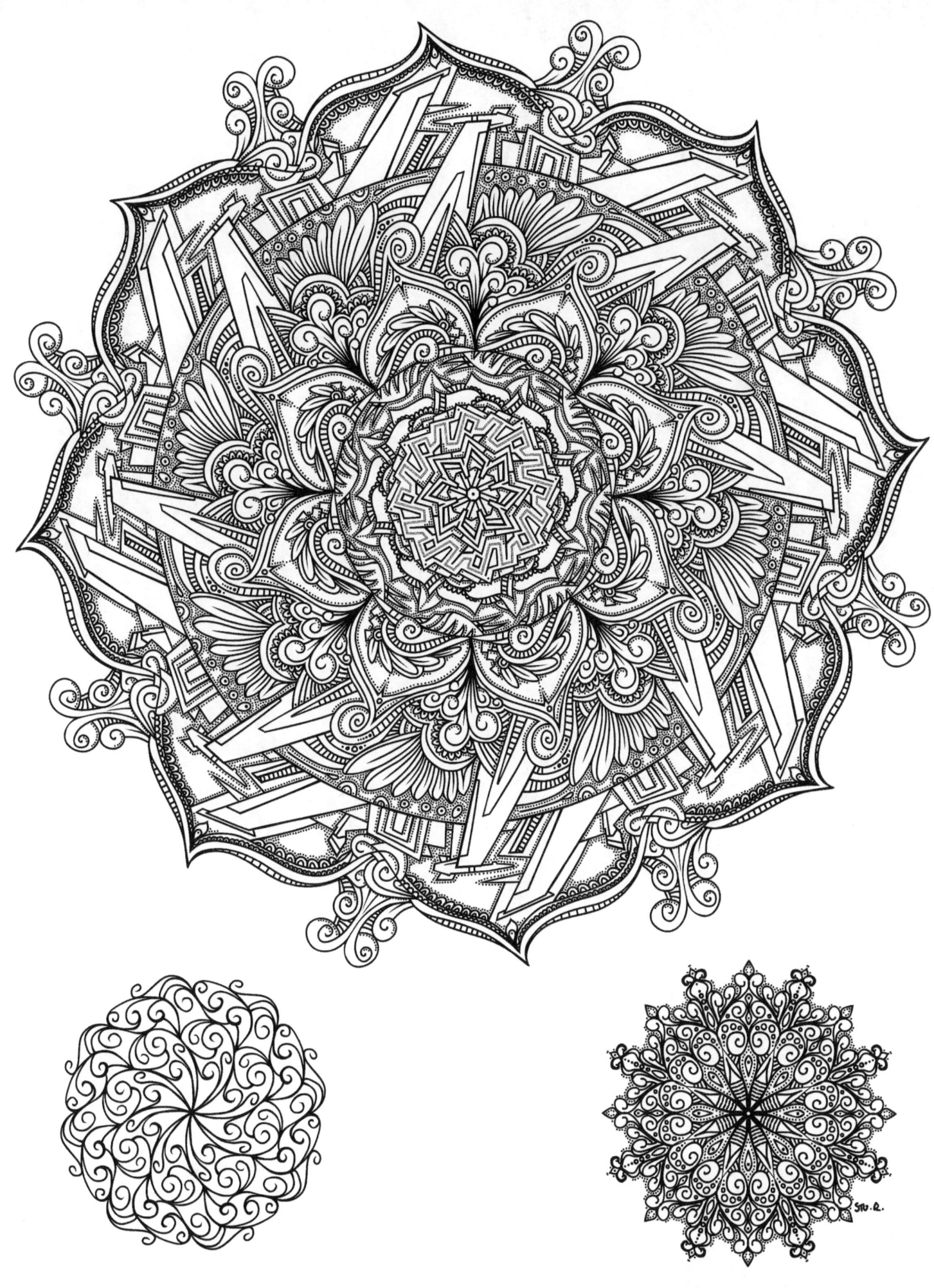

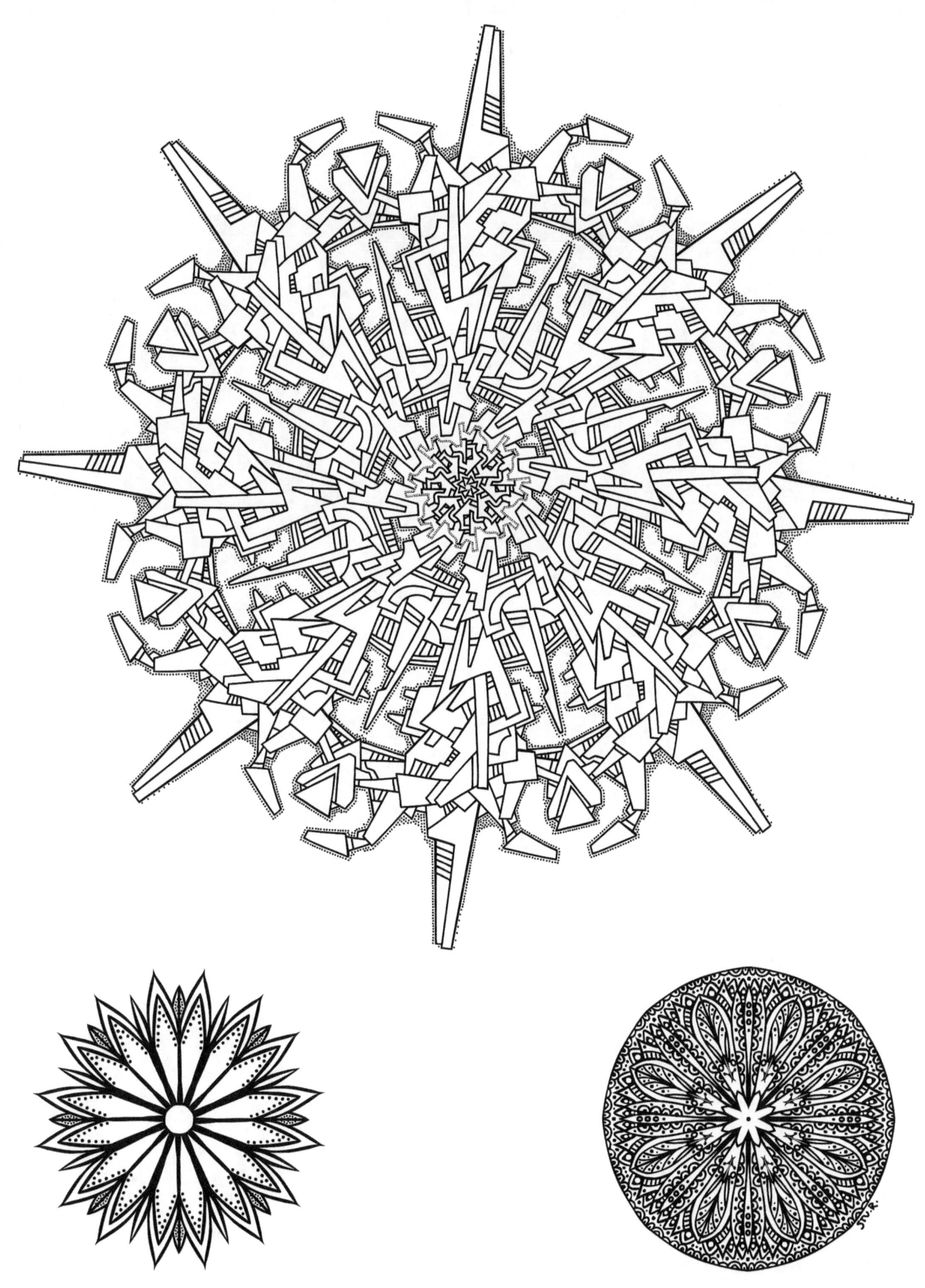

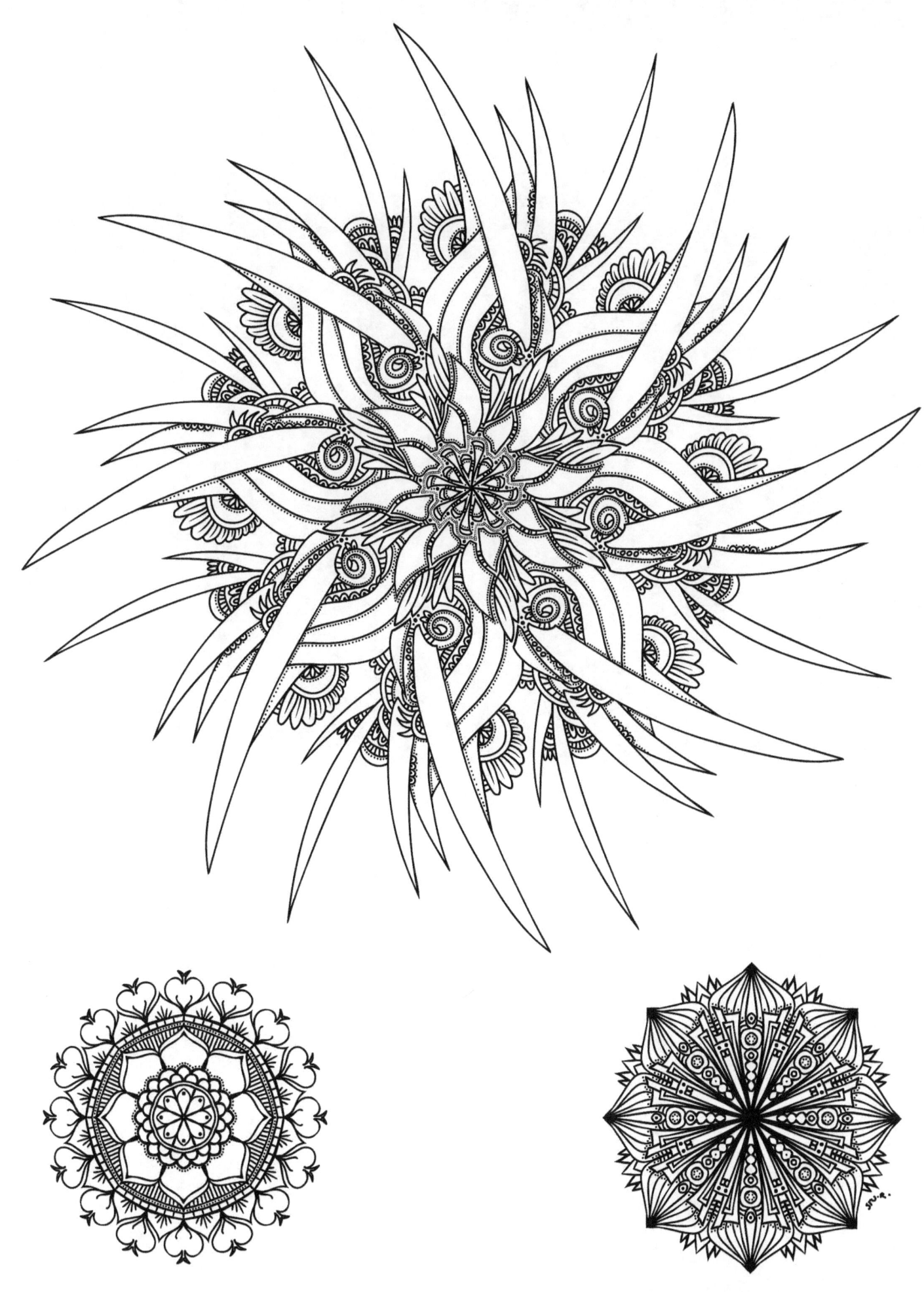

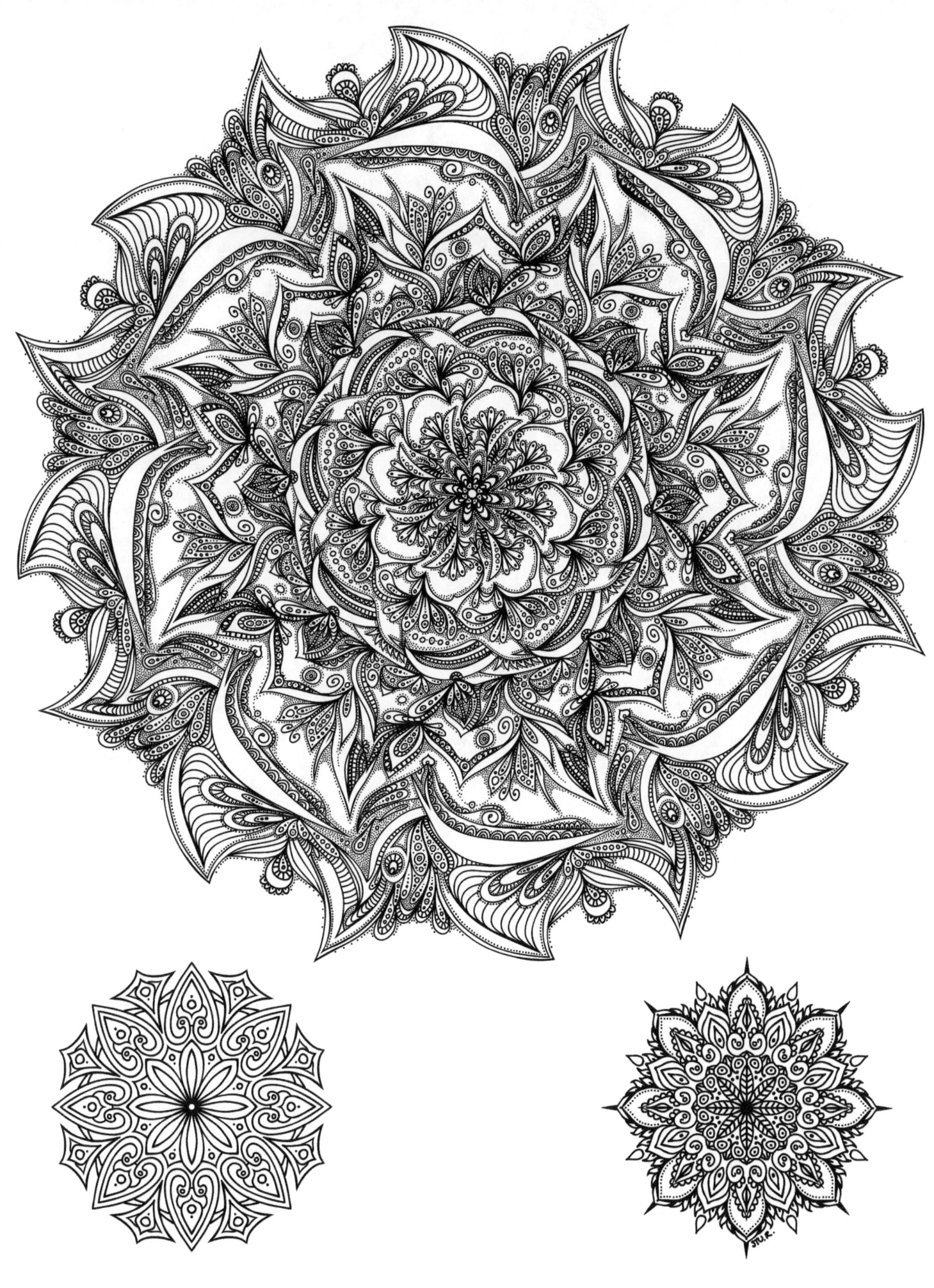

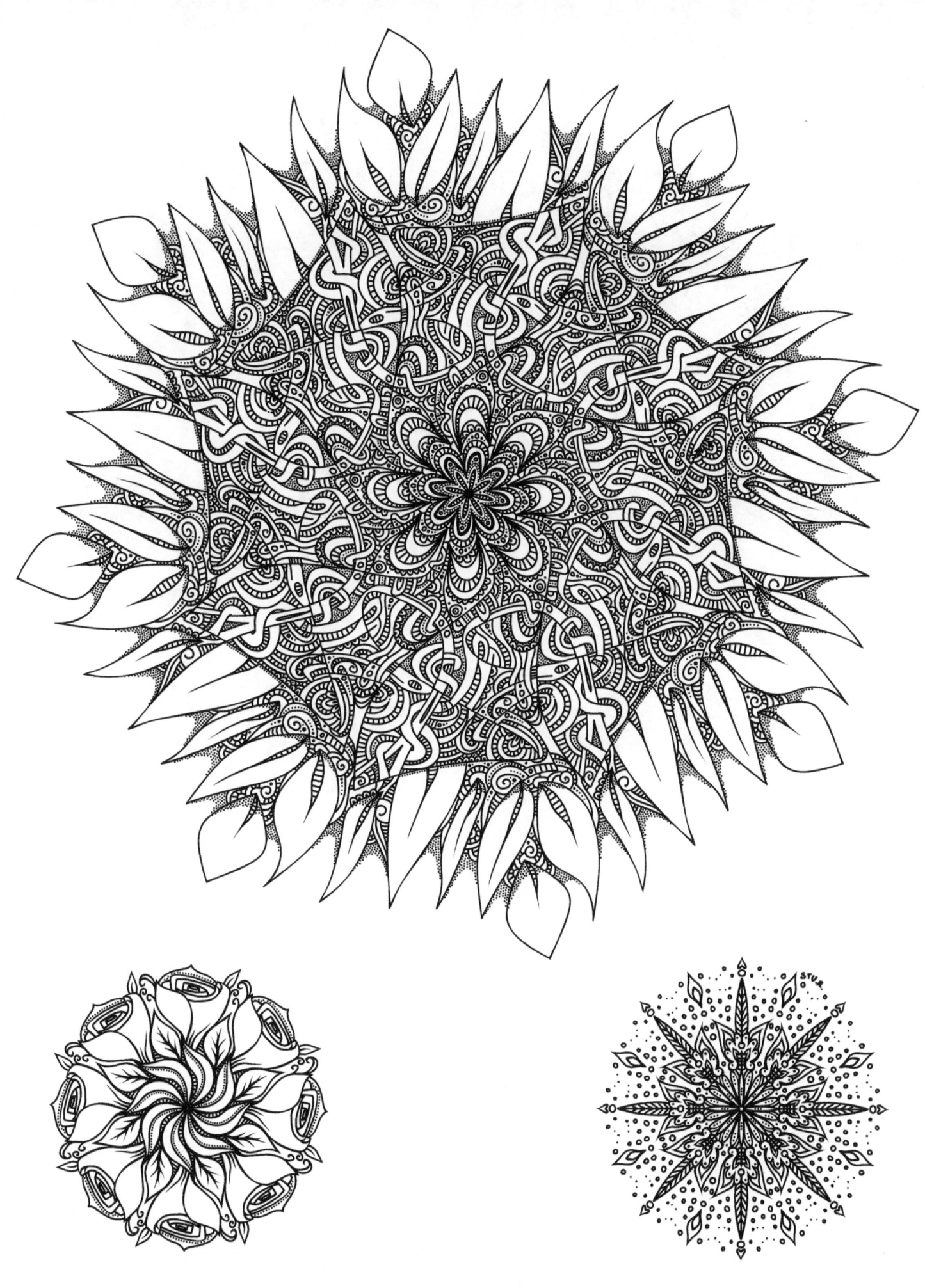

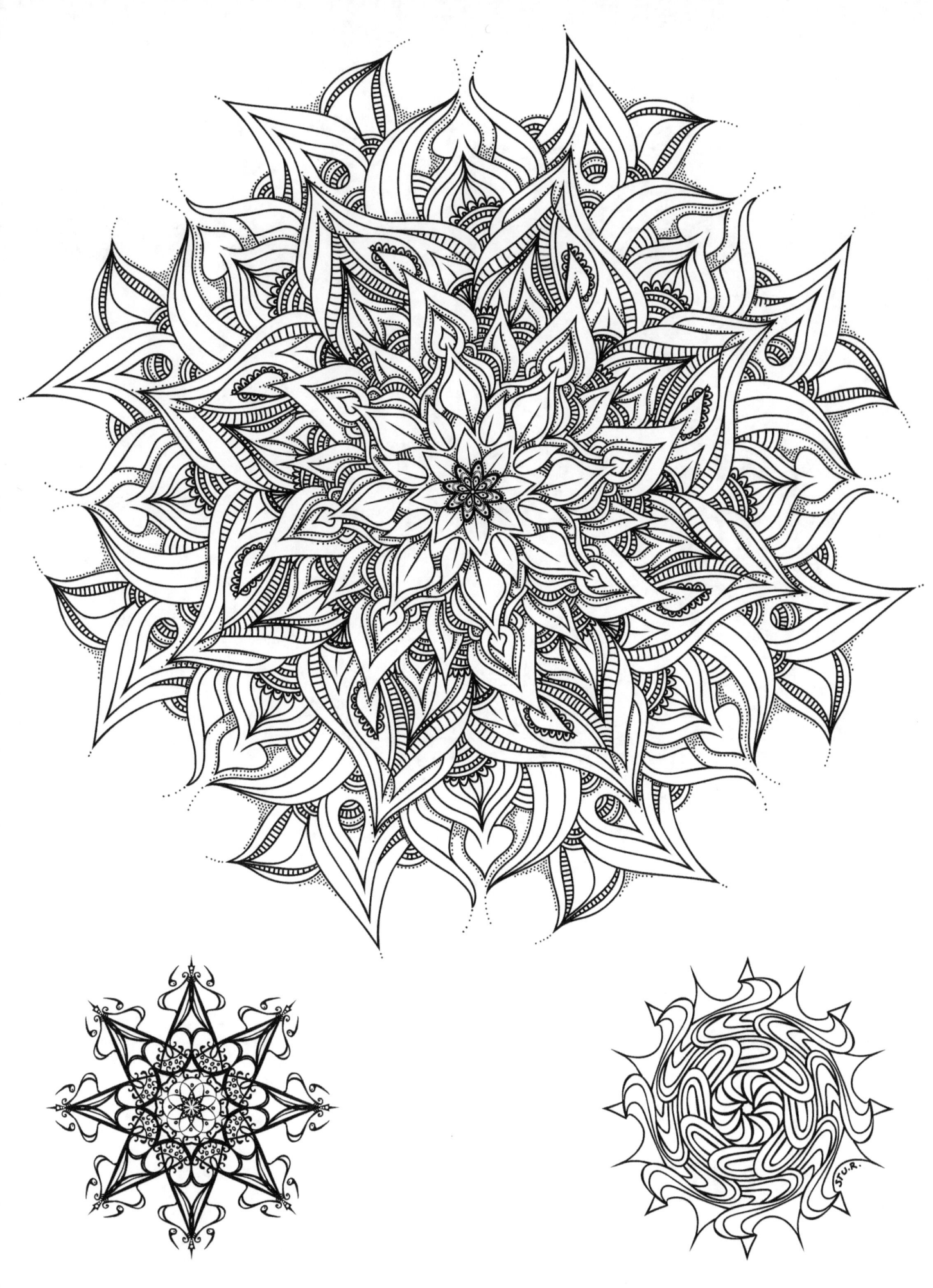

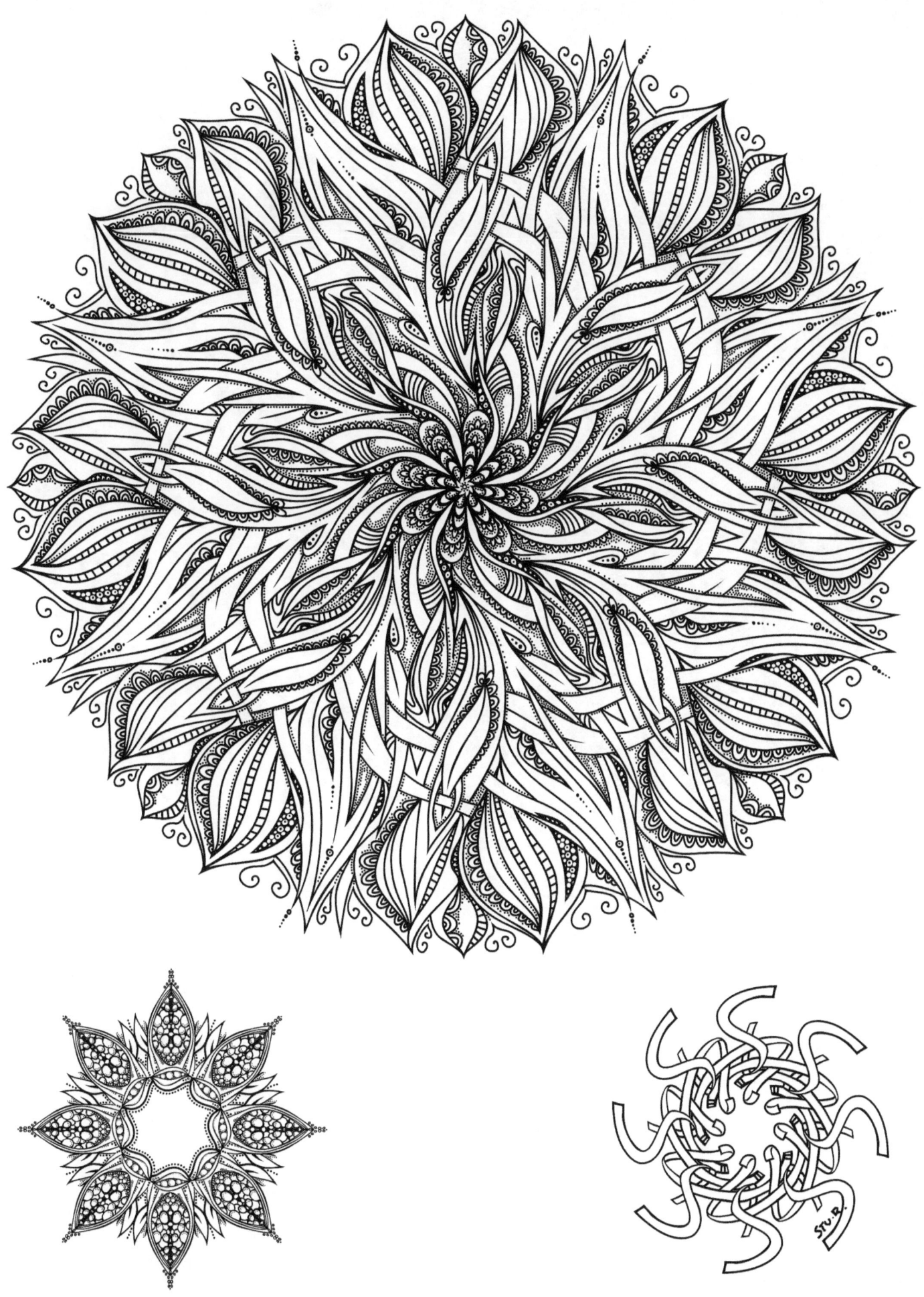

So, did you find it?

If you did, make sure to share how it turned out.
See www.stuartroyce.com for links to my social media

And if you like the artwork in this book,
please consider leaving a review.

Thank you for colouring.

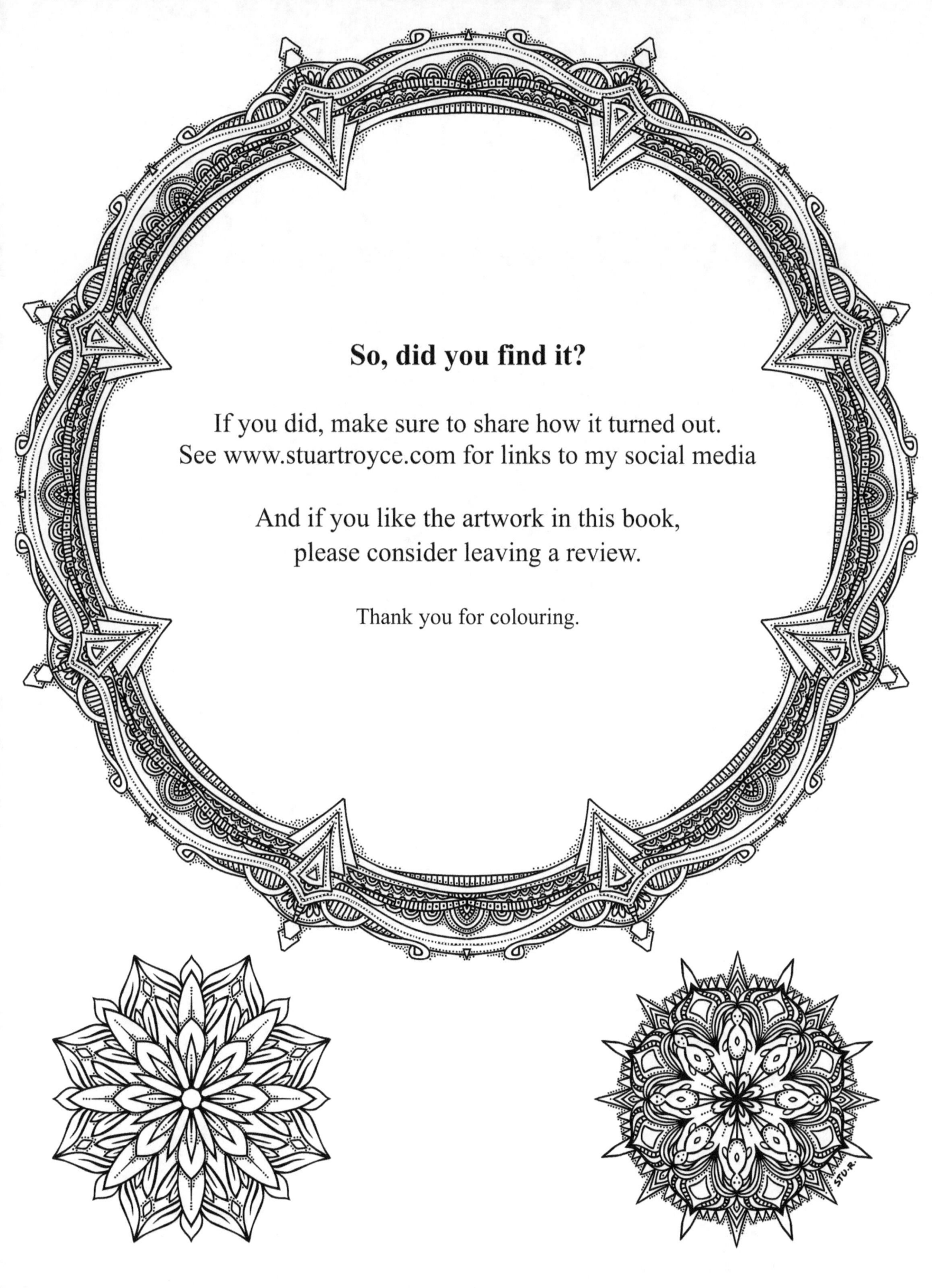

t

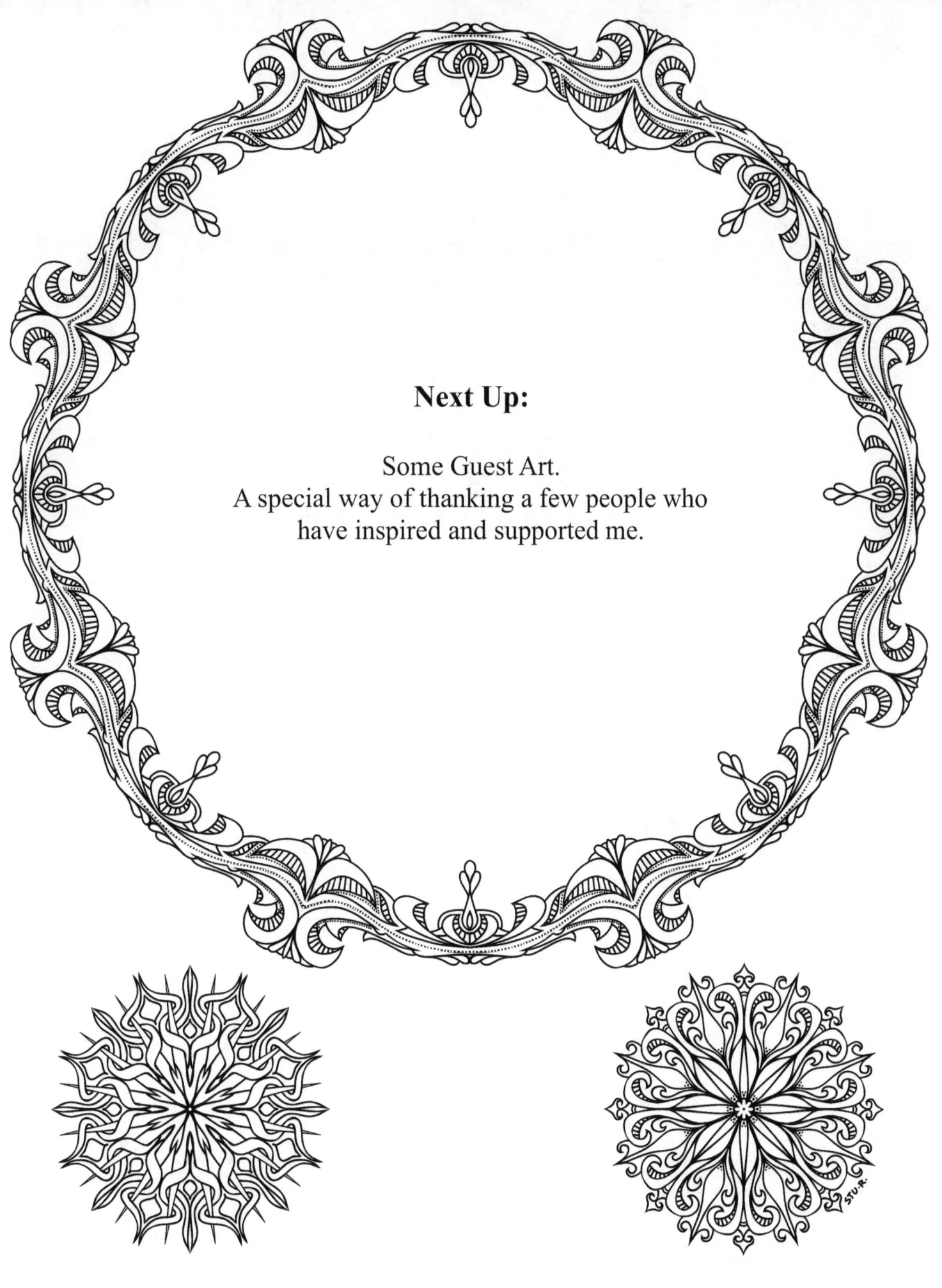

Next Up:

Some Guest Art.
A special way of thanking a few people who
have inspired and supported me.

Guest Mandala From **Austin Magruder** *[https://www.instagram.com/aus10m]*

 Avid cyclist Austin's art first caught my eye when I saw his gorgeous and vibrant colours on Facebook and Instagram. He really made the images from Circolour come alive and shared A LOT of work, each one a thing of joy. But when I found out he was colouring them during dialysis treatment, I was both surprised and inspired, my art in any other form had never helped people get through something in such a way before (at least that I knew of), and here was an example of how it really can help people take their mind off something so miserable. It gave me purpose to keep creating, and **The Secret Mandala** was born.

 A talented doodler himself, he seemed pretty enthusiastic about having the chance to contribute a piece to this book, and here it is across the page! Make sure to tag him if you colour and share it, and to find out more about Austin, please check out **http://matchmykidney.com/**.
Thanks for everything Austin, best of luck I really hope you find a new match soon.

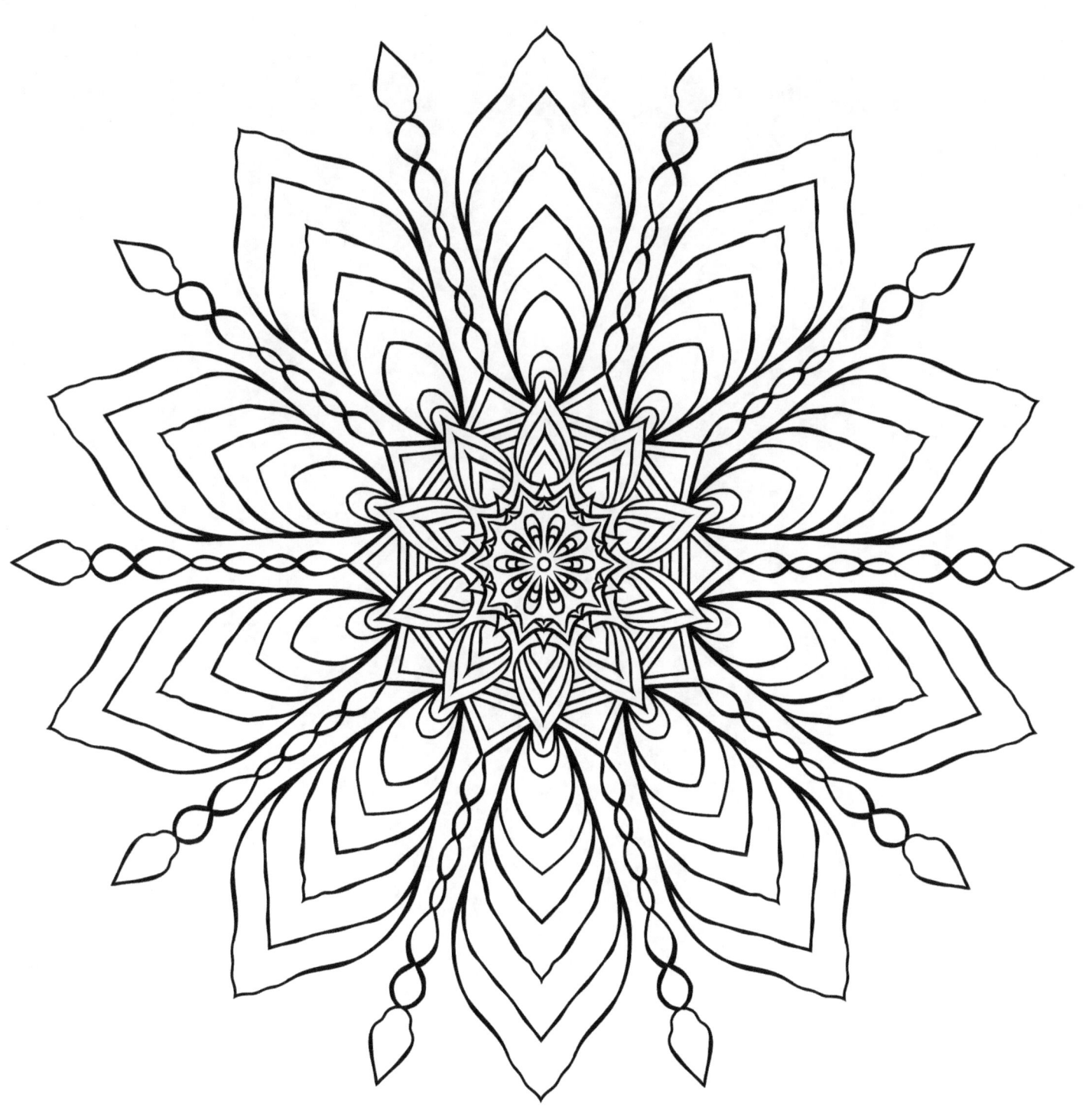

Guest Mandalas From **Diniah Nightshade** *[https://www.instagram.com/diniahminecraft]*

 One of my biggest fans, Diniah received Eclectica as a Christmas gift in 2015, and although a very private person, was one of the first people to share my work. Now, Diniah has already coloured in more of my stuff than anyone else I know, and has probably spent more time staring at my patterns than I have! But what really struck me is how it has helped her bond with family, and grow as an artist herself. Reluctantly sharing her own doodles and patterns with the world, and being open to feedback, she's growing as an artist all the time. An example of how colouring can make awesome things happen. My next book will probably just be a pad, because that's all a budding artist needs. :)

 I wanted to include one of Diniah's drawings to say thanks and inspire otheres to get stuck in. So here it is across the page. If you colour and share it, please remember to tag Diniah, as i know she'll get a kick out of seeing it coloured in as much as I do with mine.
Thanks for everything Diniah, keep colouring, and keep on growing, and giving back with your own art.

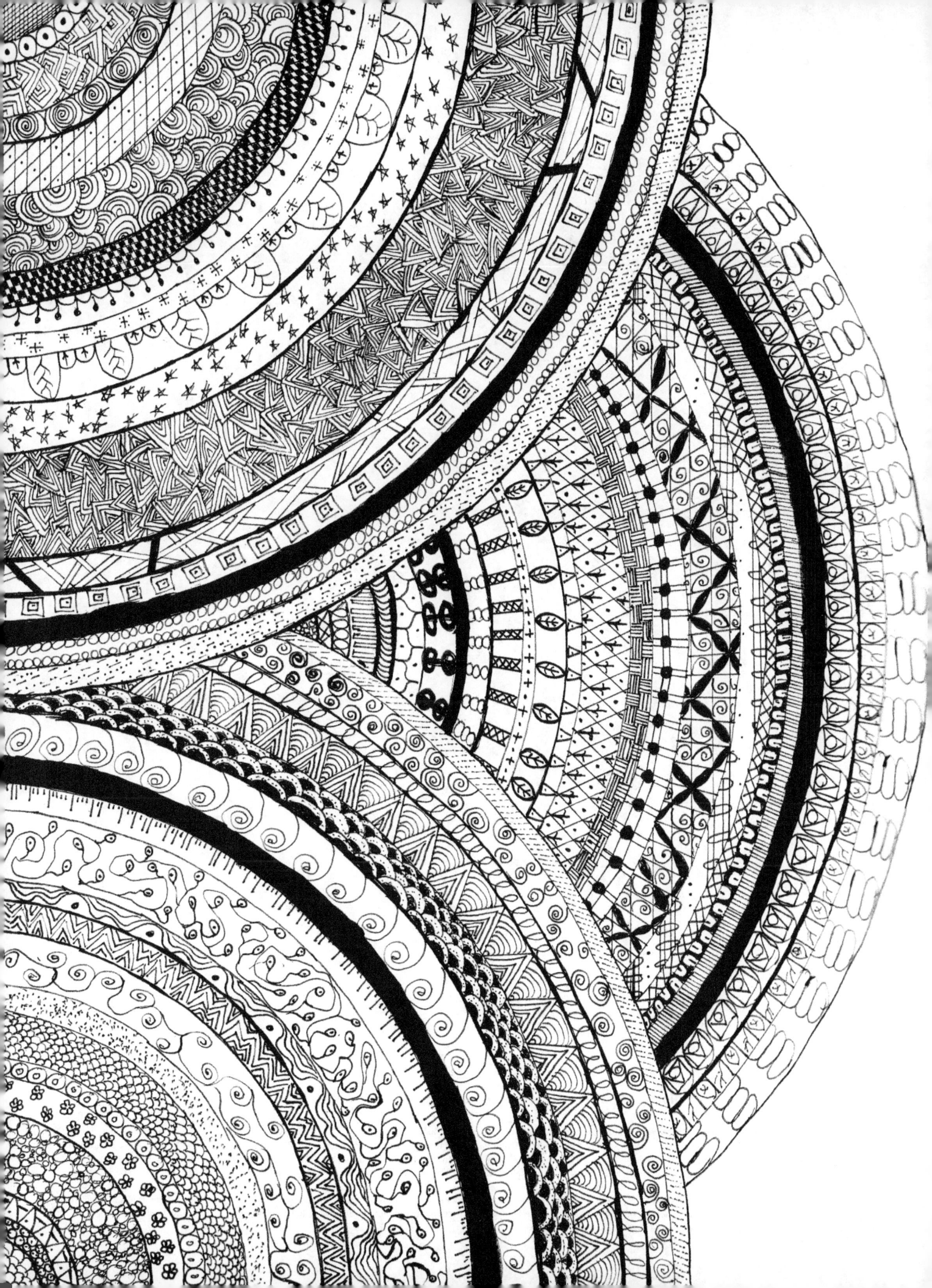

Guest Mandala From **Cheryl Colors** *[https://www.instagram.com/cherylcolorsworldwide]*

 Founder of Adult Coloring Worldwide, one of the largest most supportive colouring communities on the web, we all owe Cheryl a thanks. She's always been supportive and free with her advice and encouragement, and between her and the ACW community I've managed to grow my audience and reach more people than I would have alone. A talented Colorist, she's also recently turned her hand to creating her own colouring books. In her own words, she creates,"Art by colorists for colorists". Like me, she too believes that EVERYONE has the capability to create art, and colouring is a great entryway to making this journey, with a community that is welcoming and encouraging to beginners.

 I wanted to offer her a spot in my most recent book, as a small token of my appreciation. Her work is fun and also great for people with site issues as there is lots of large areas that are very marker friendly, worth checking out! So please pop over to her facebook page to find out more info and links to her books. www.facebook.com/cherylcolors
Thanks Cheryl, for your advice and support. Keep on colouring!

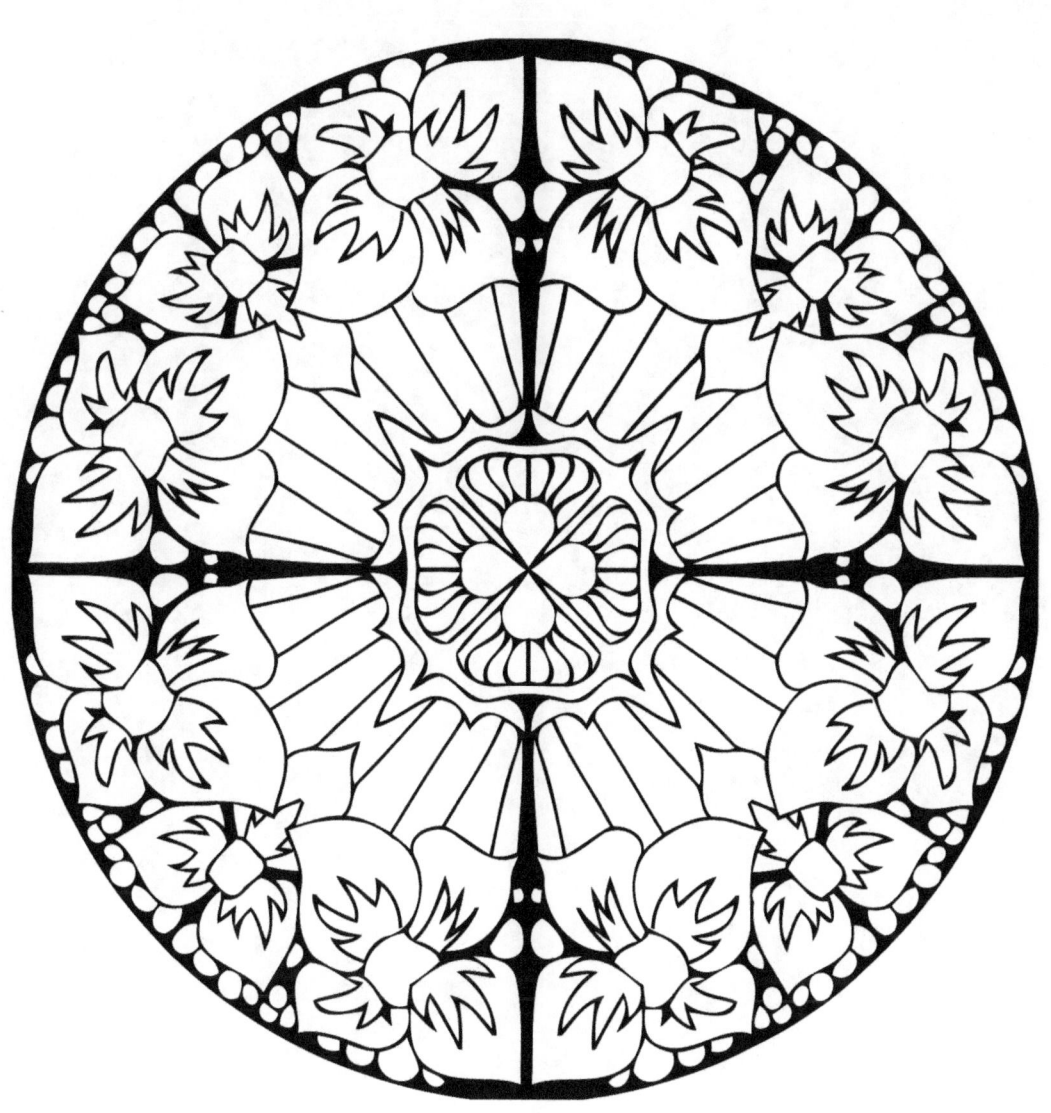

Next Up:

Full Sized Solo Mandalas and Patterns
No hidden secrets, but lots of detail.

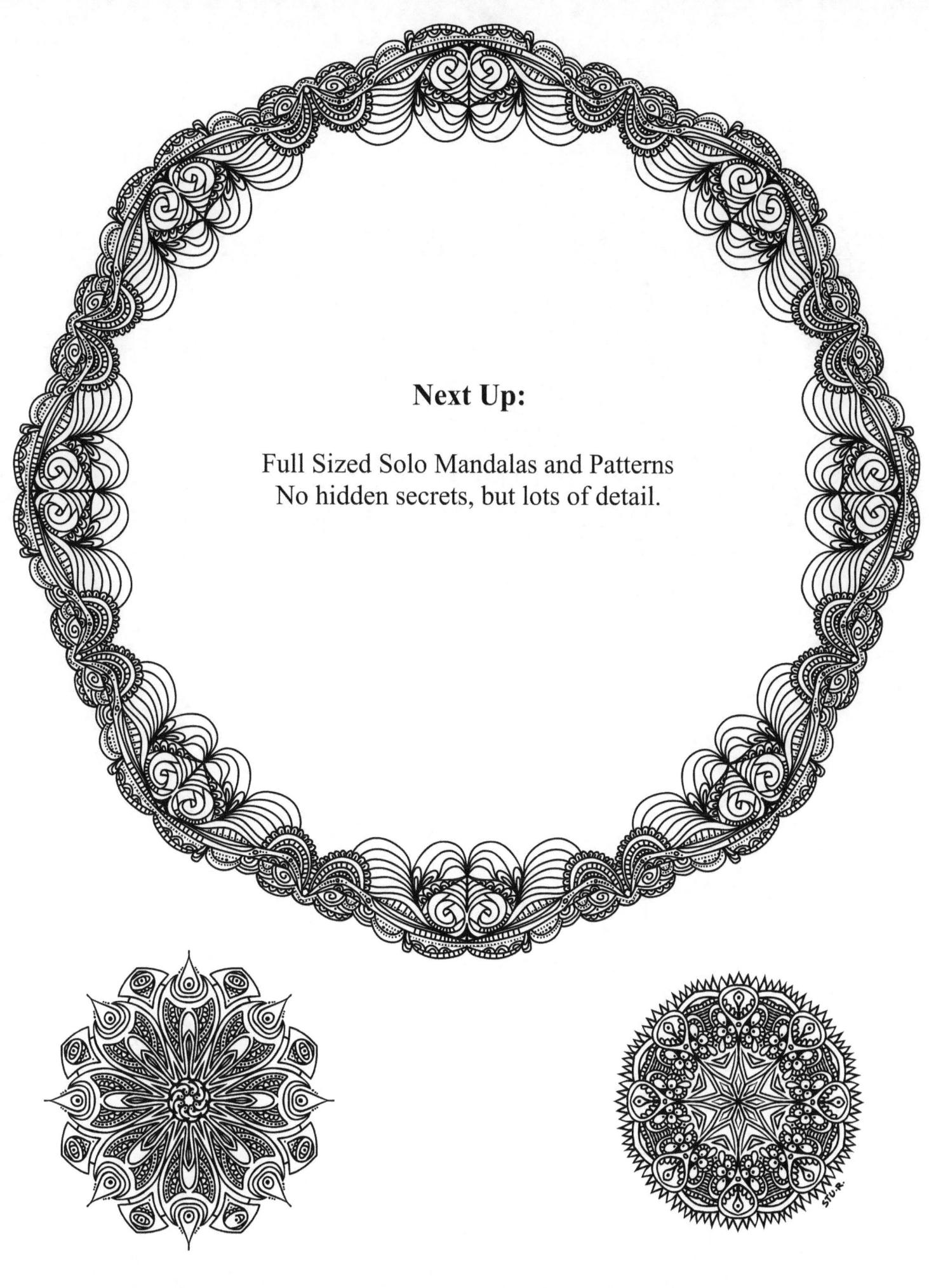

1

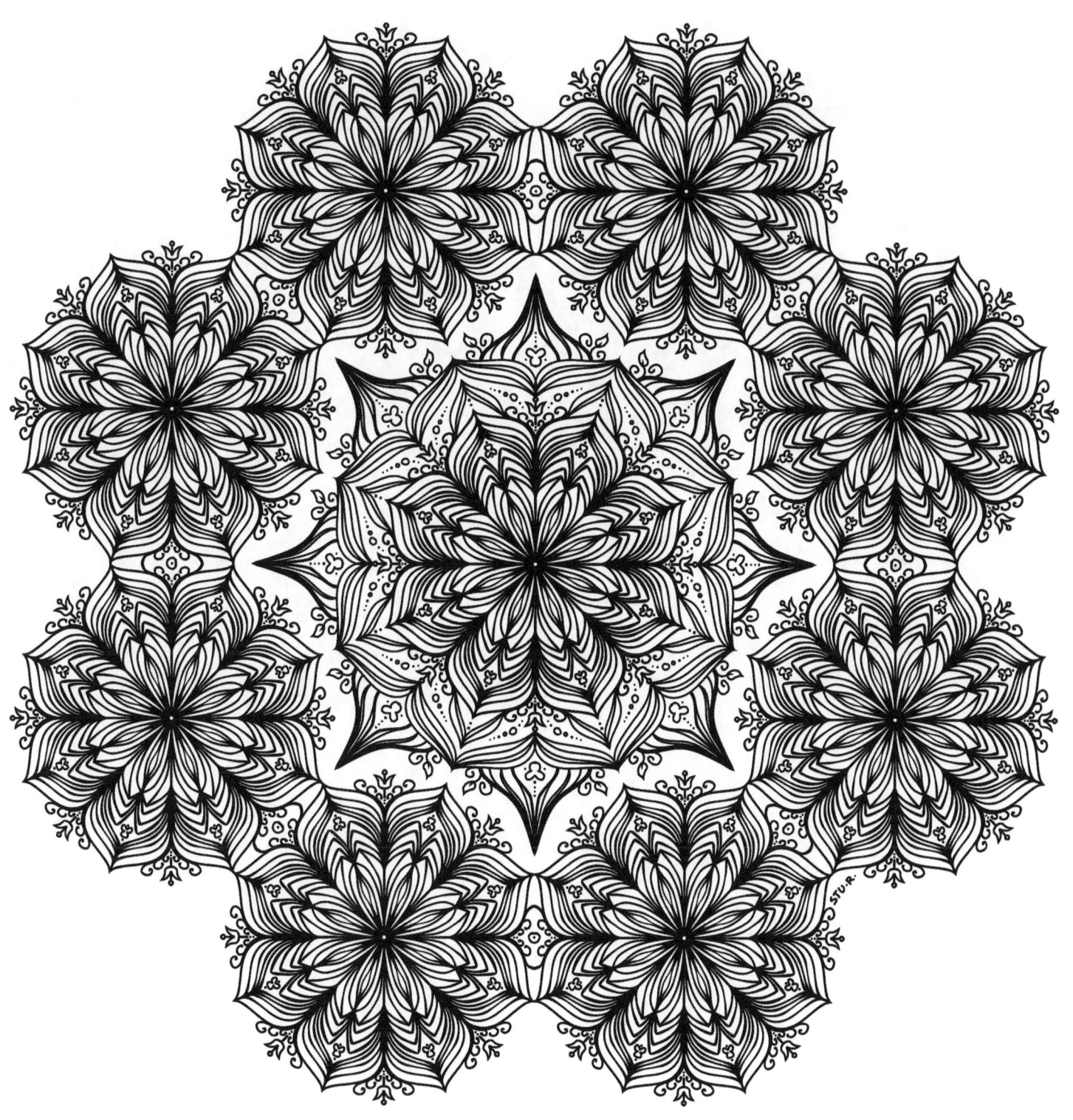

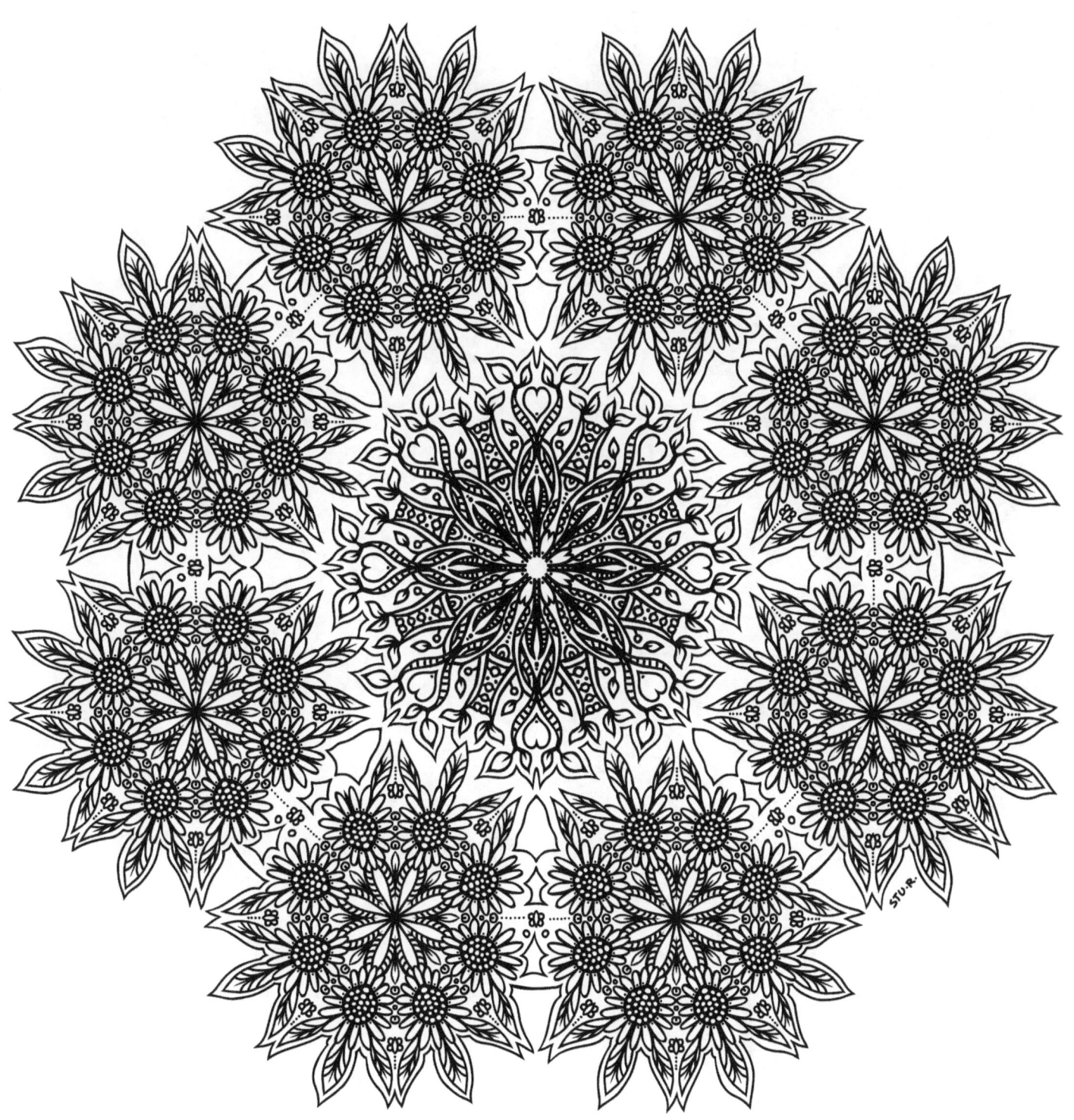

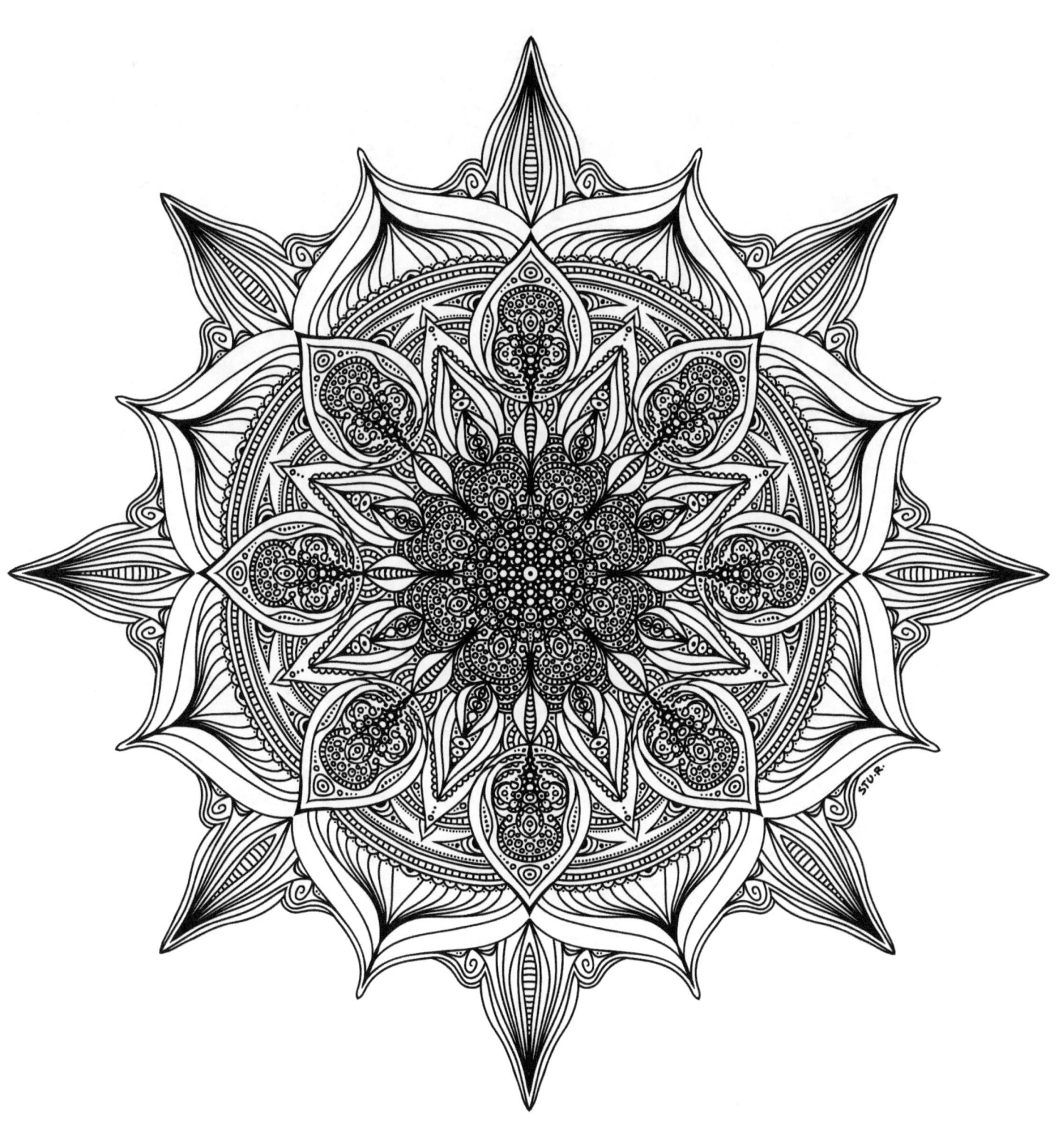

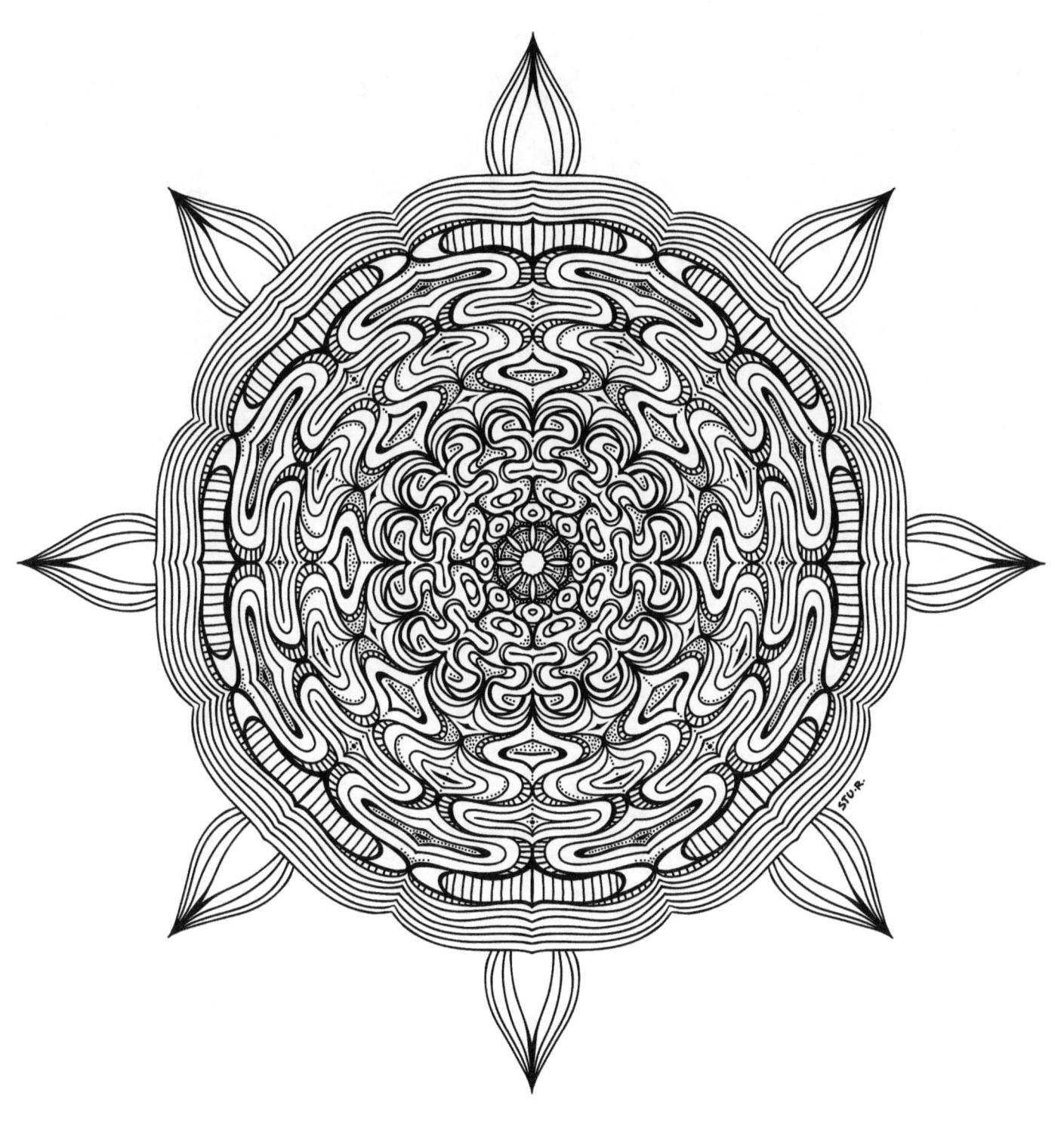

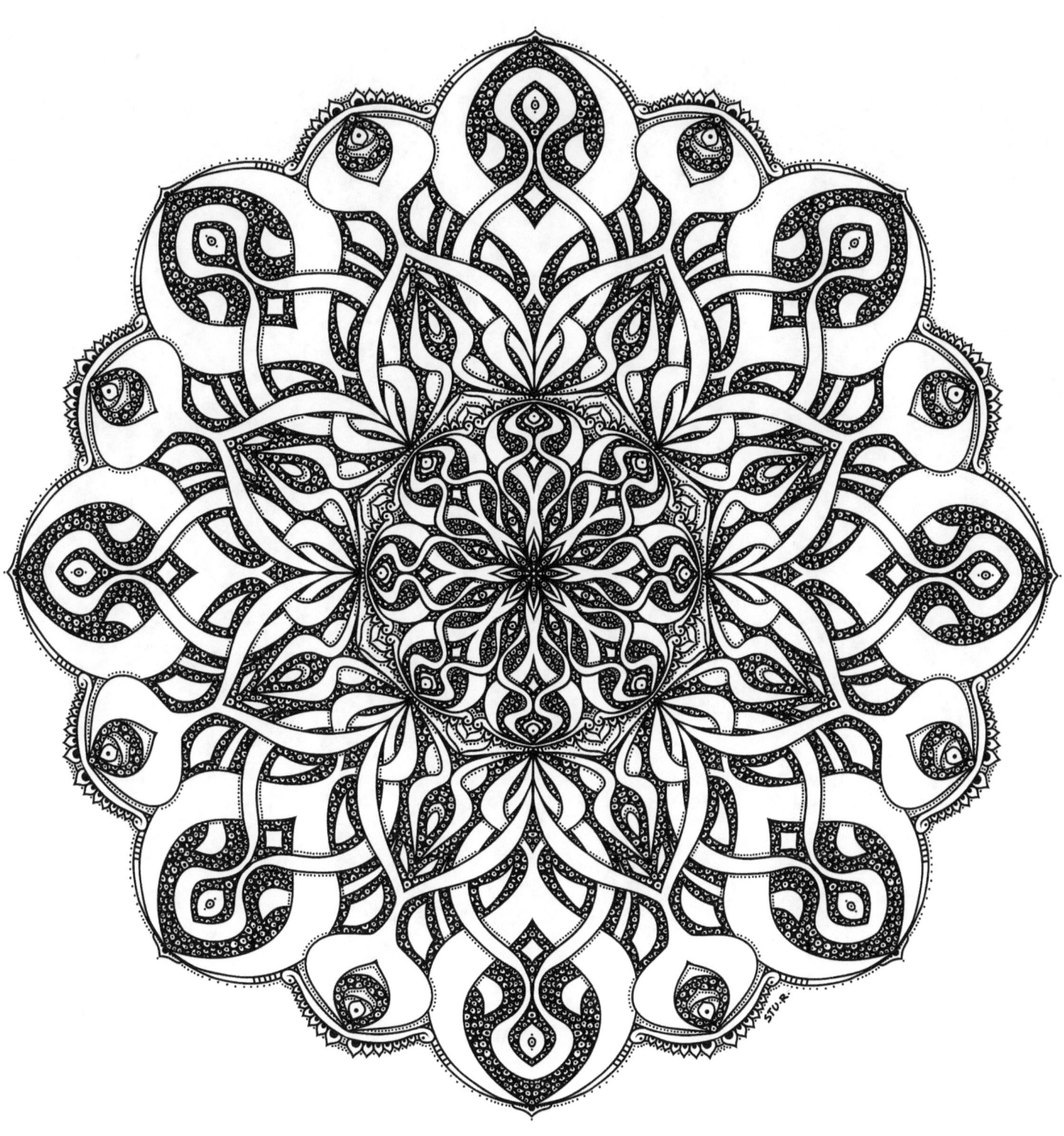

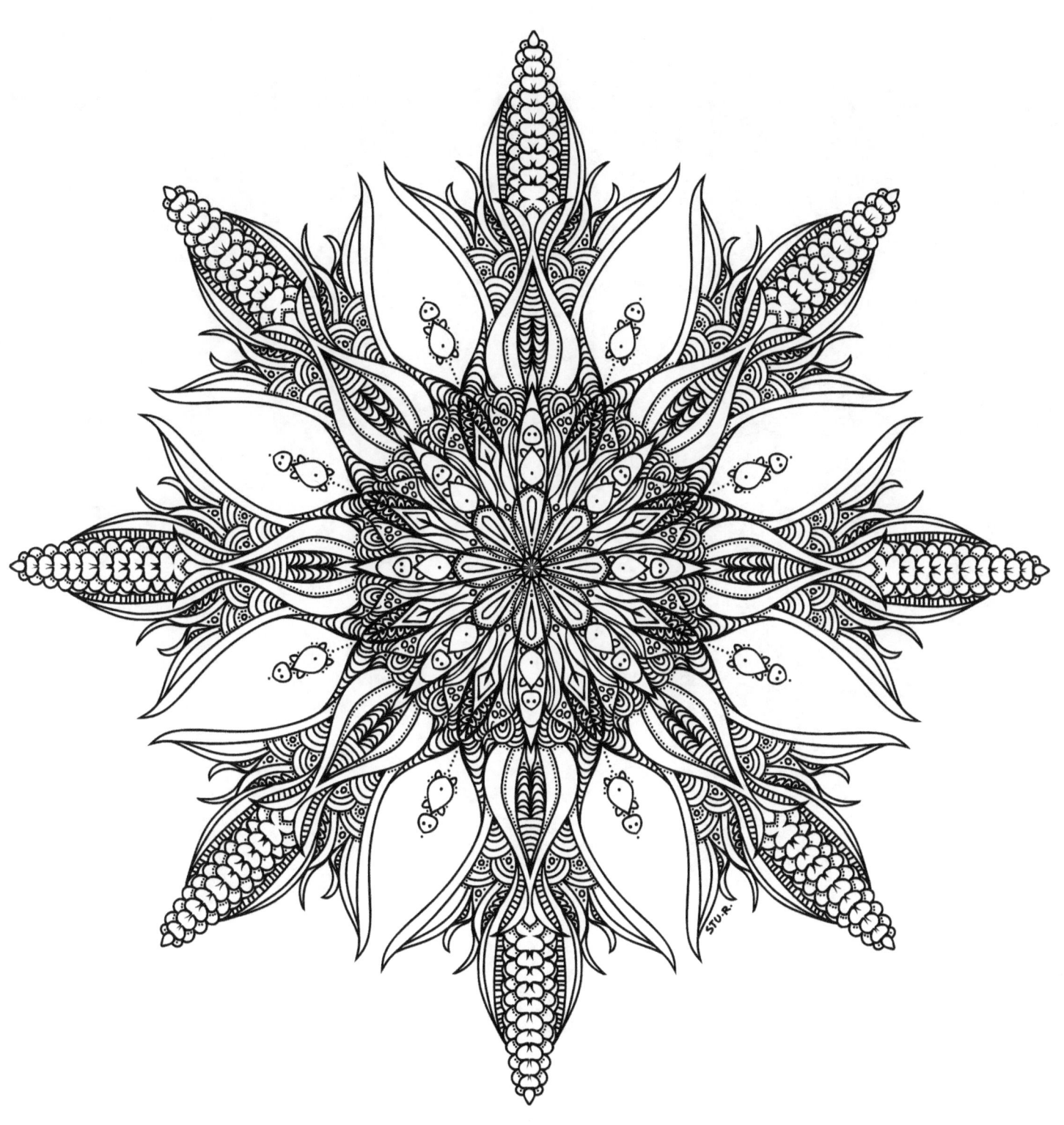

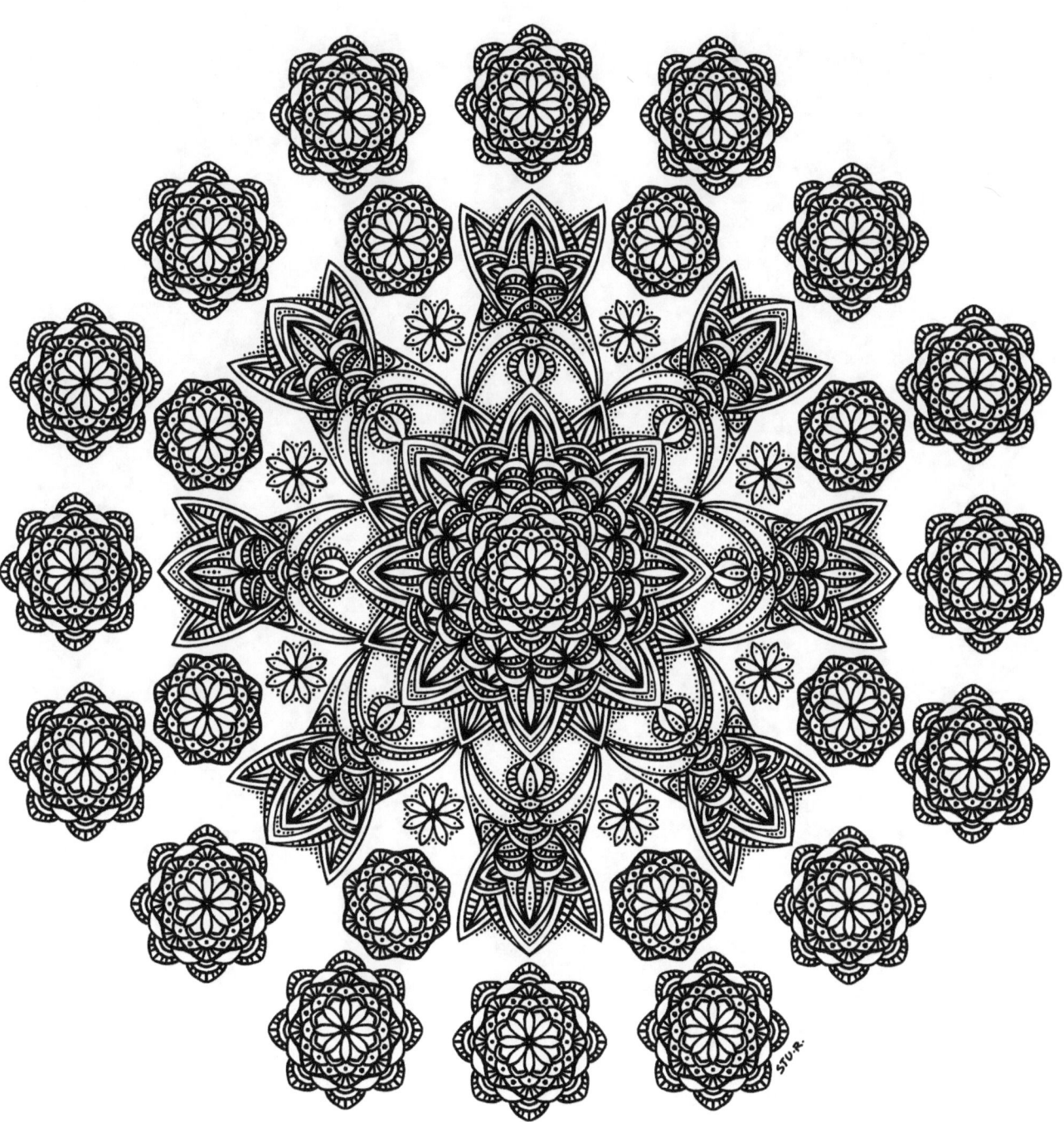

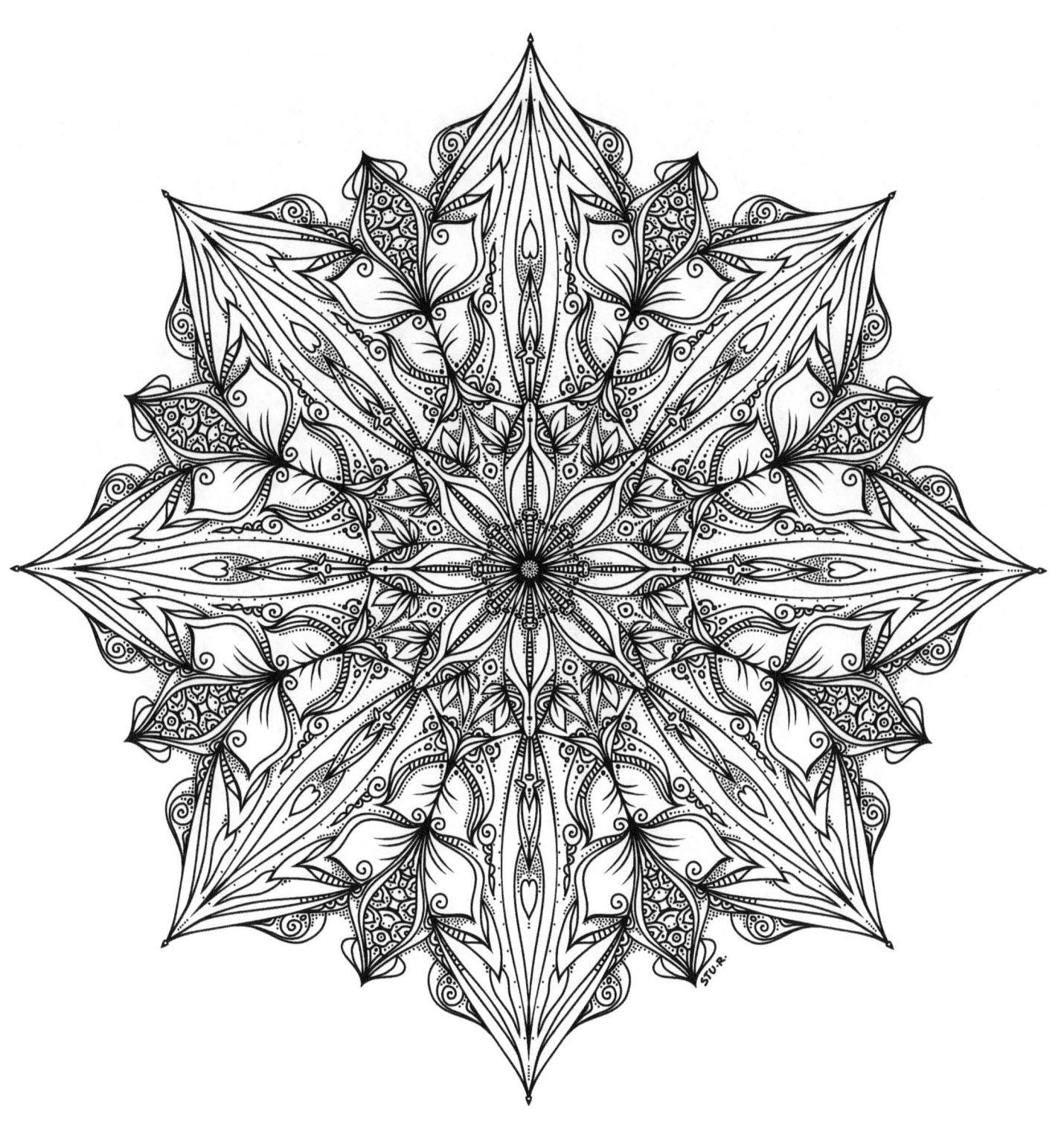

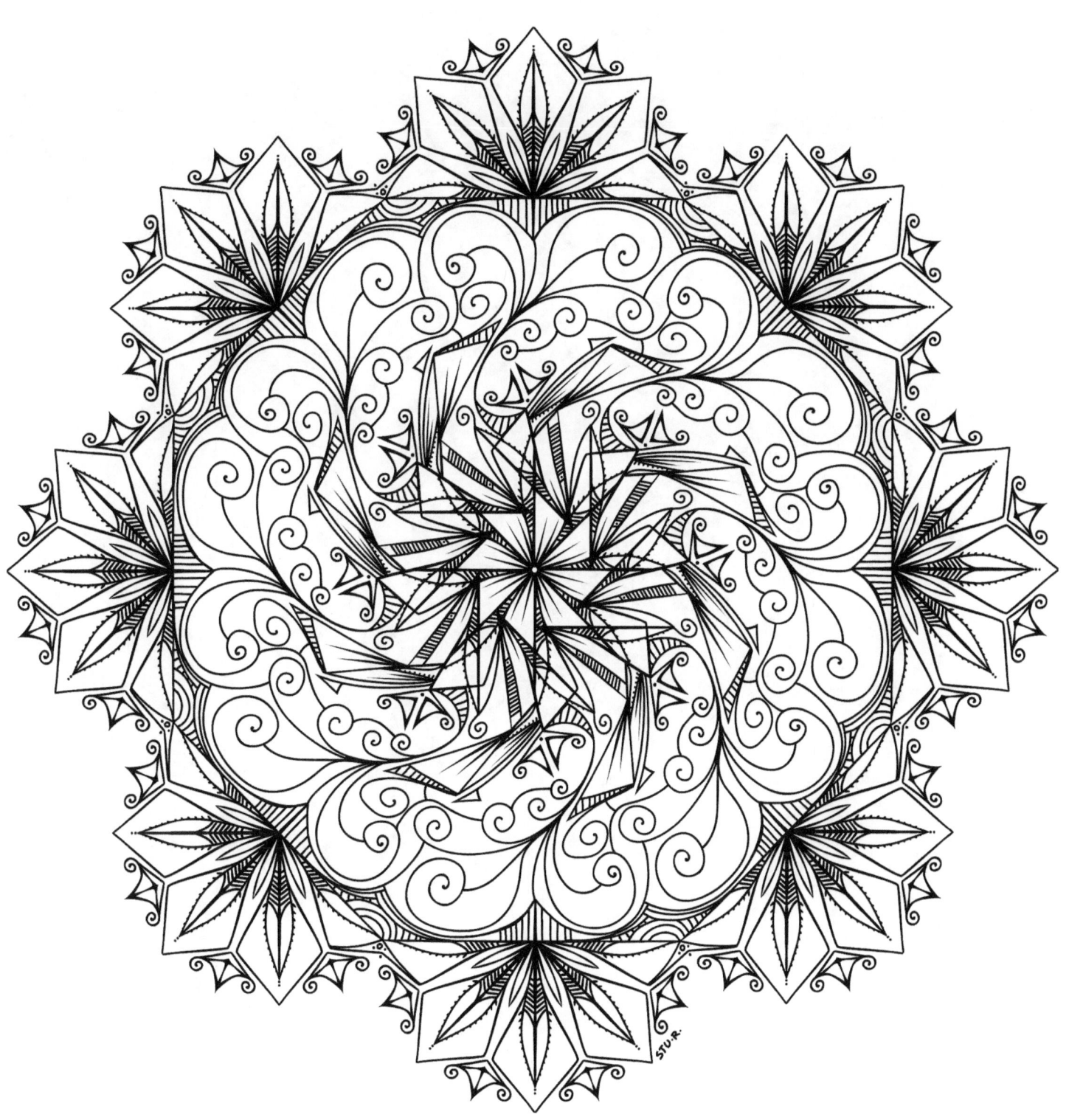

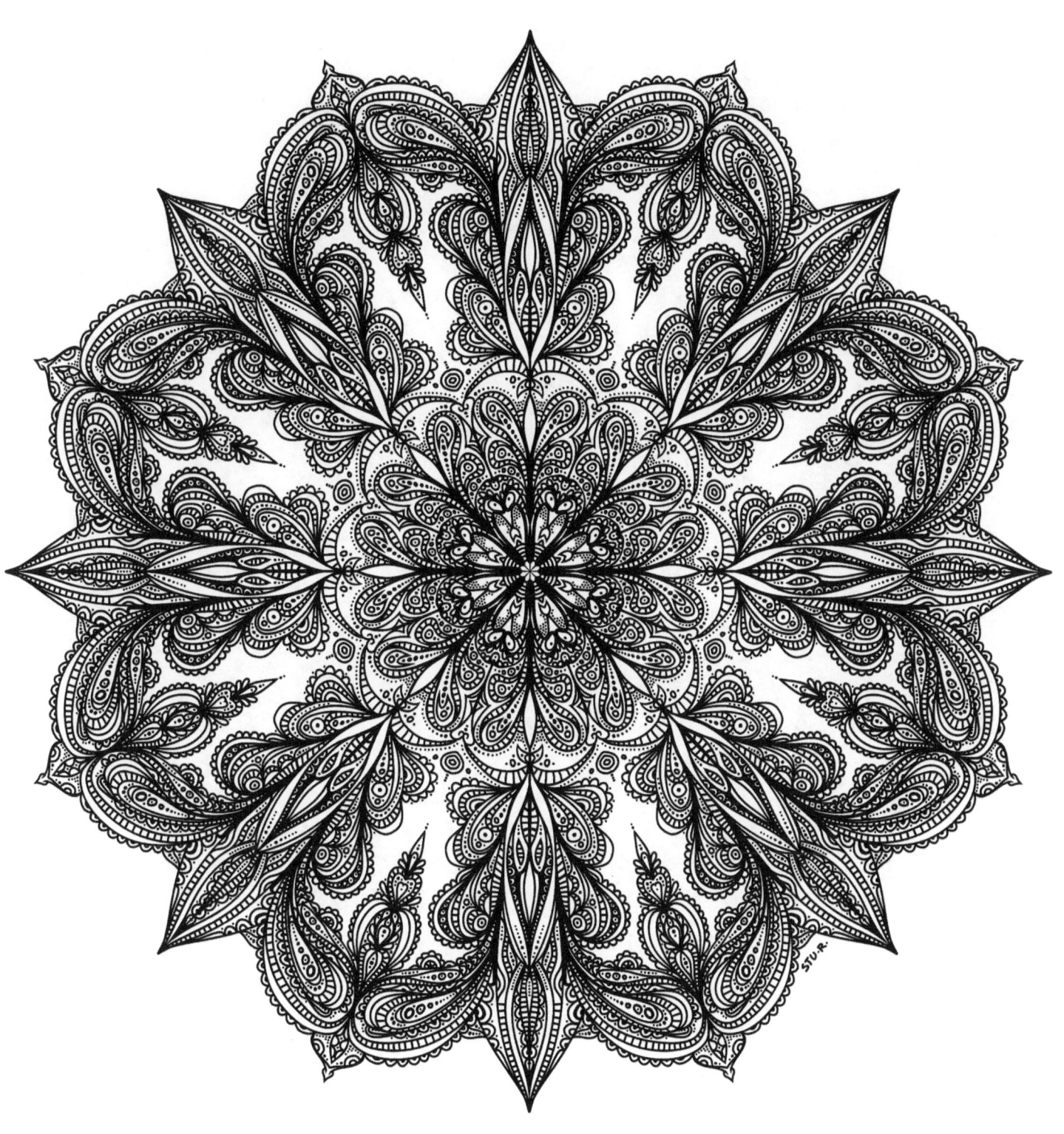

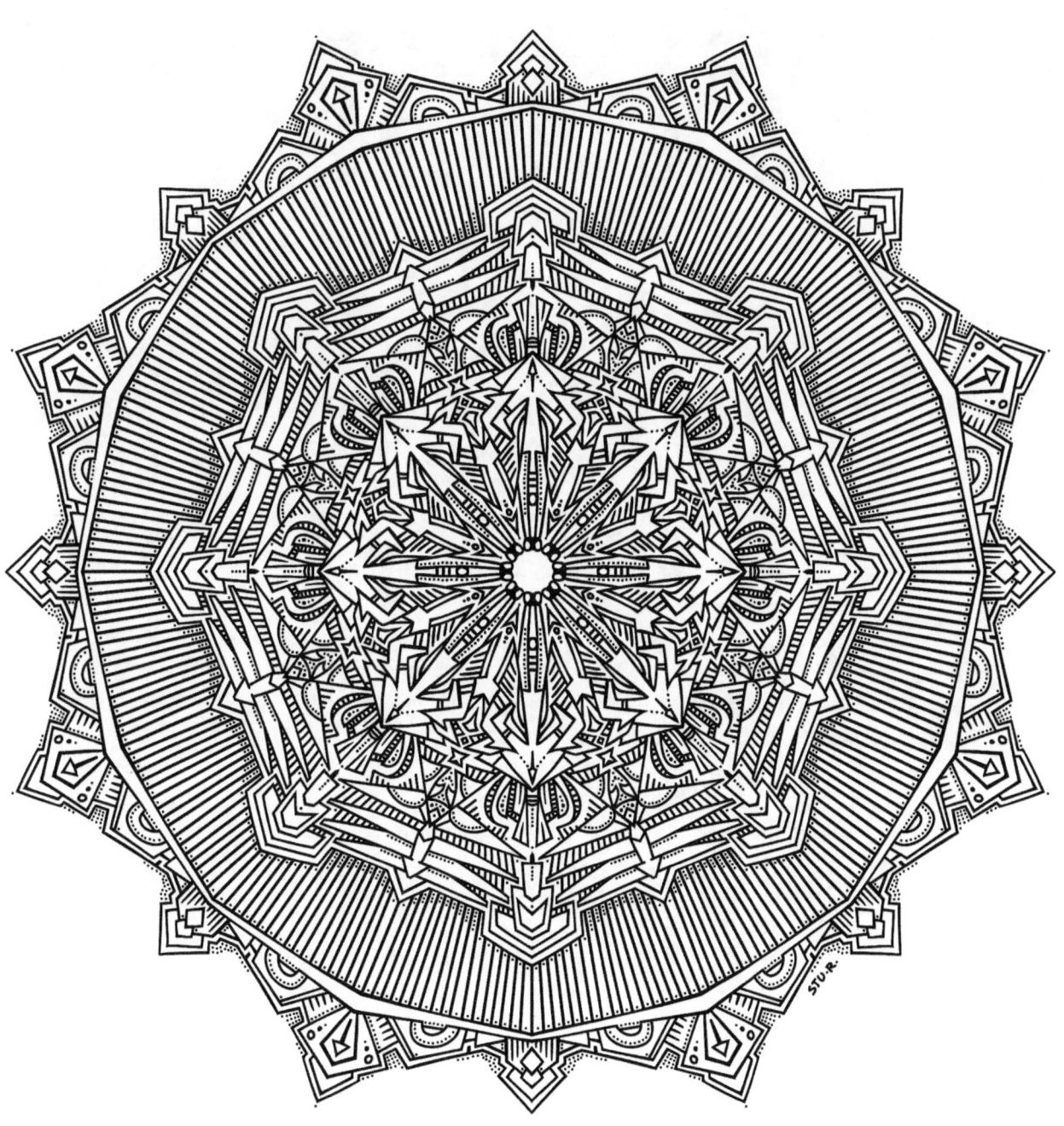

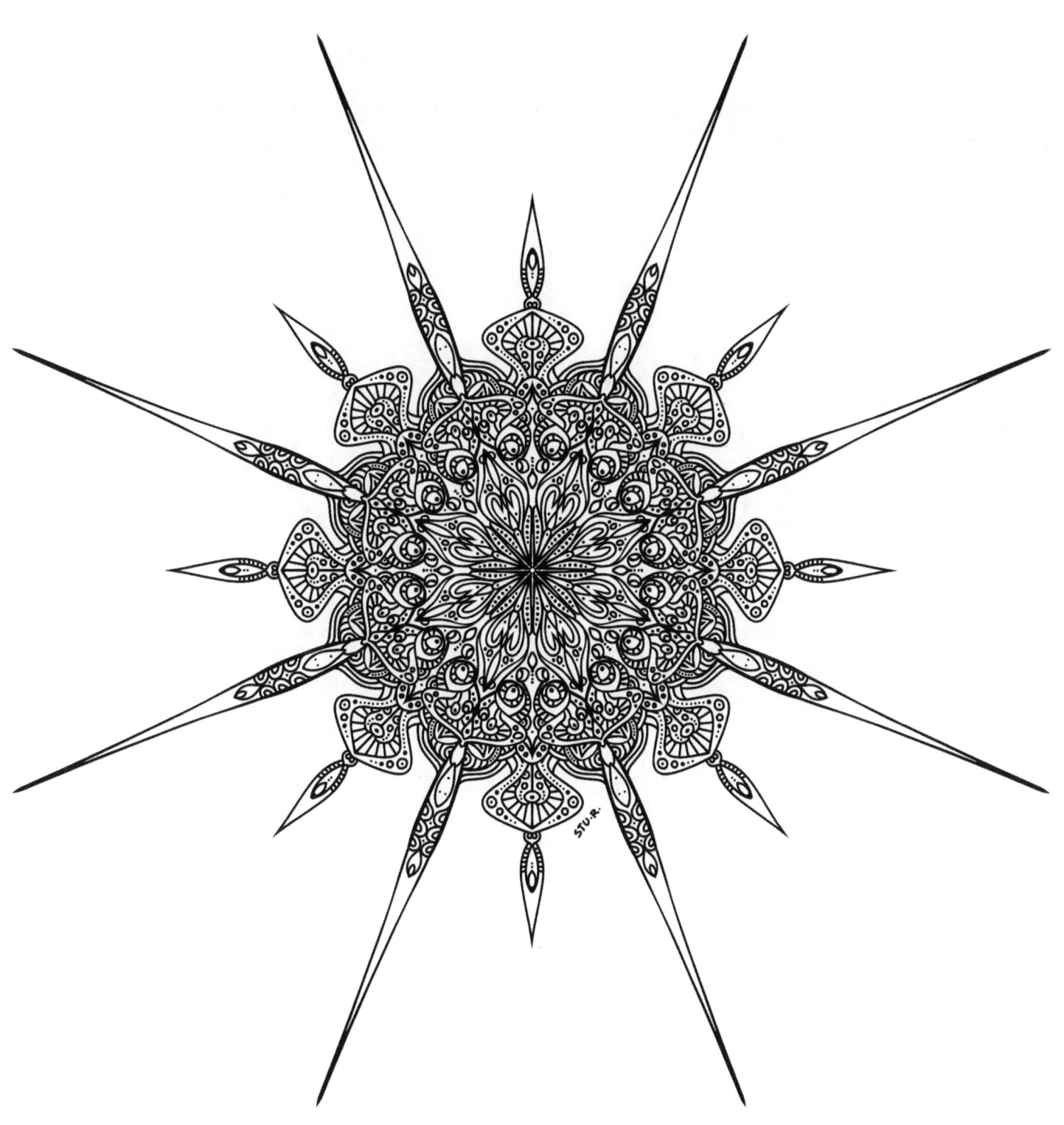

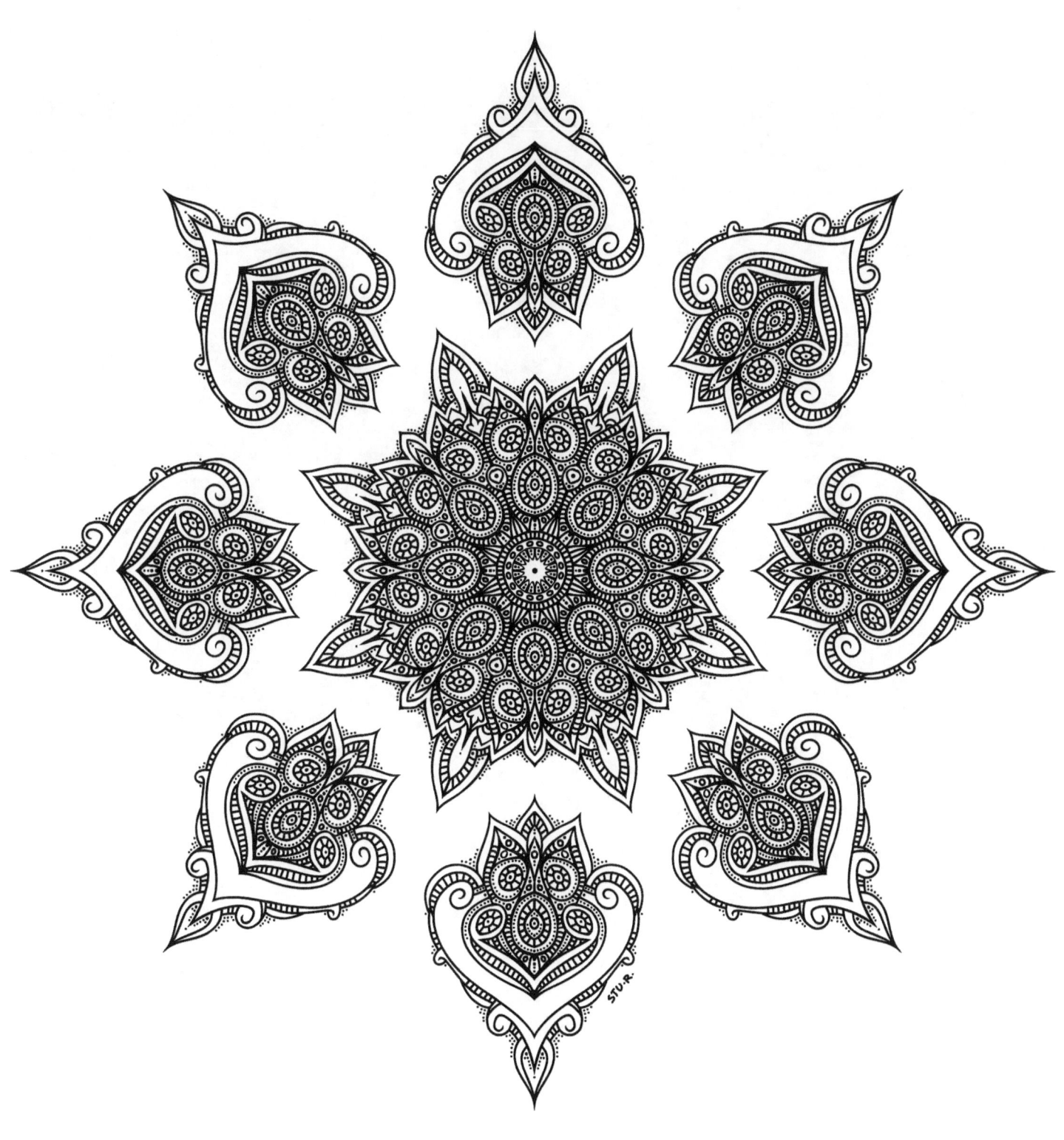

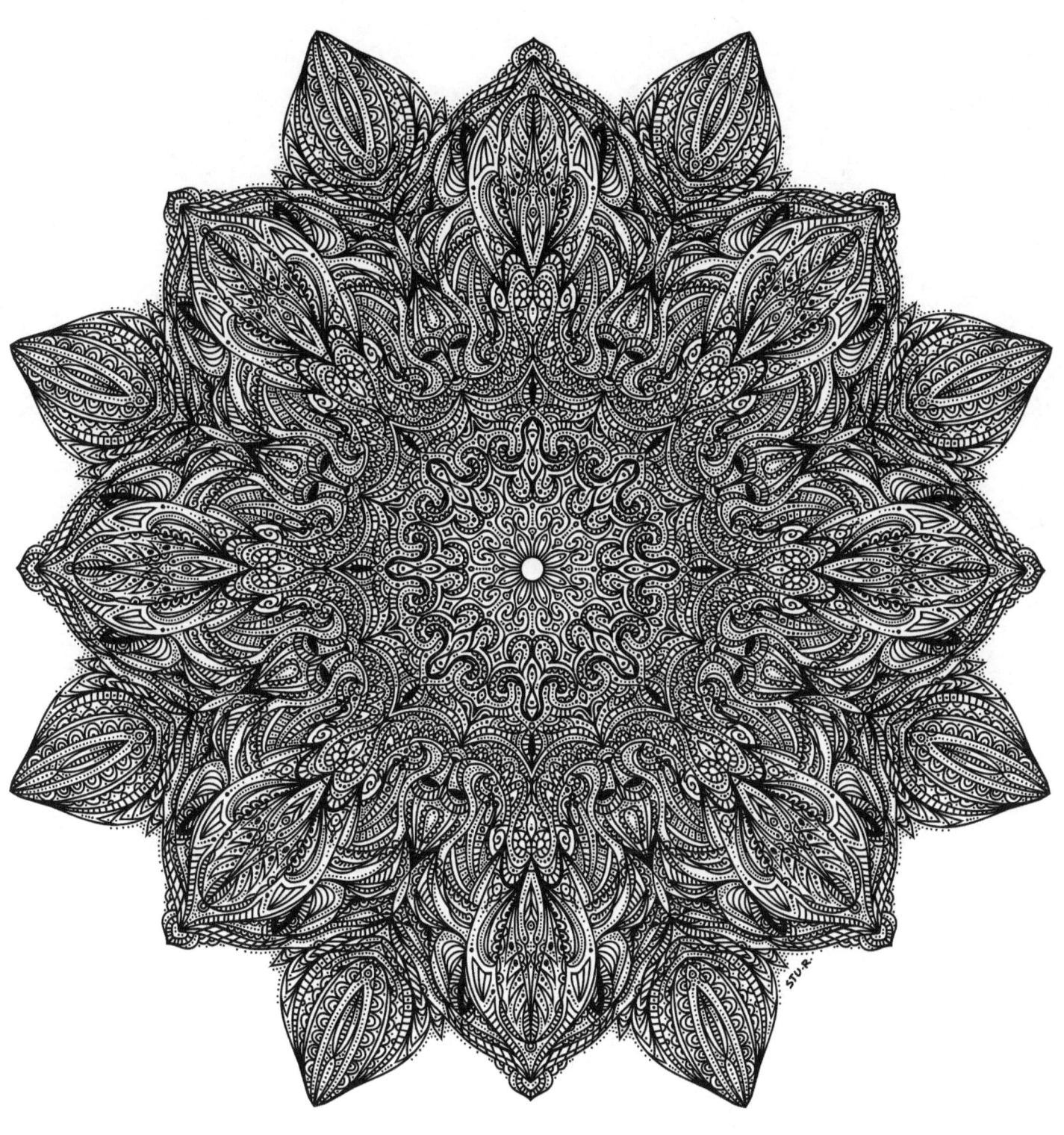

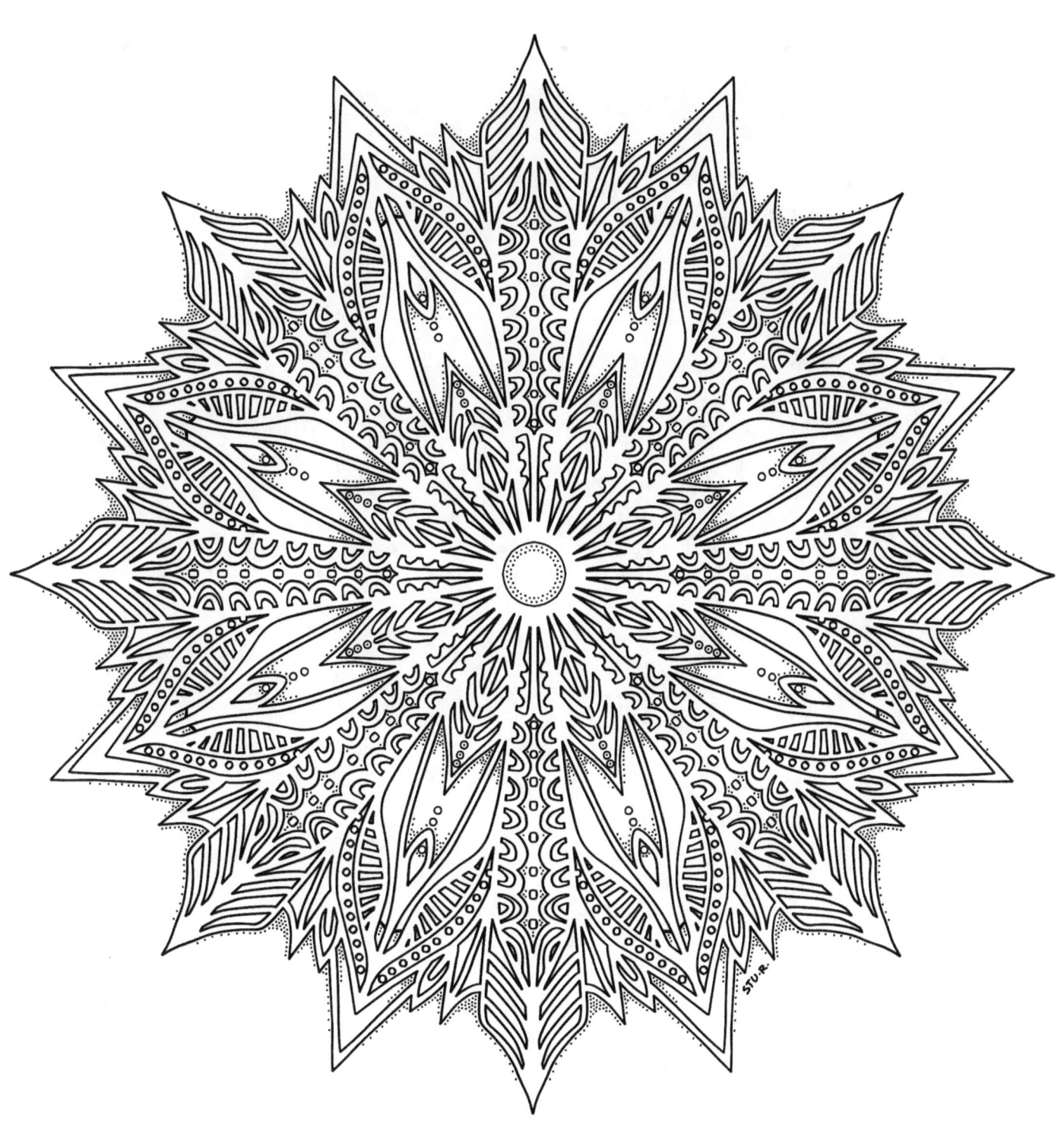

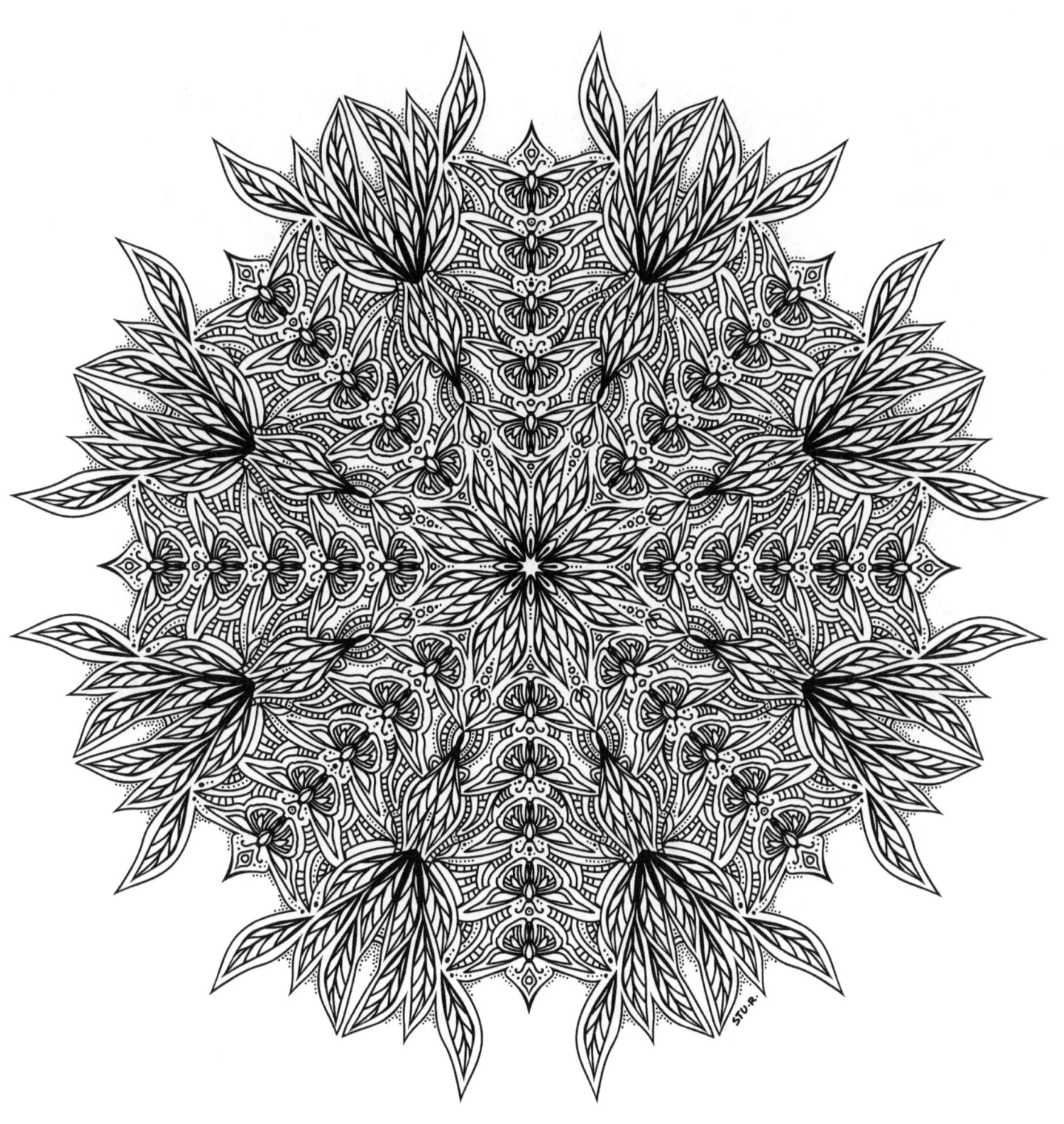

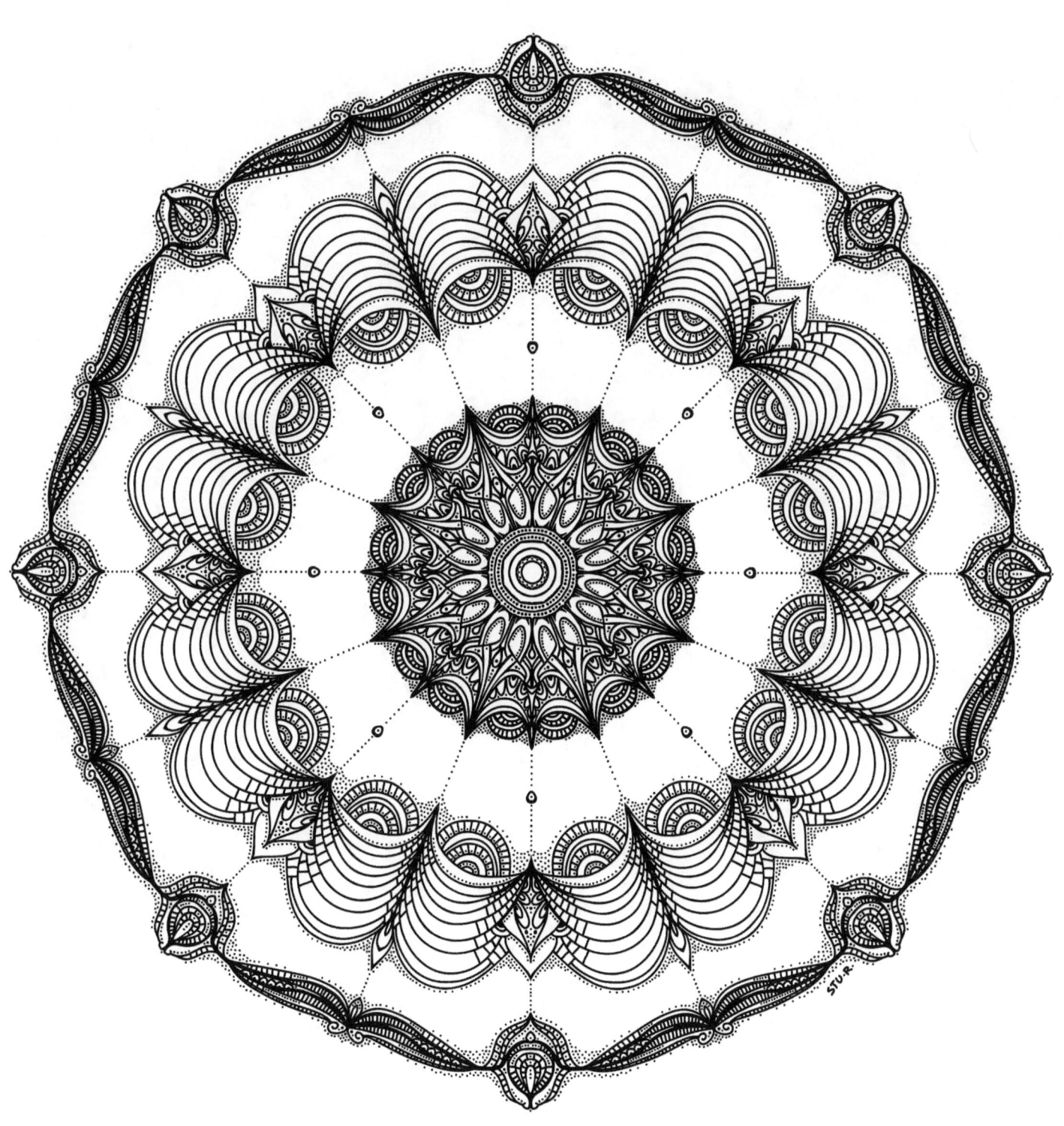

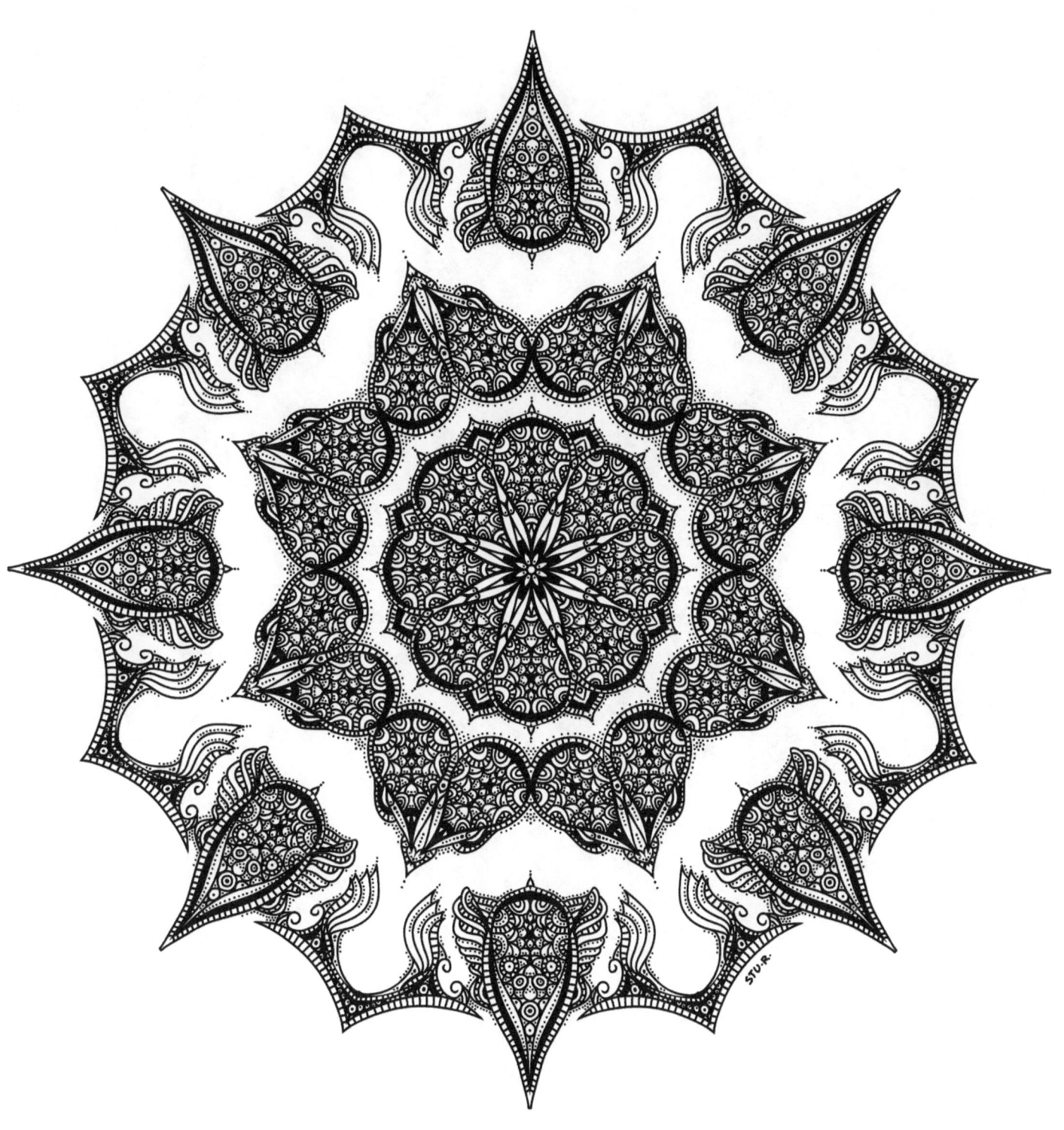

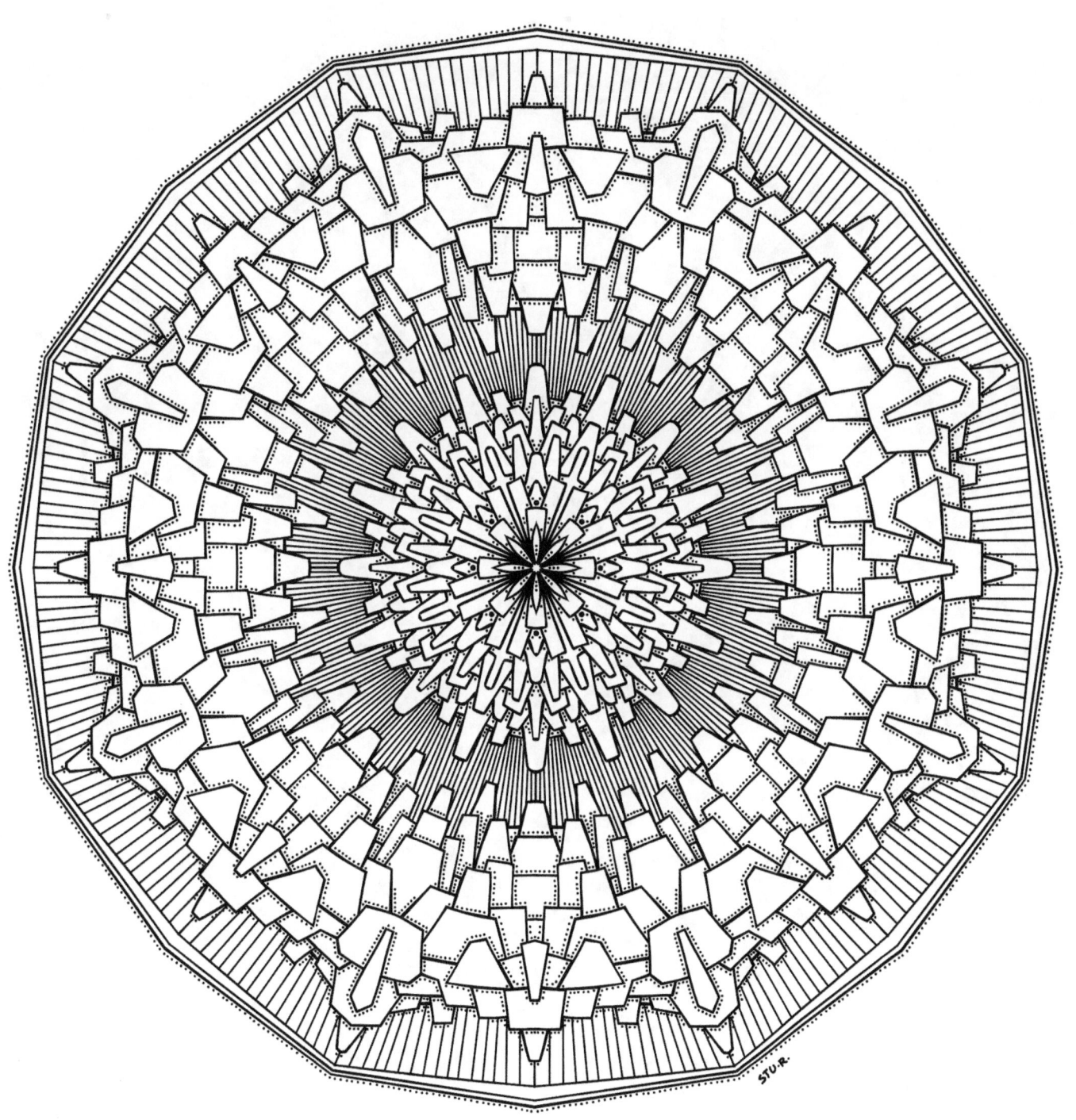

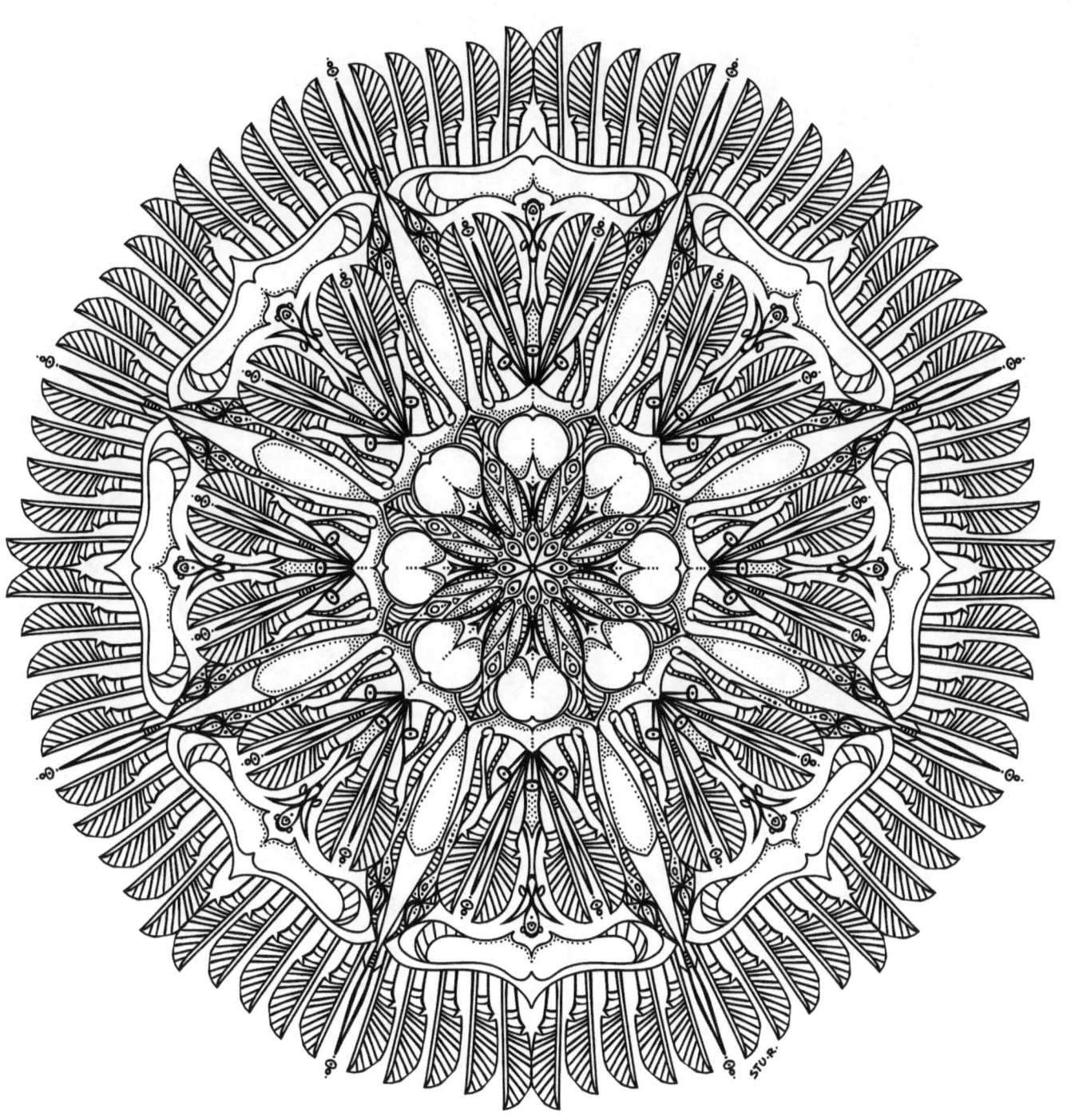

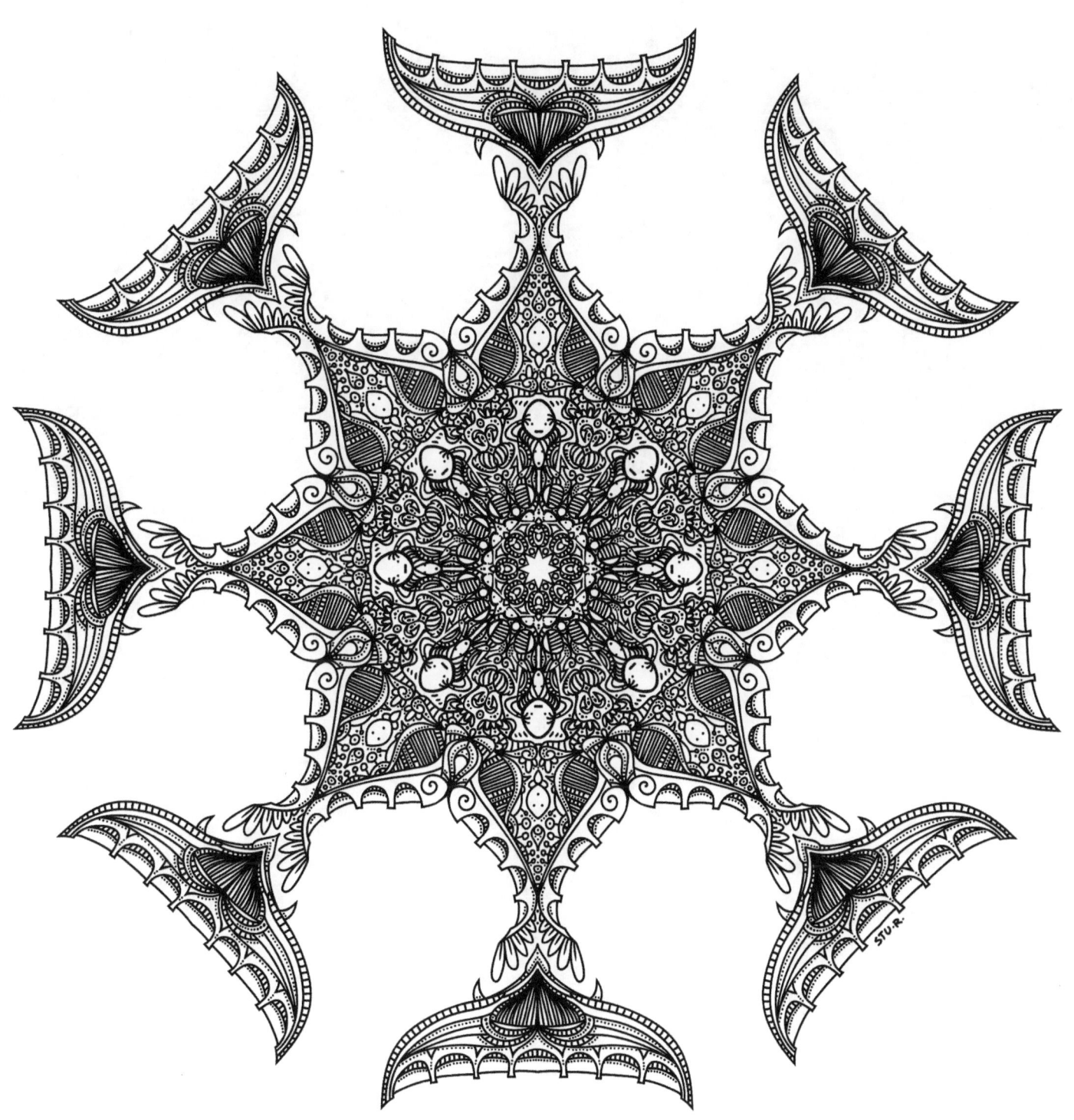

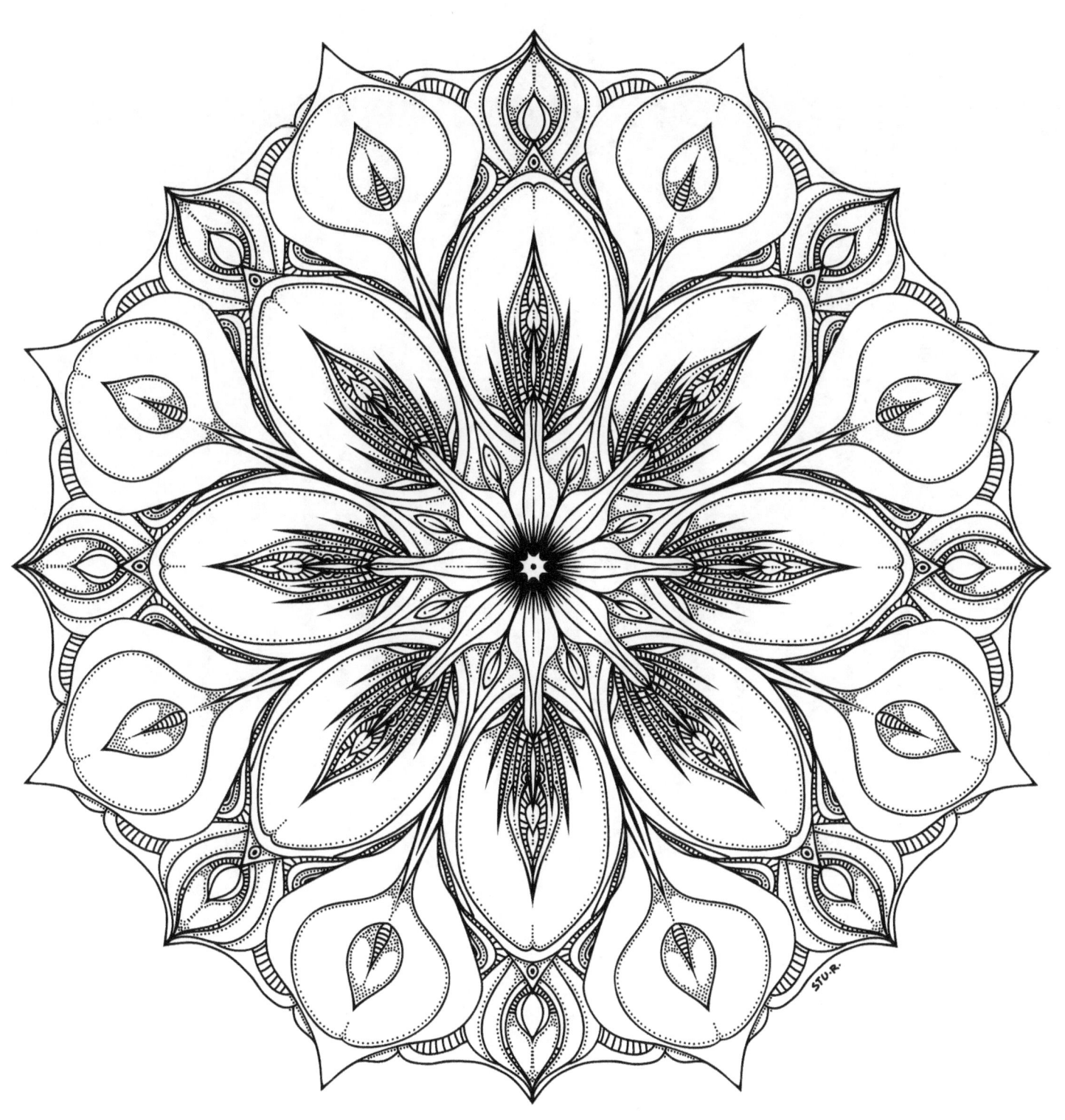

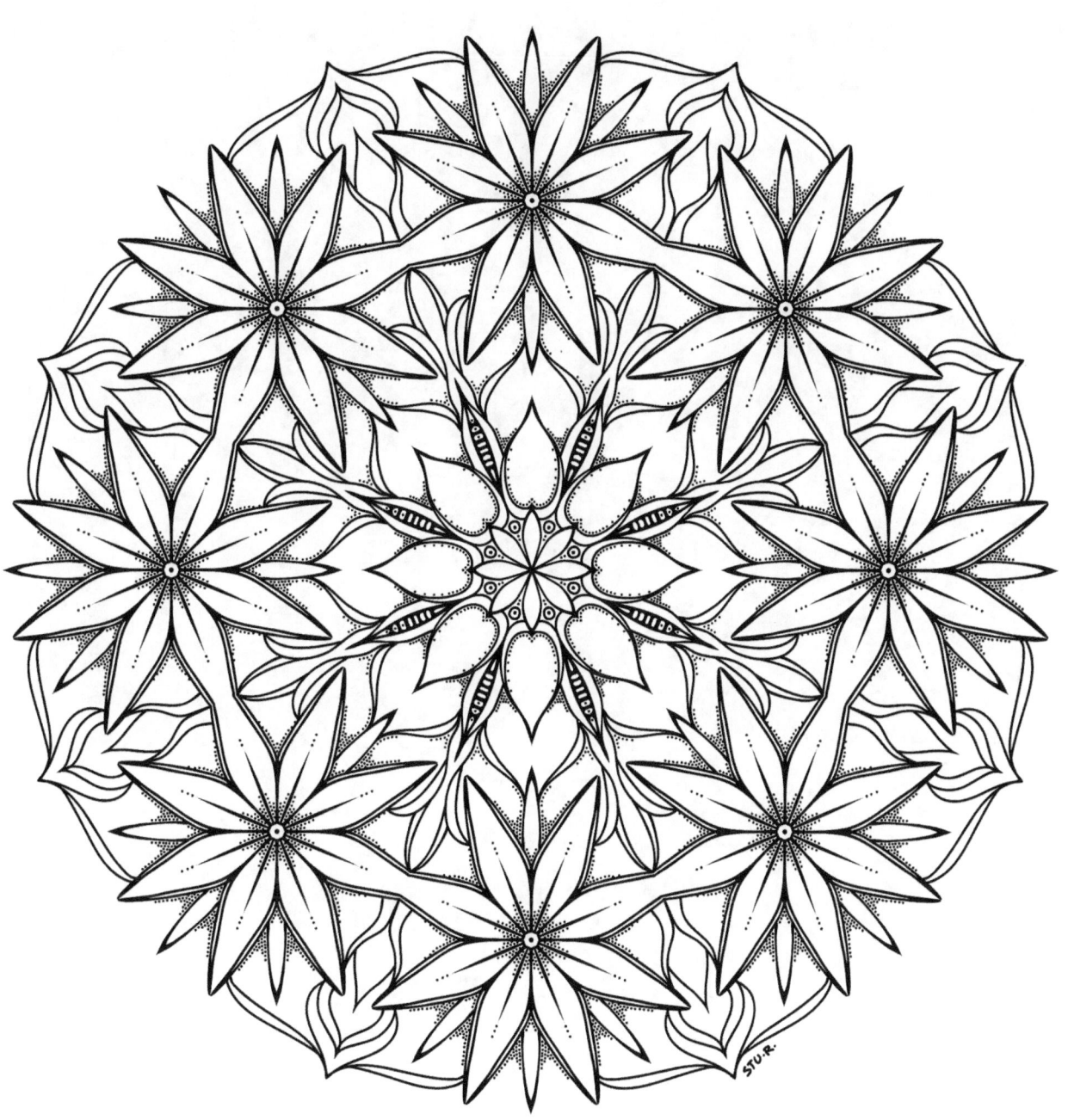

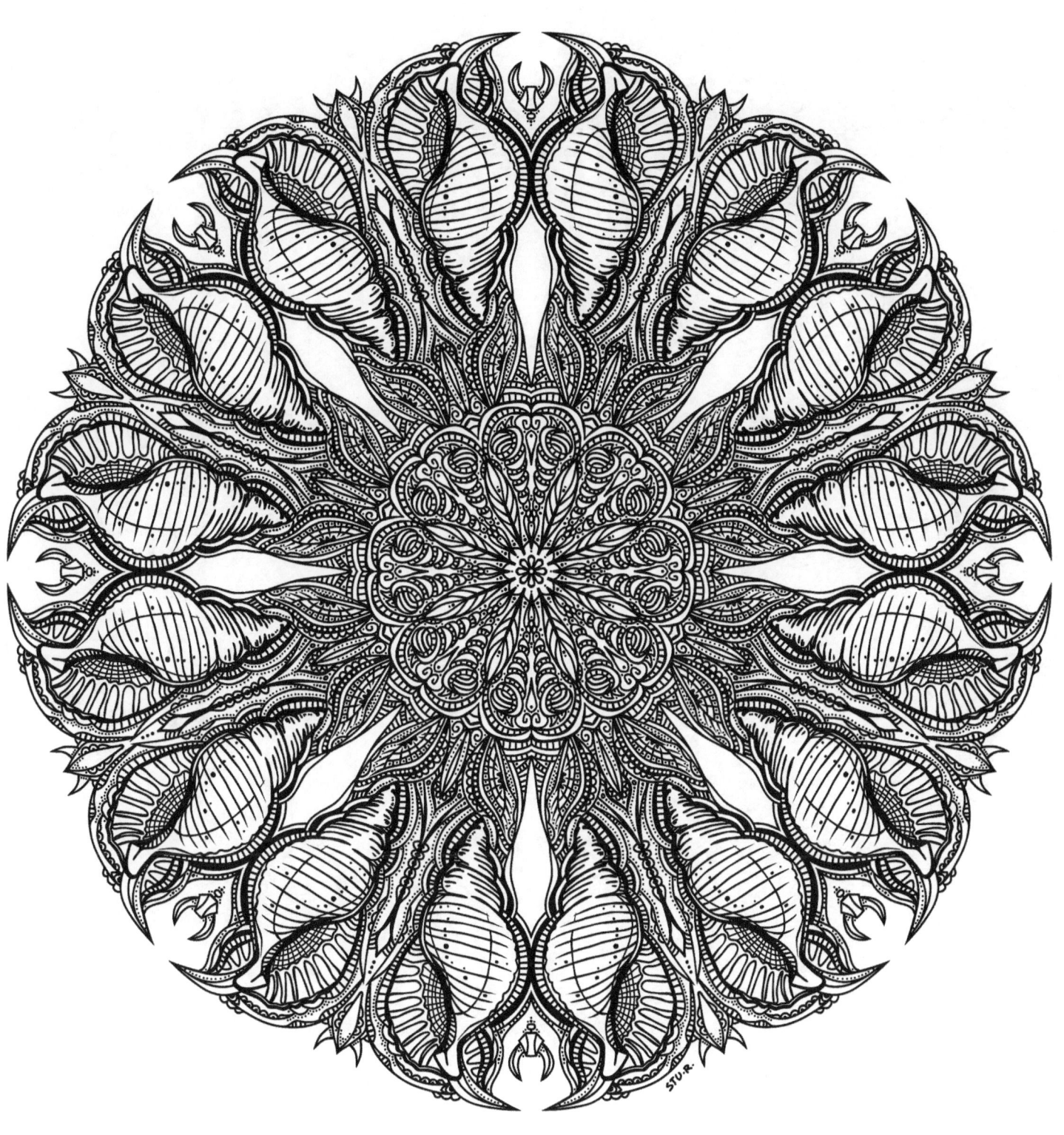

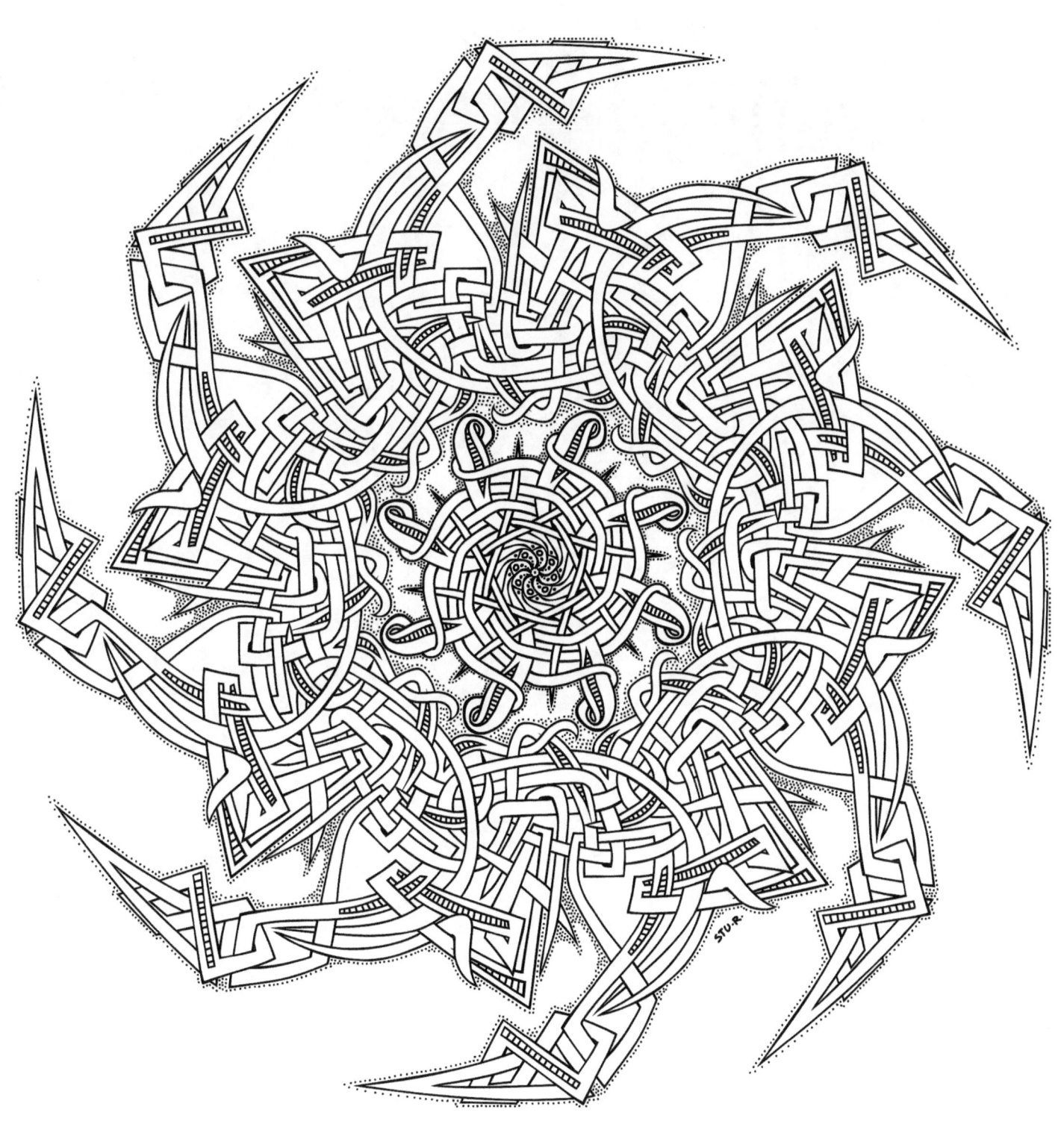

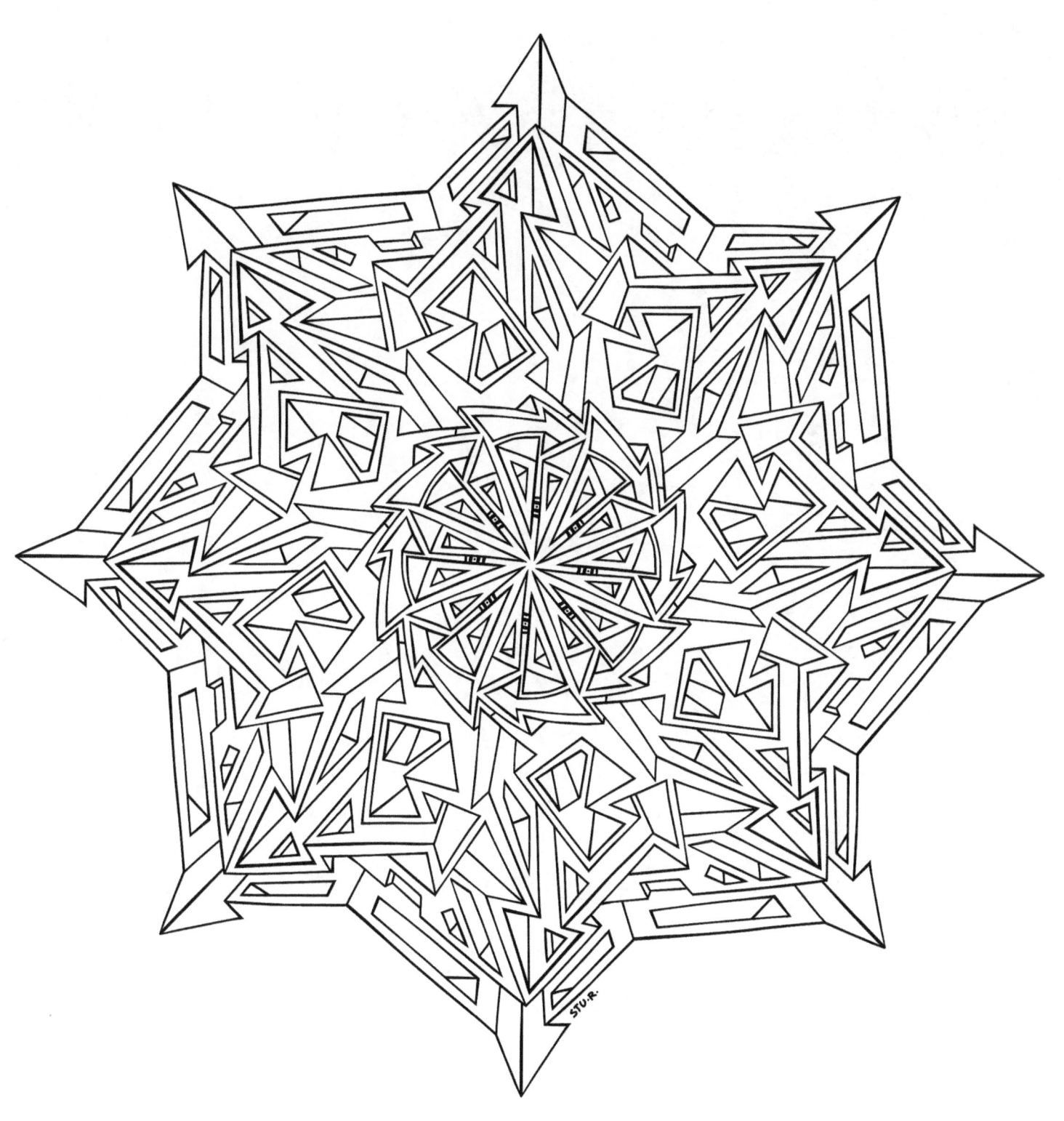

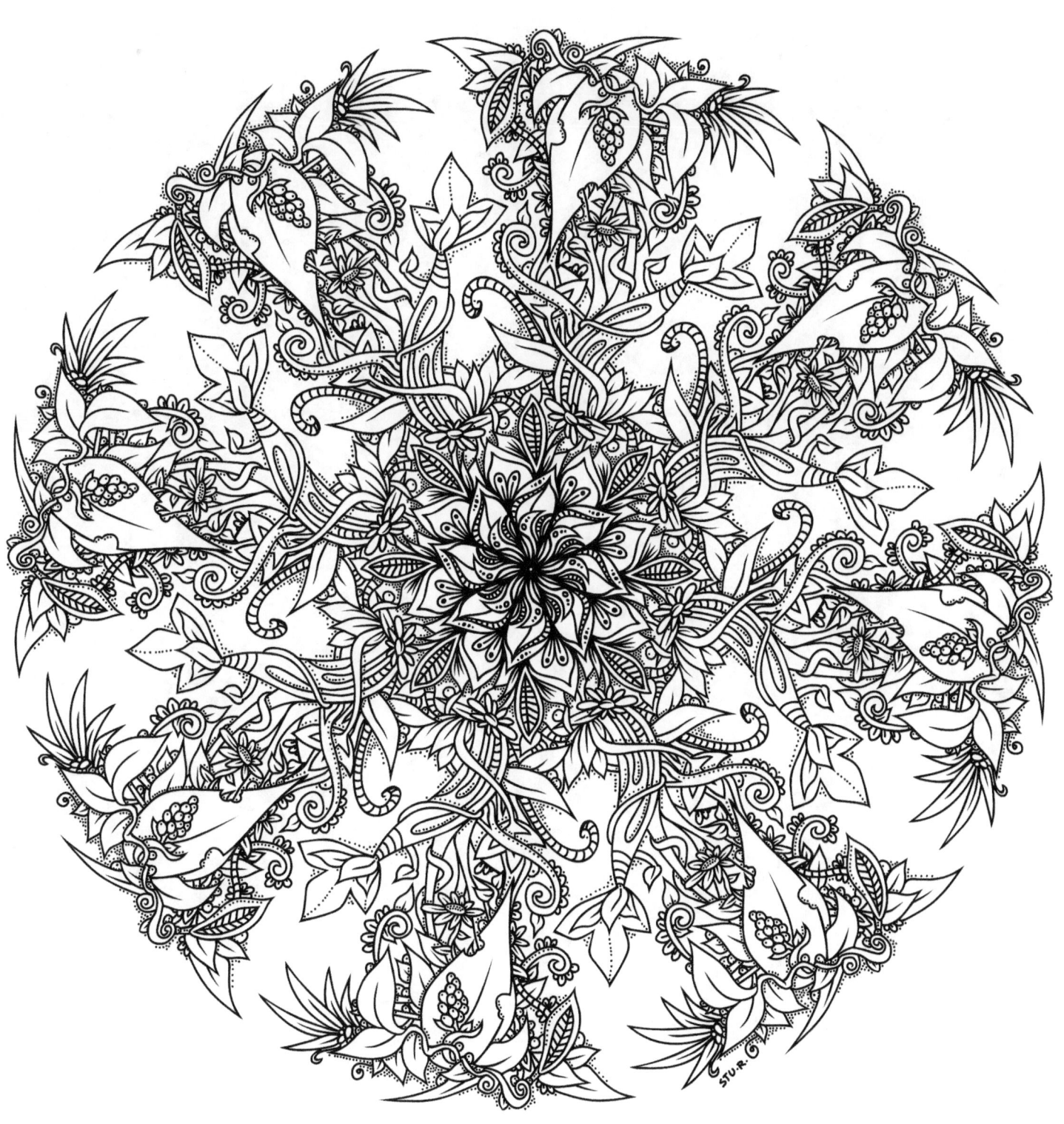

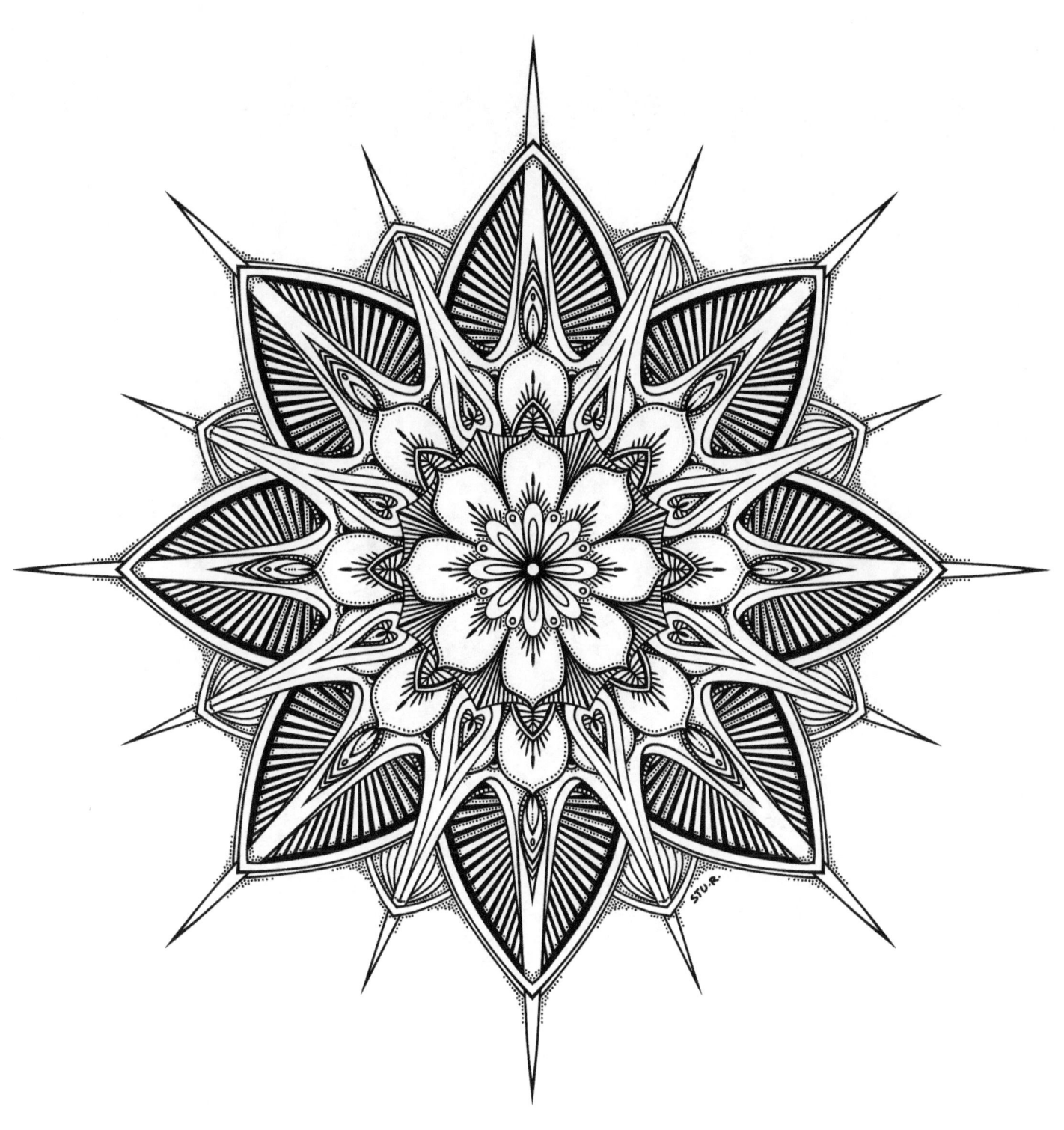

切

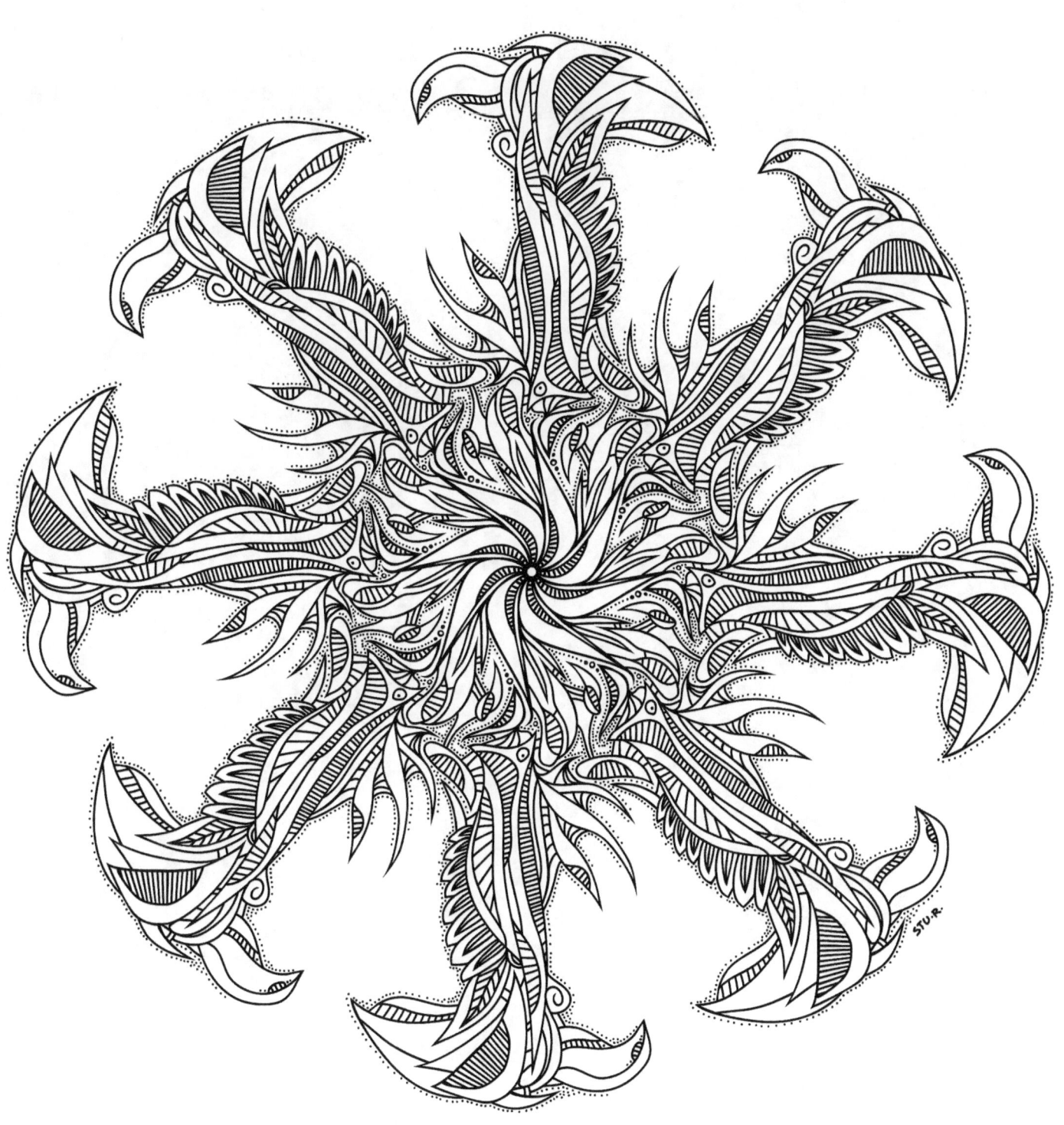

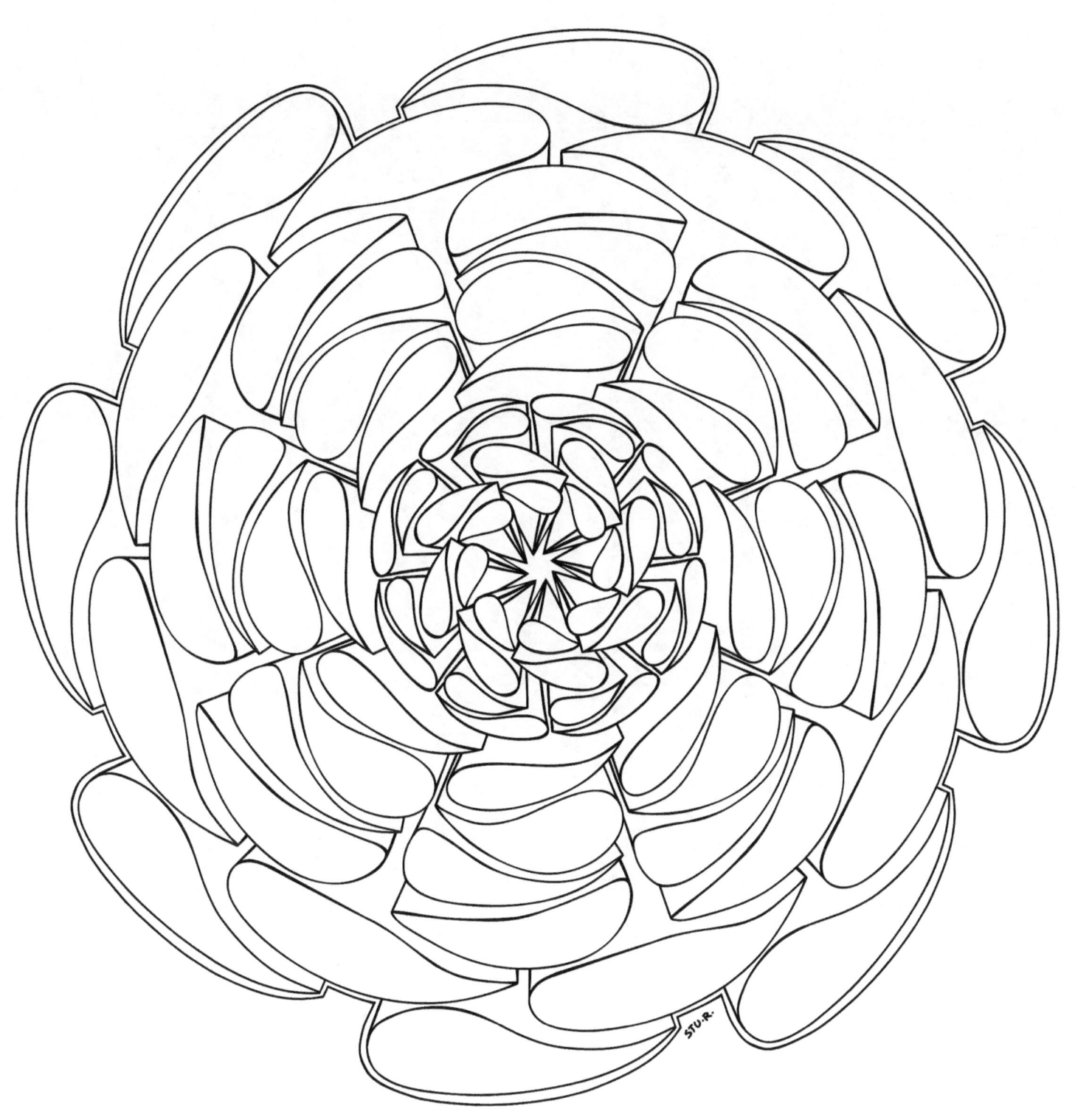

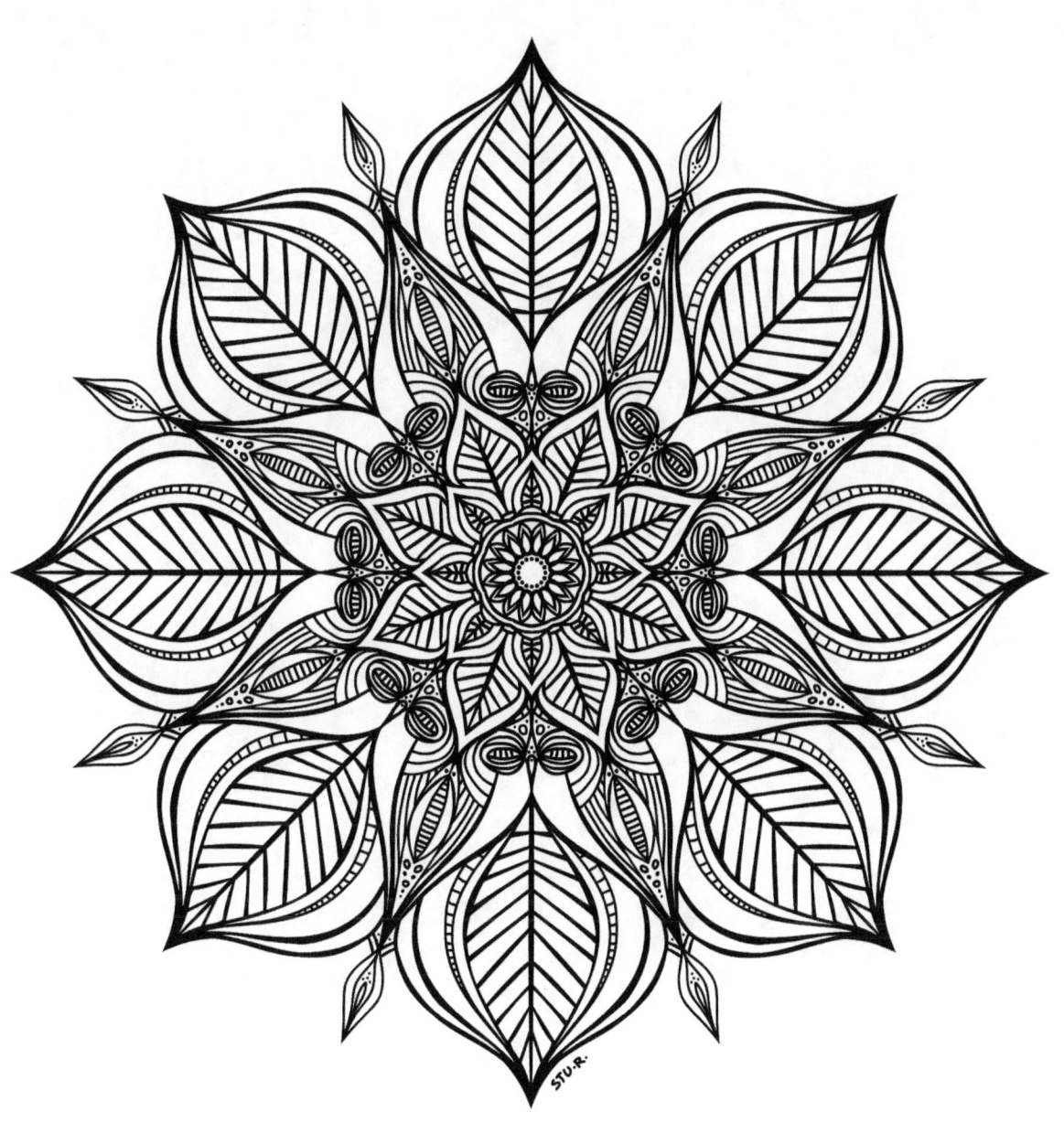

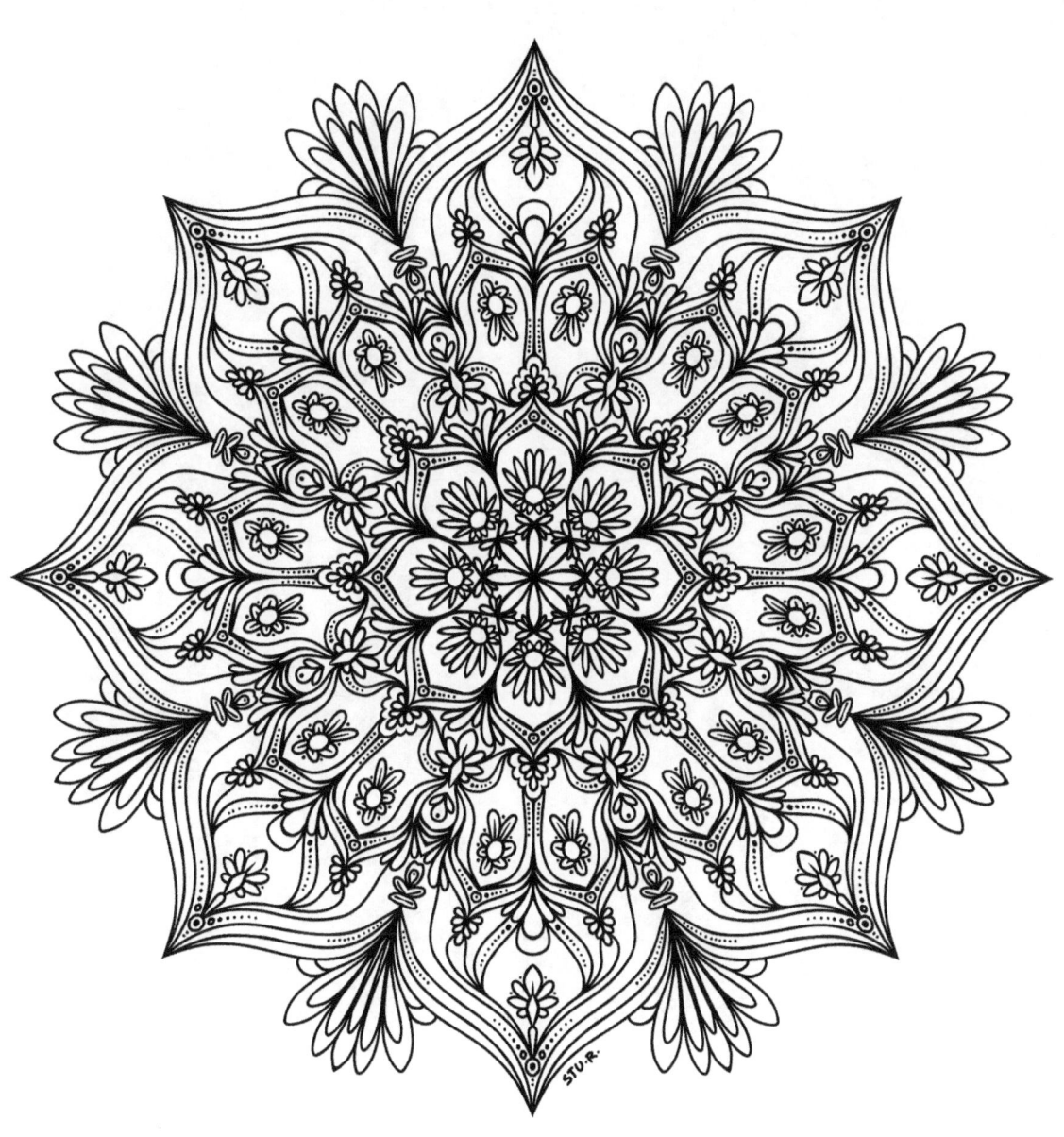

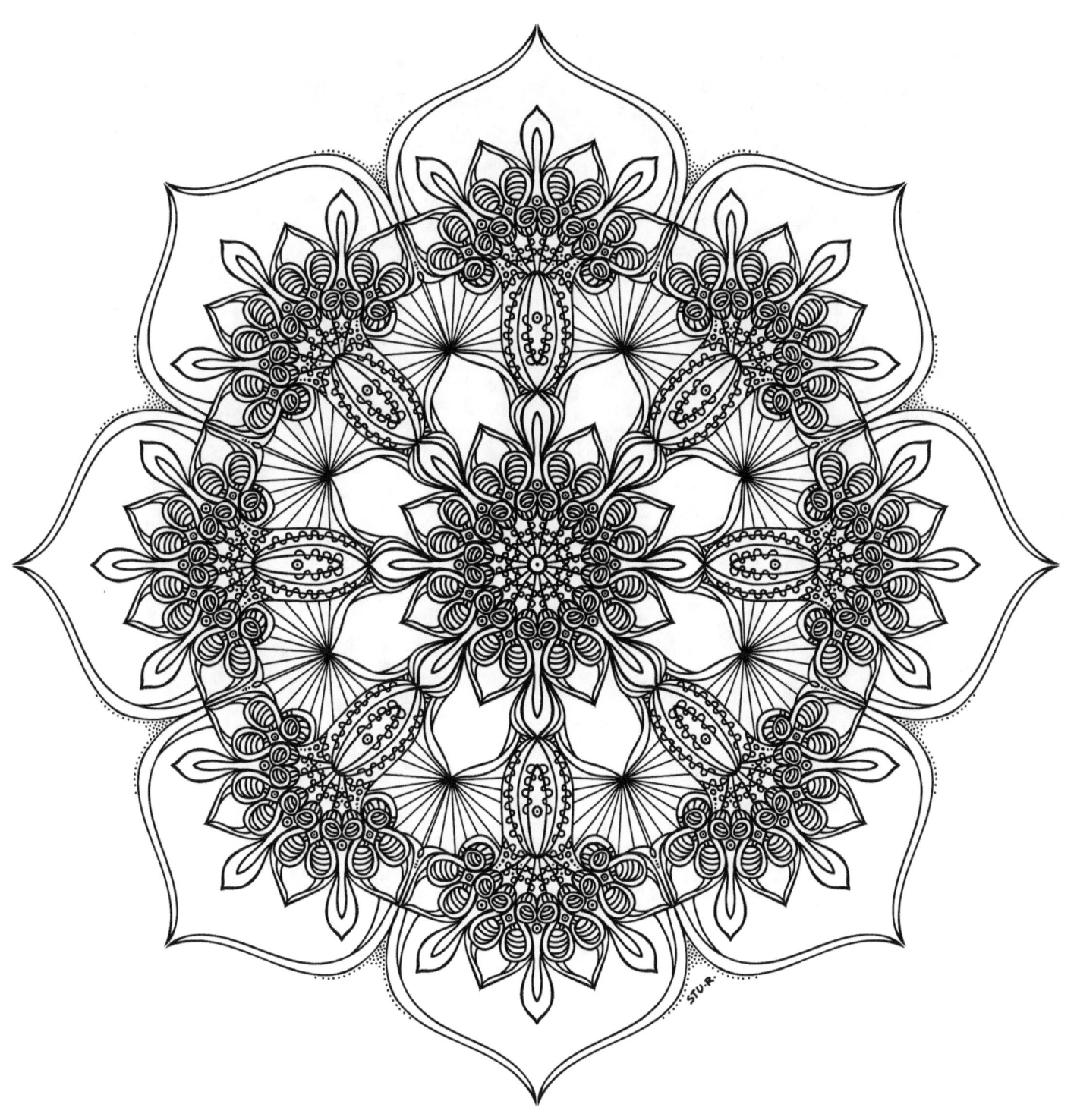

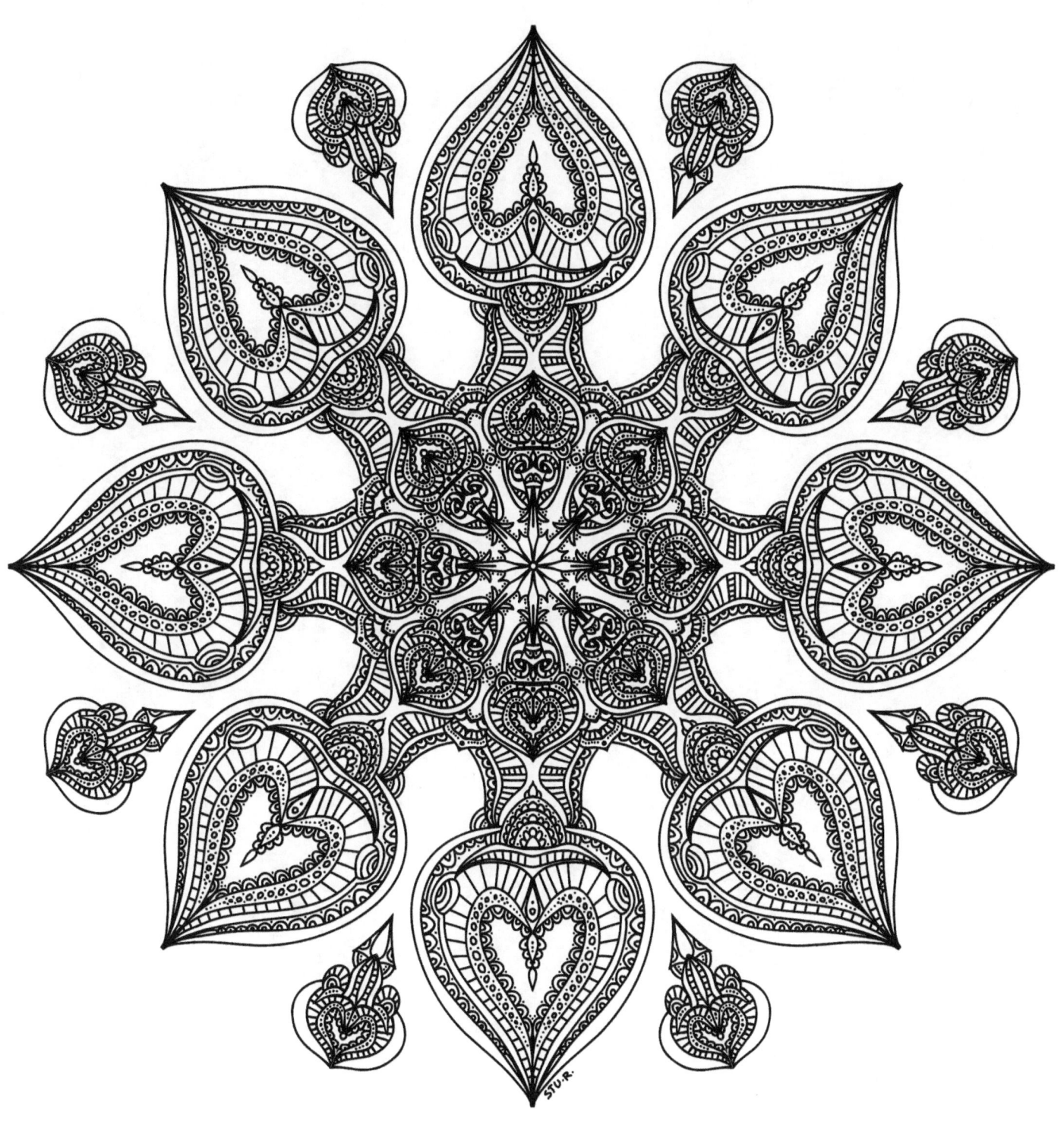

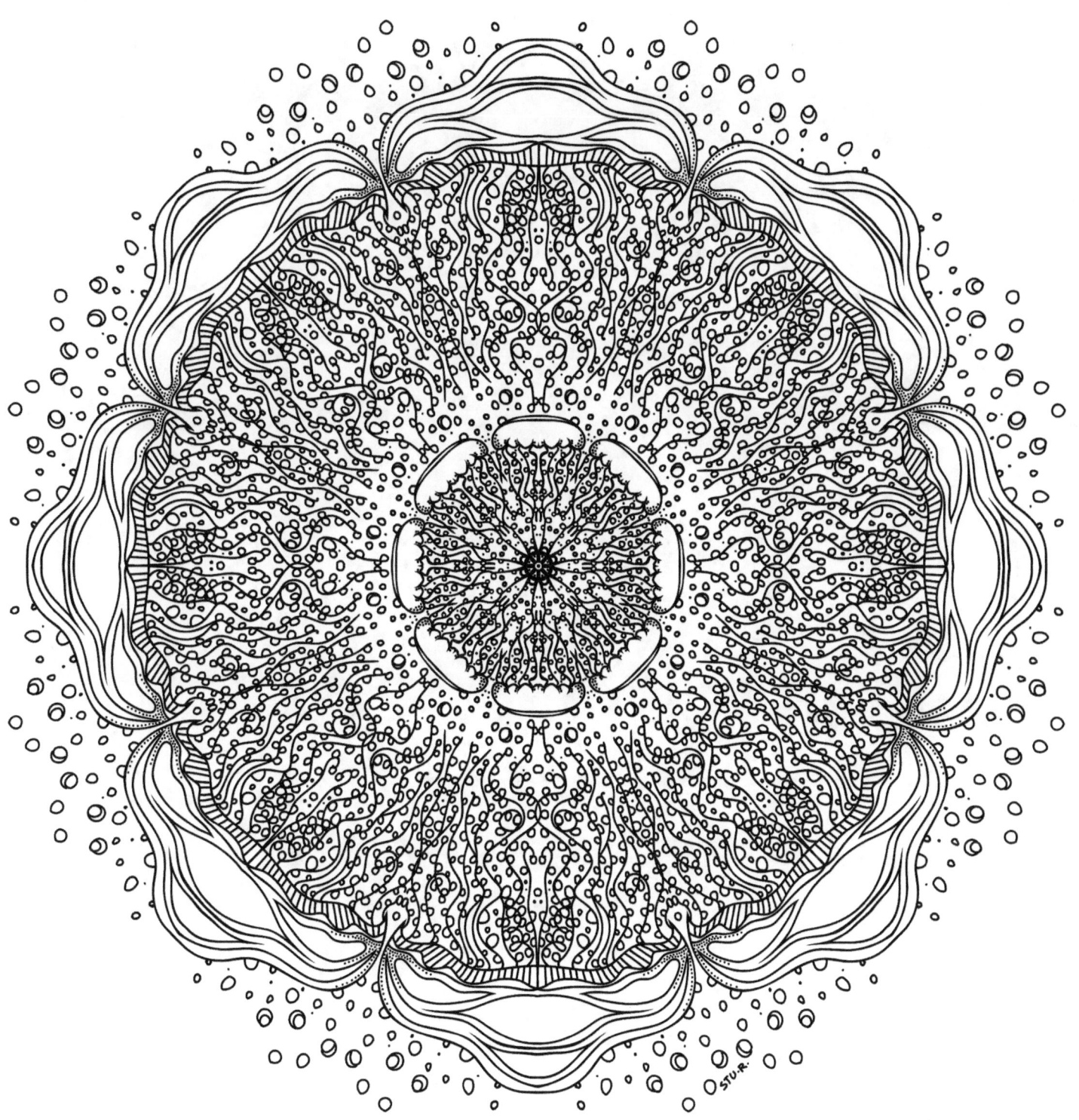

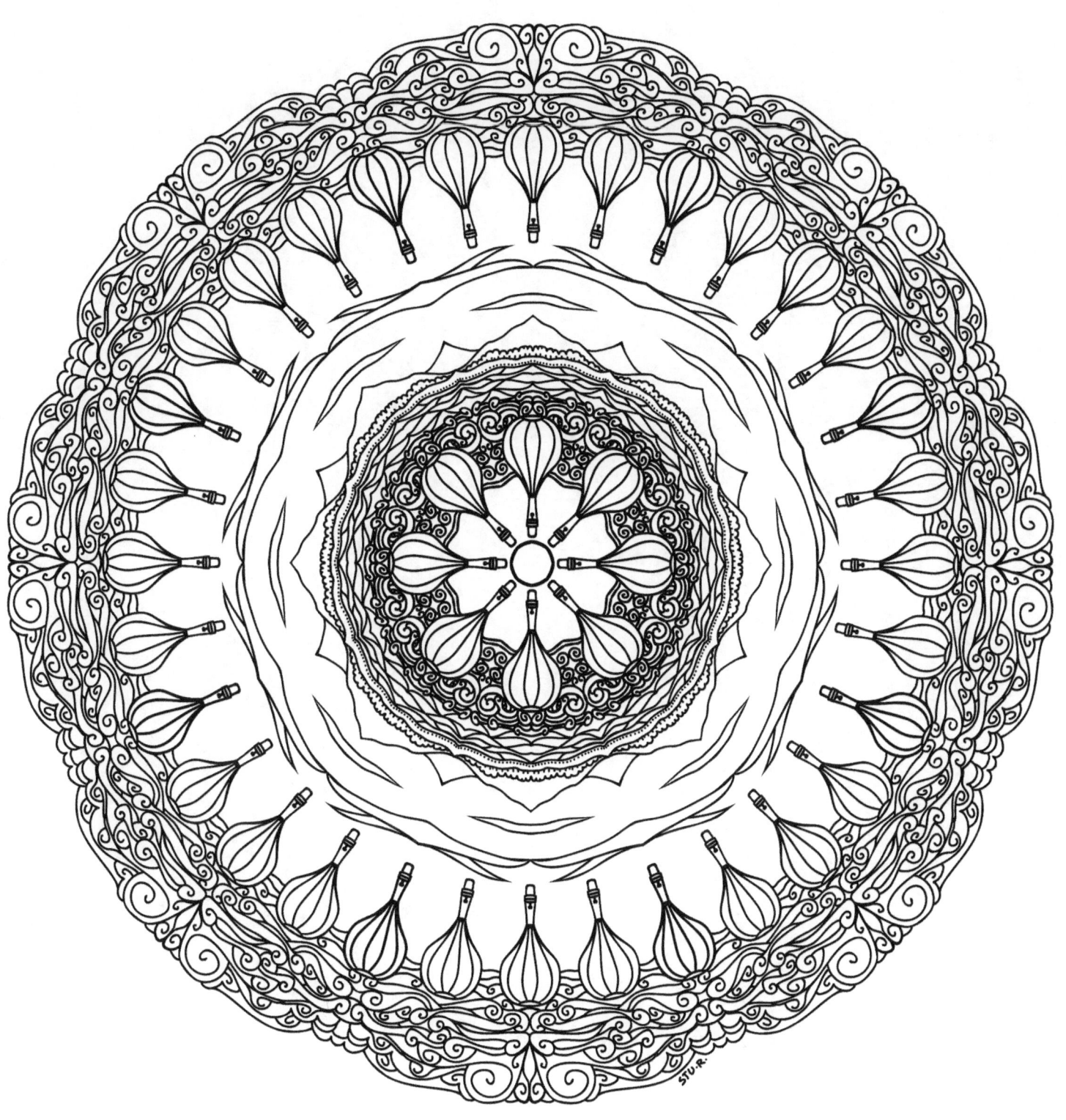

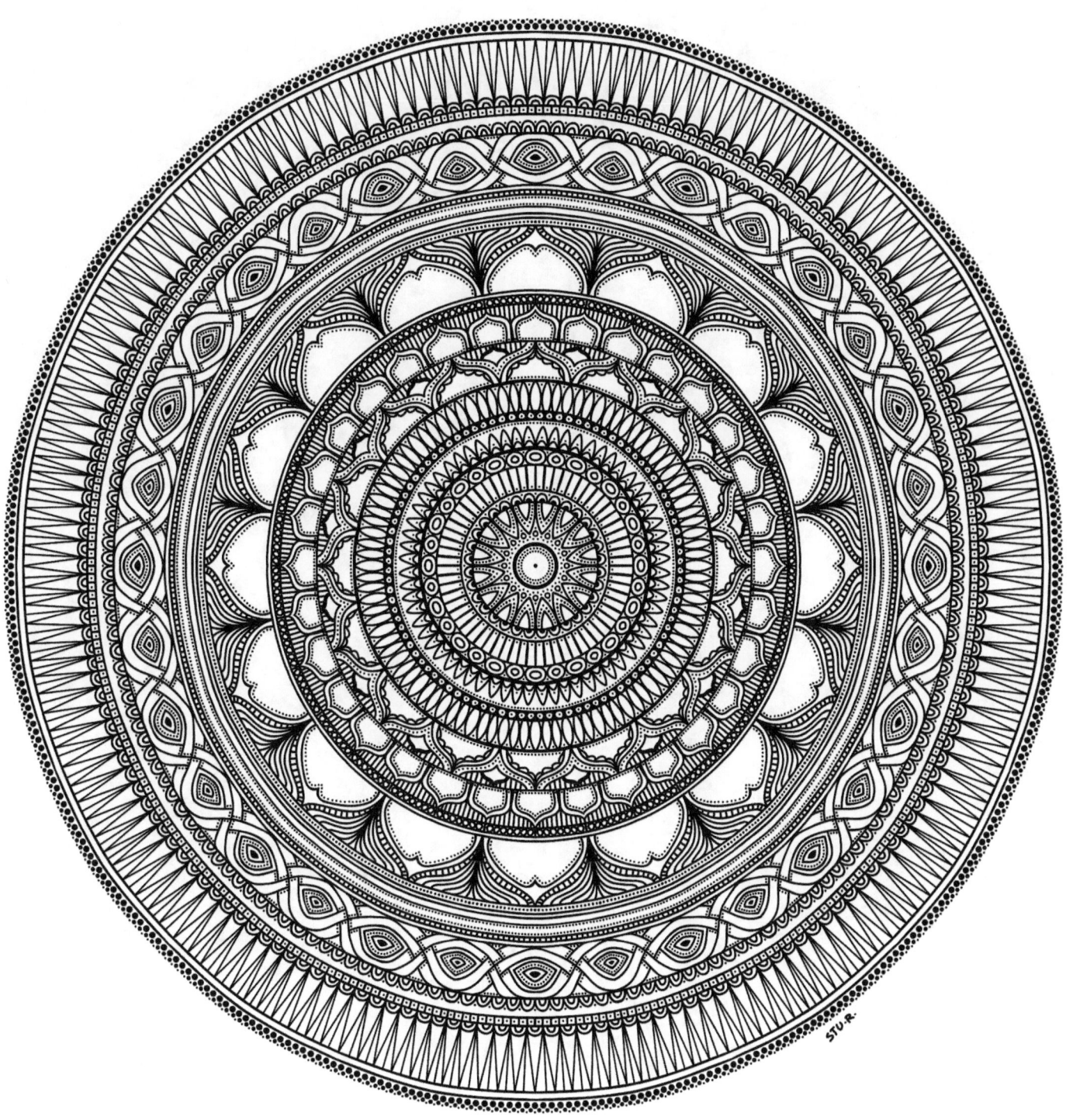

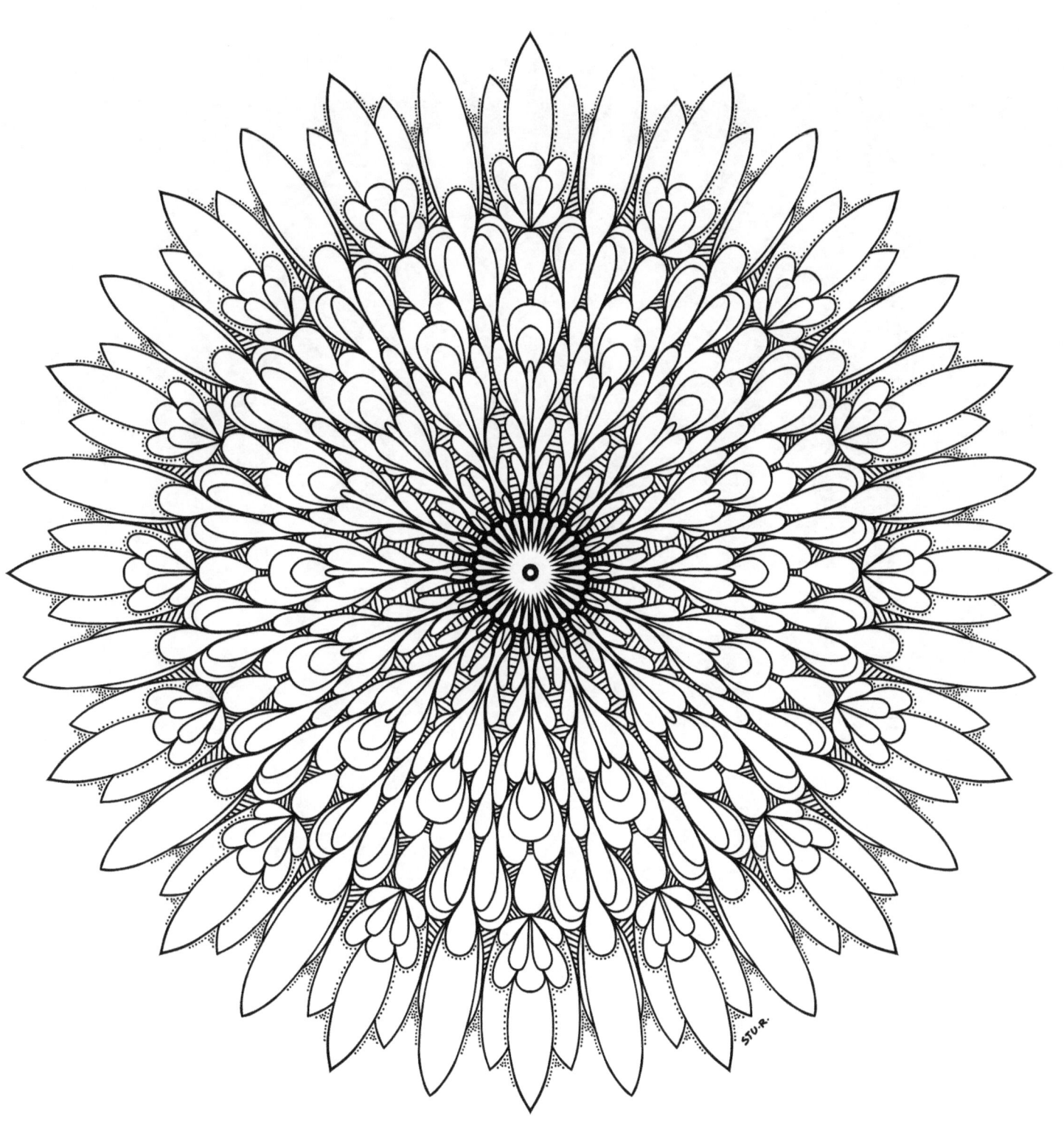

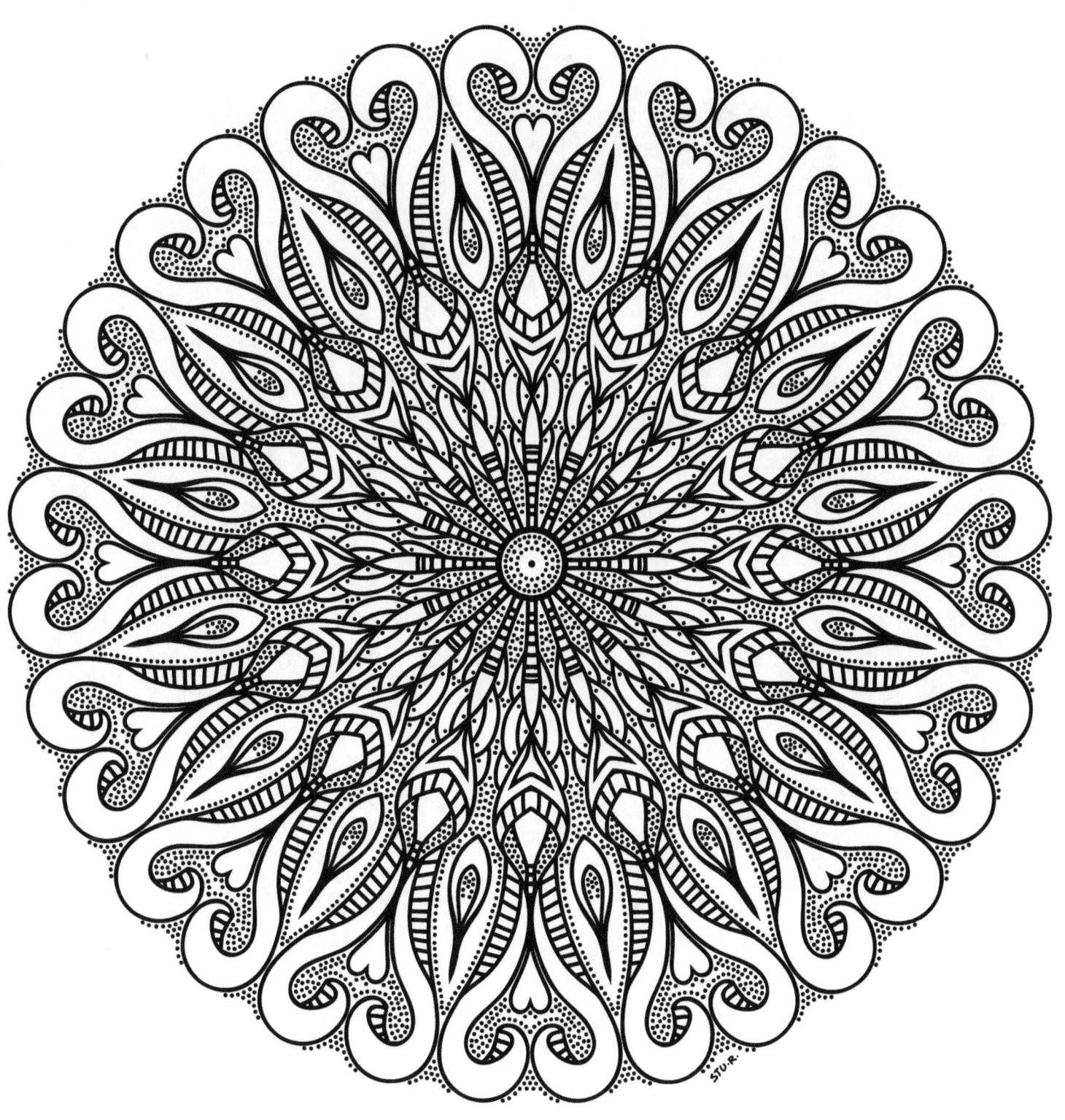

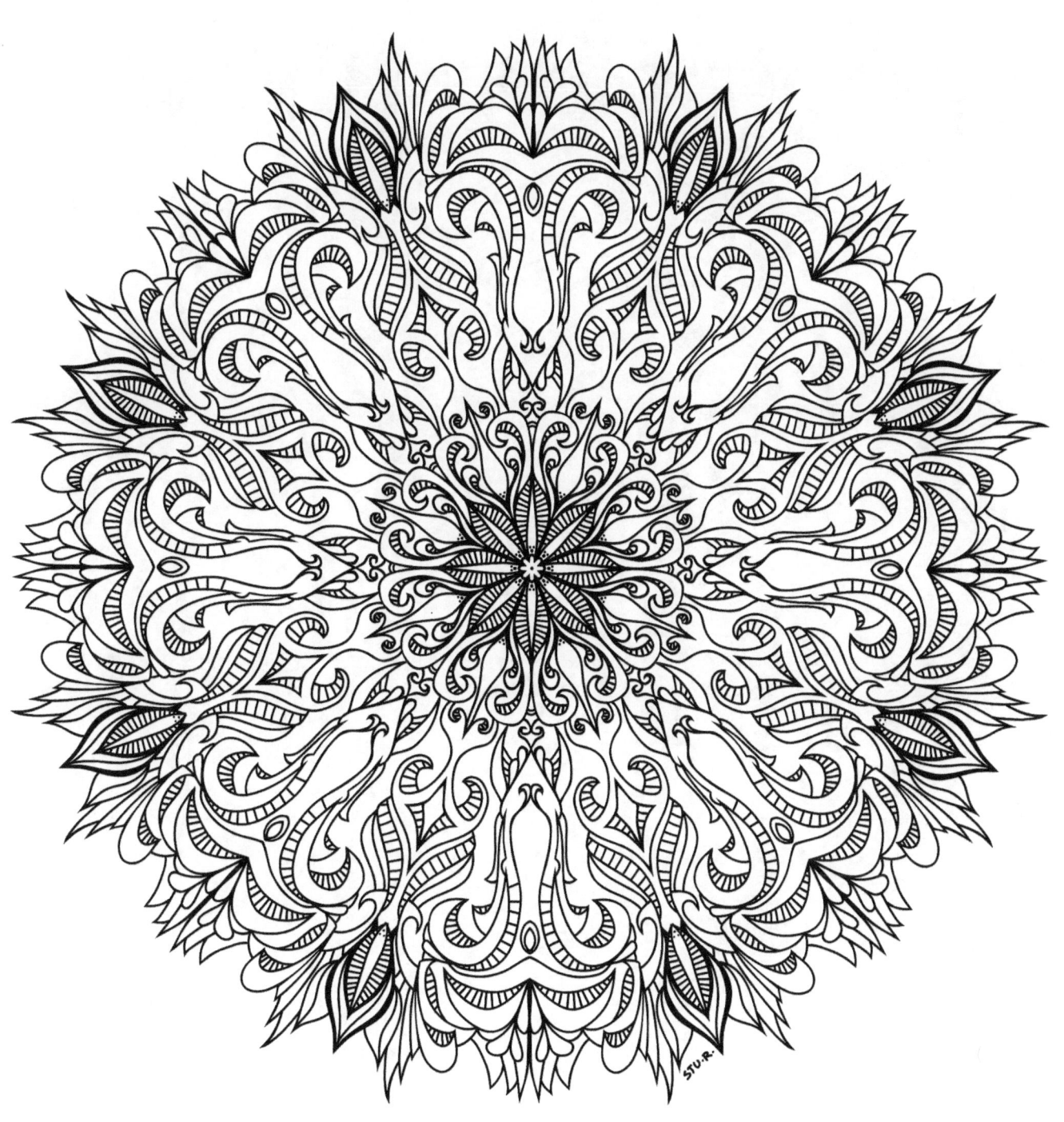

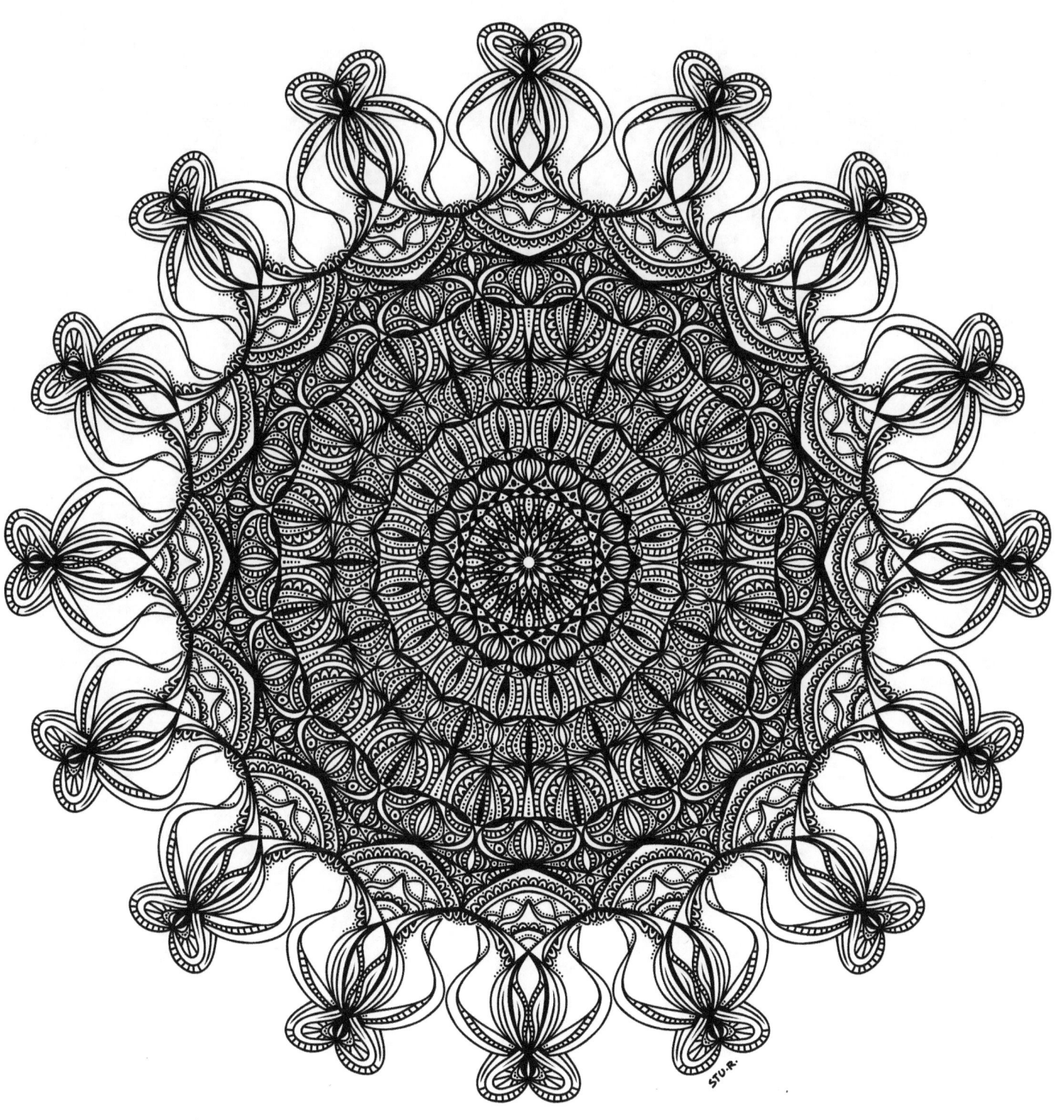

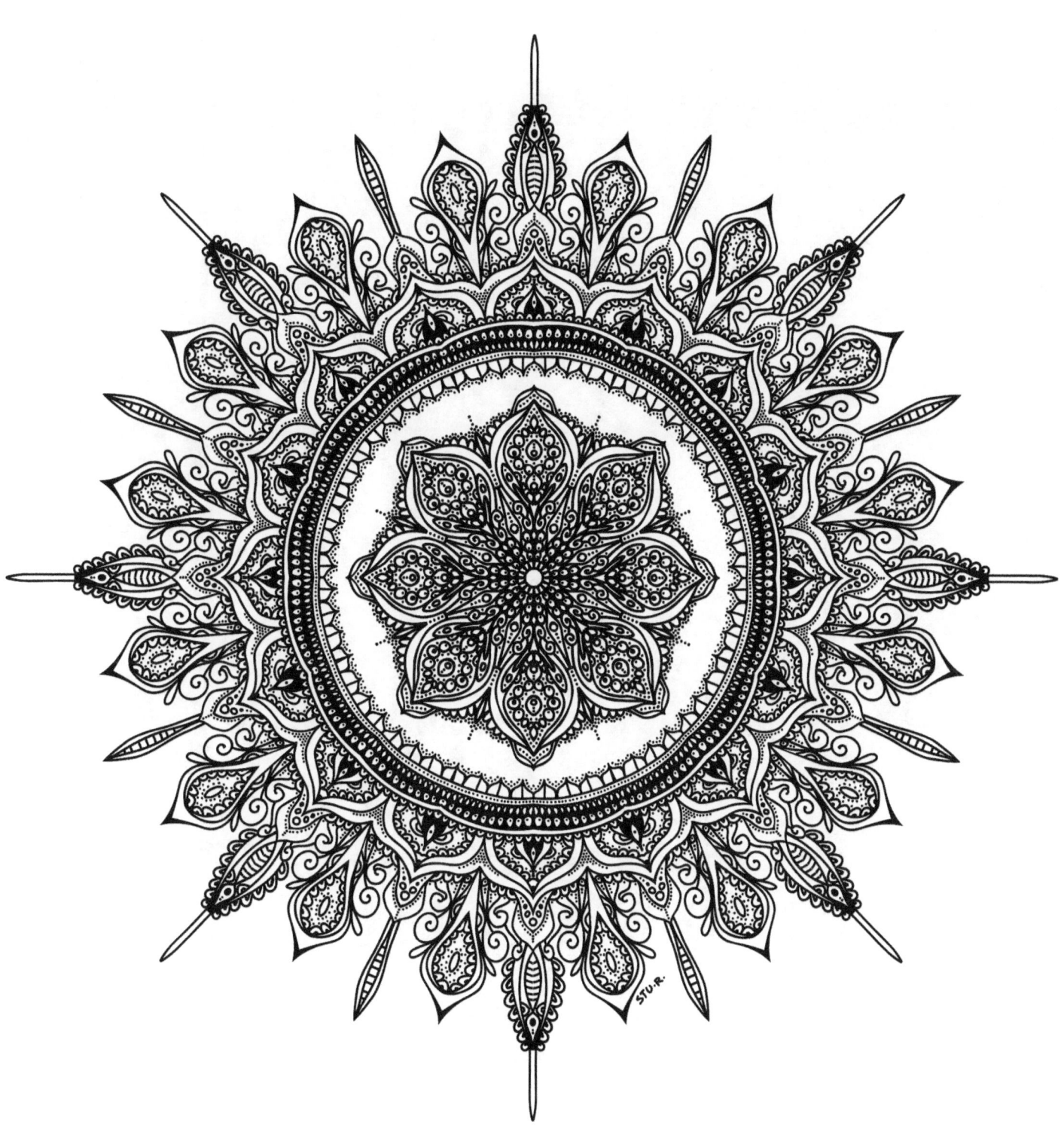

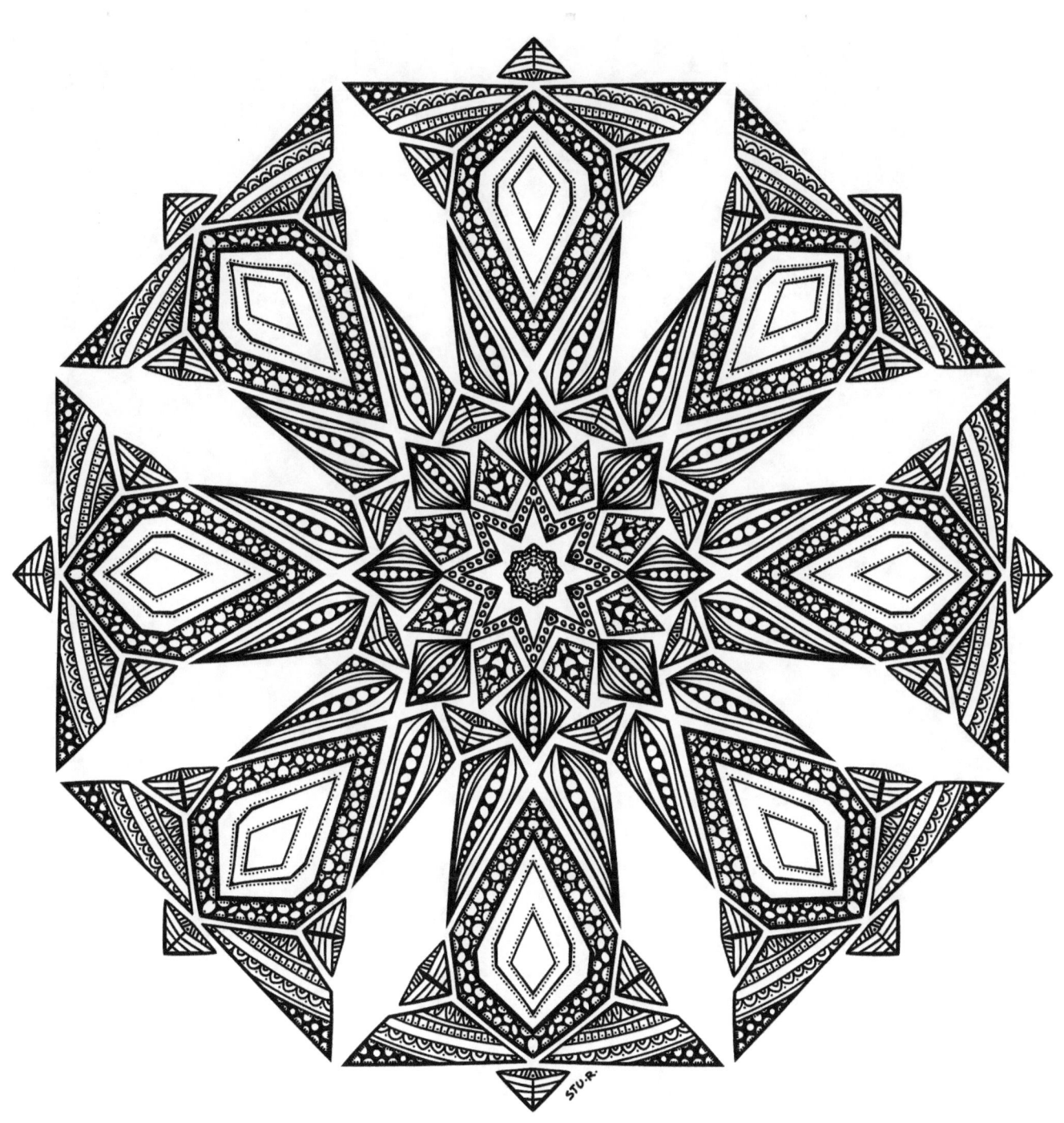

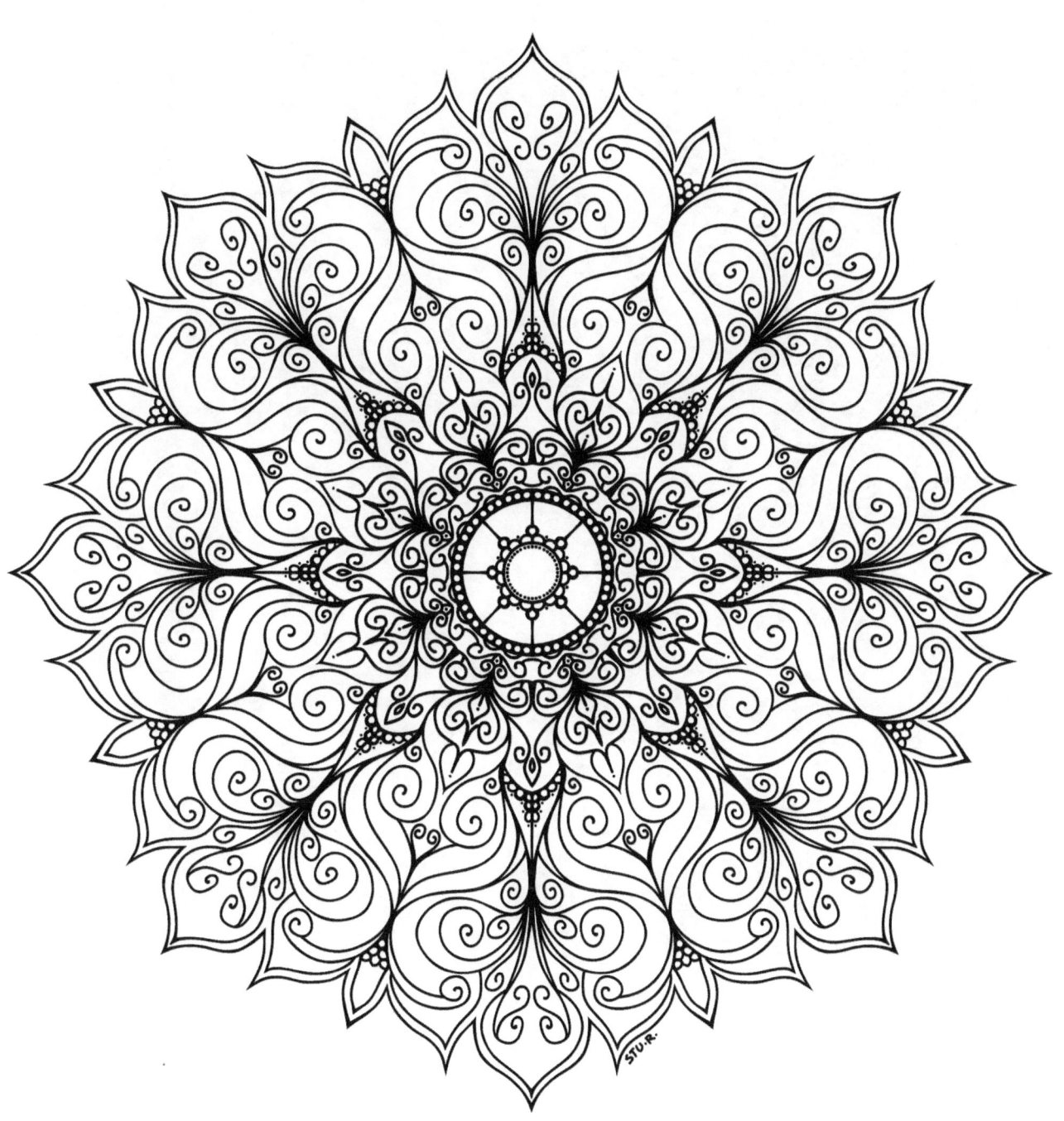

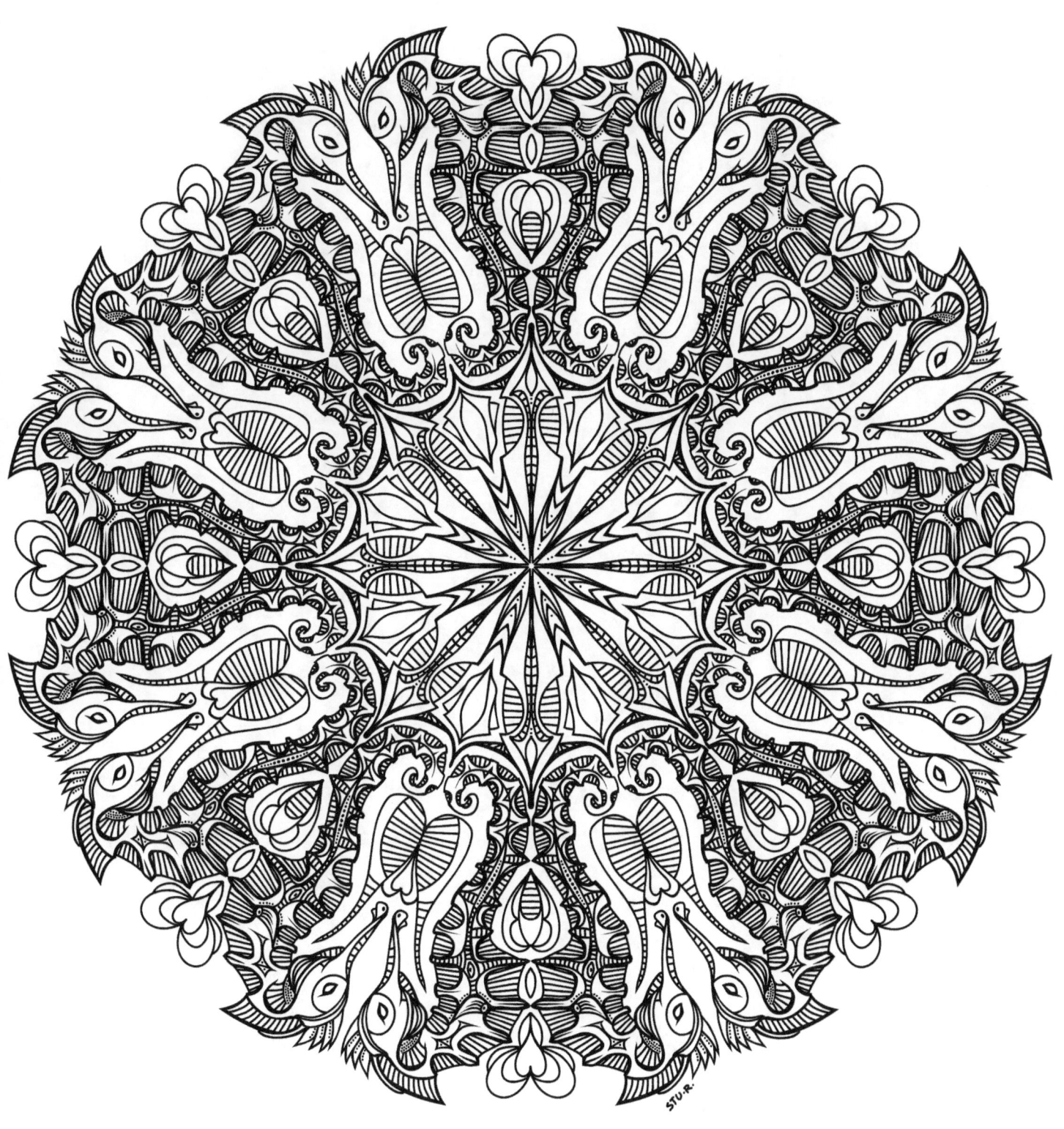

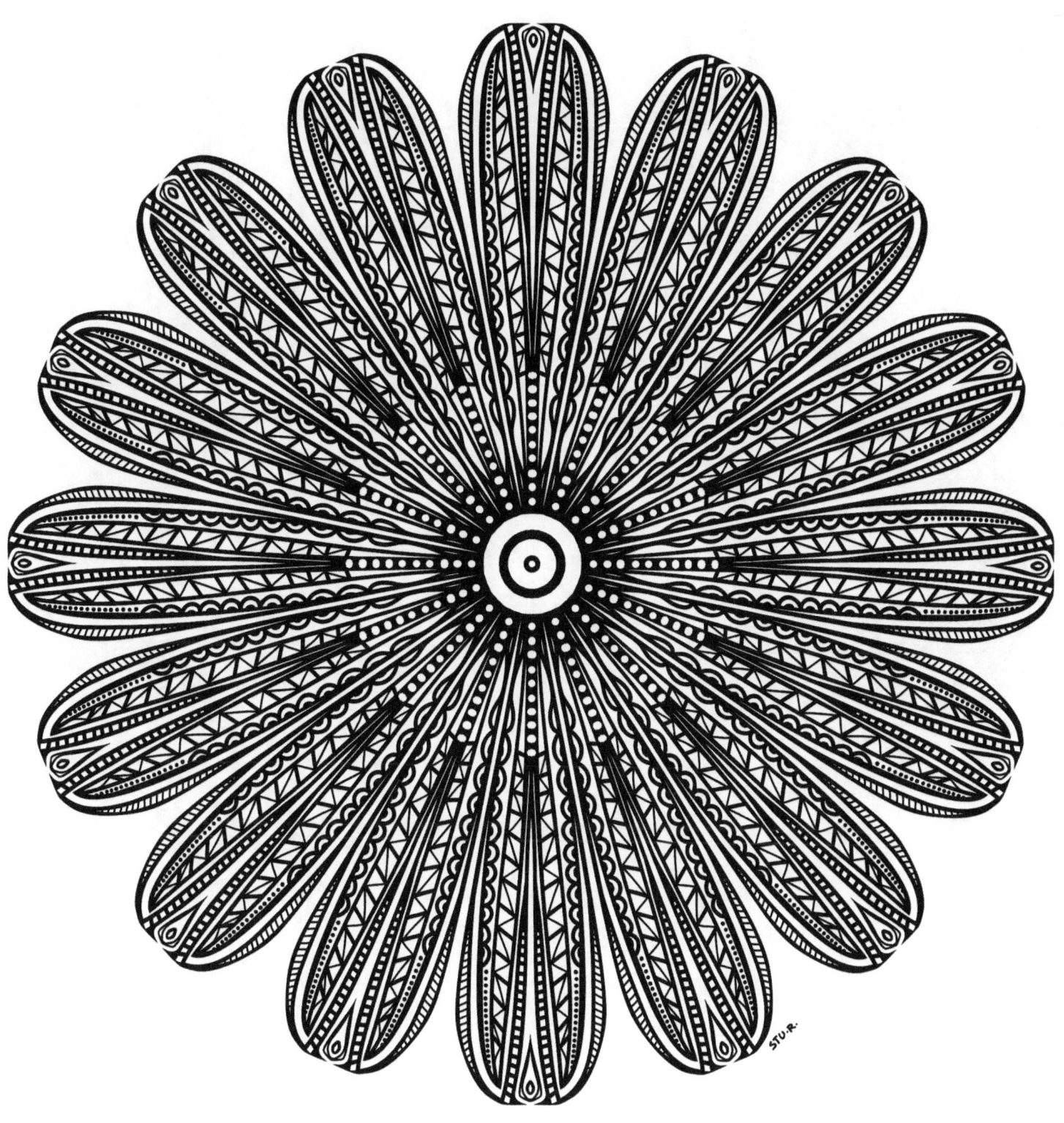

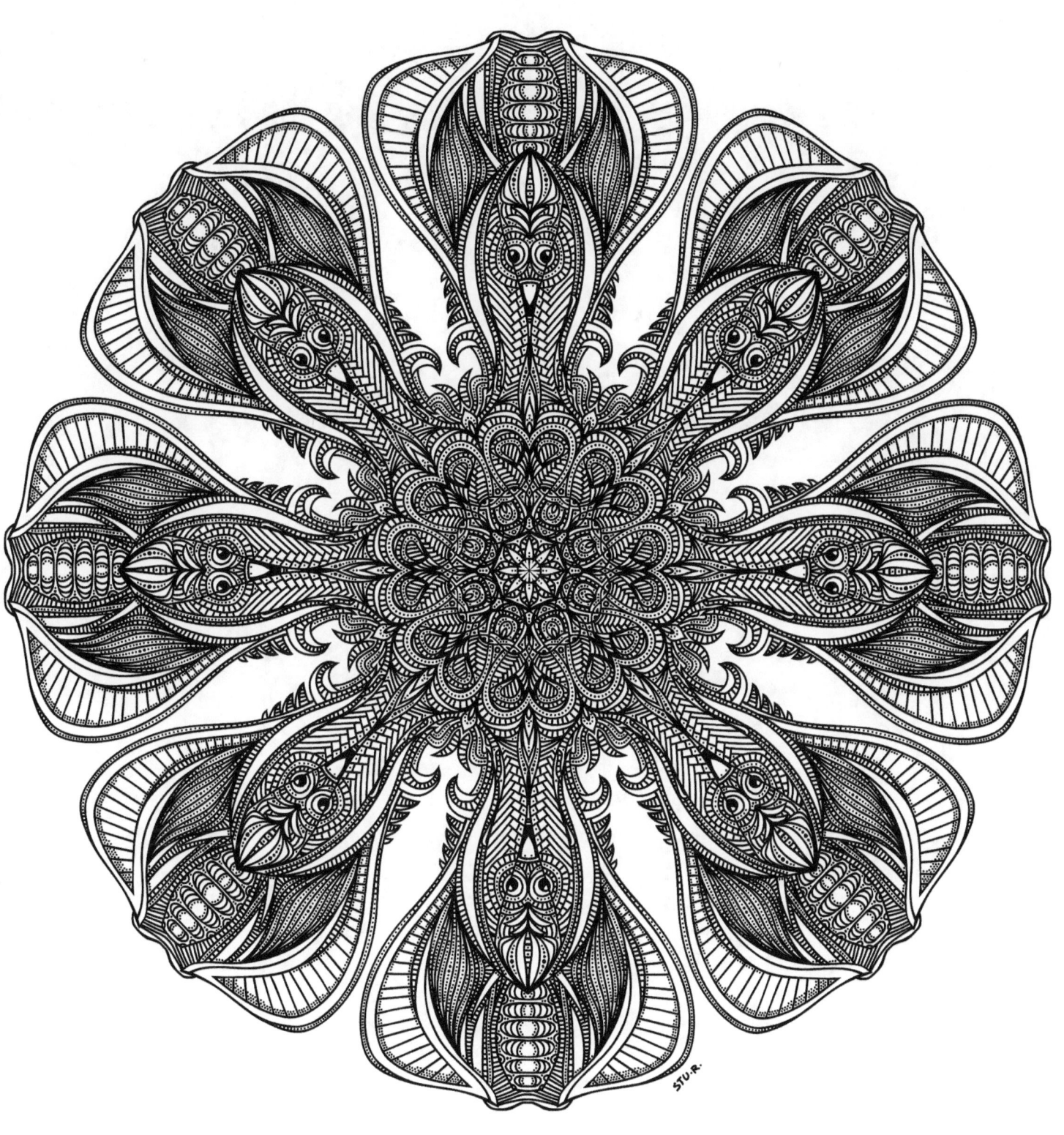

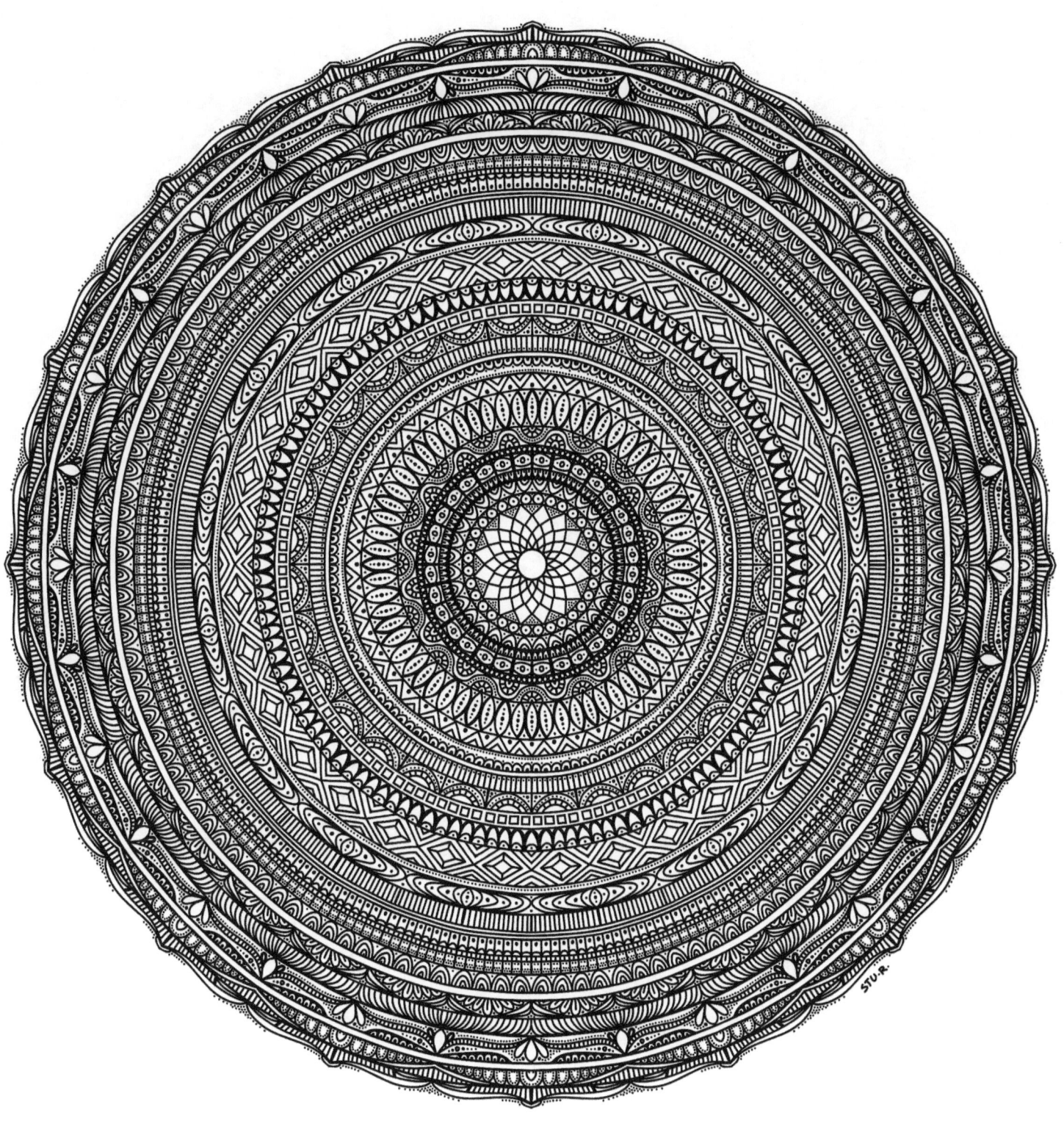

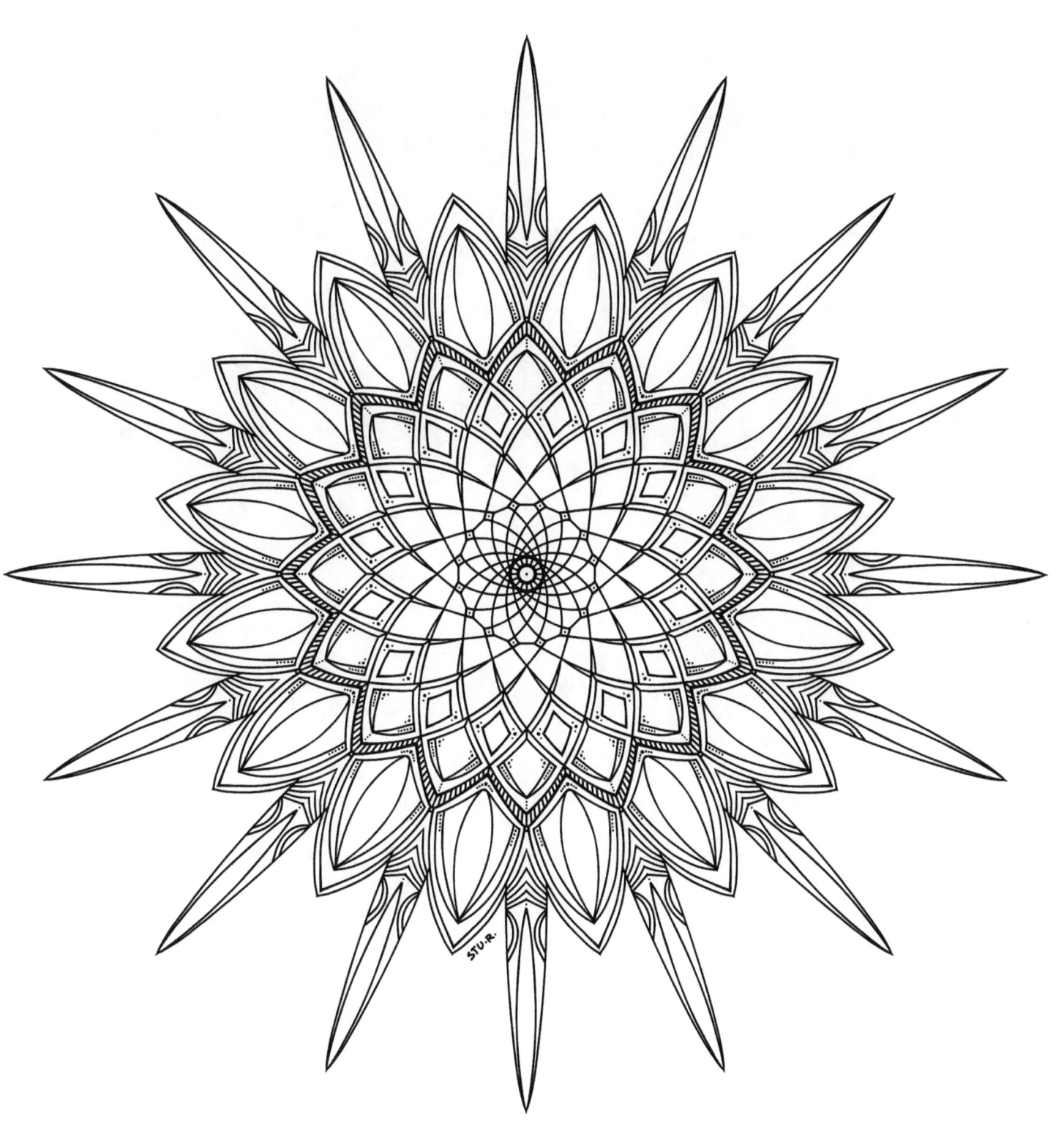

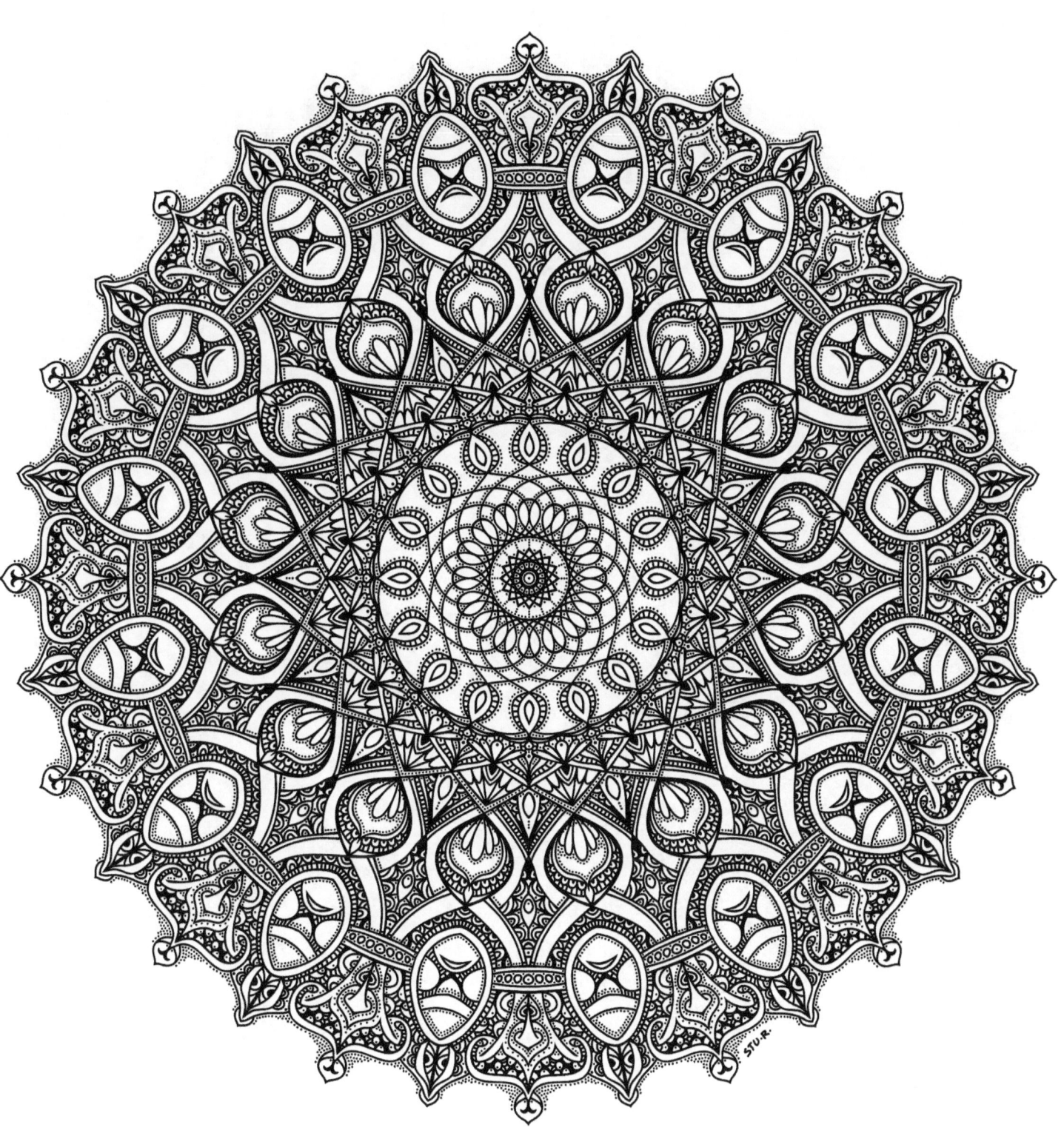

Next up:

Some Detail Zooms and Wallpapers,
for those who like full page stuff.

1

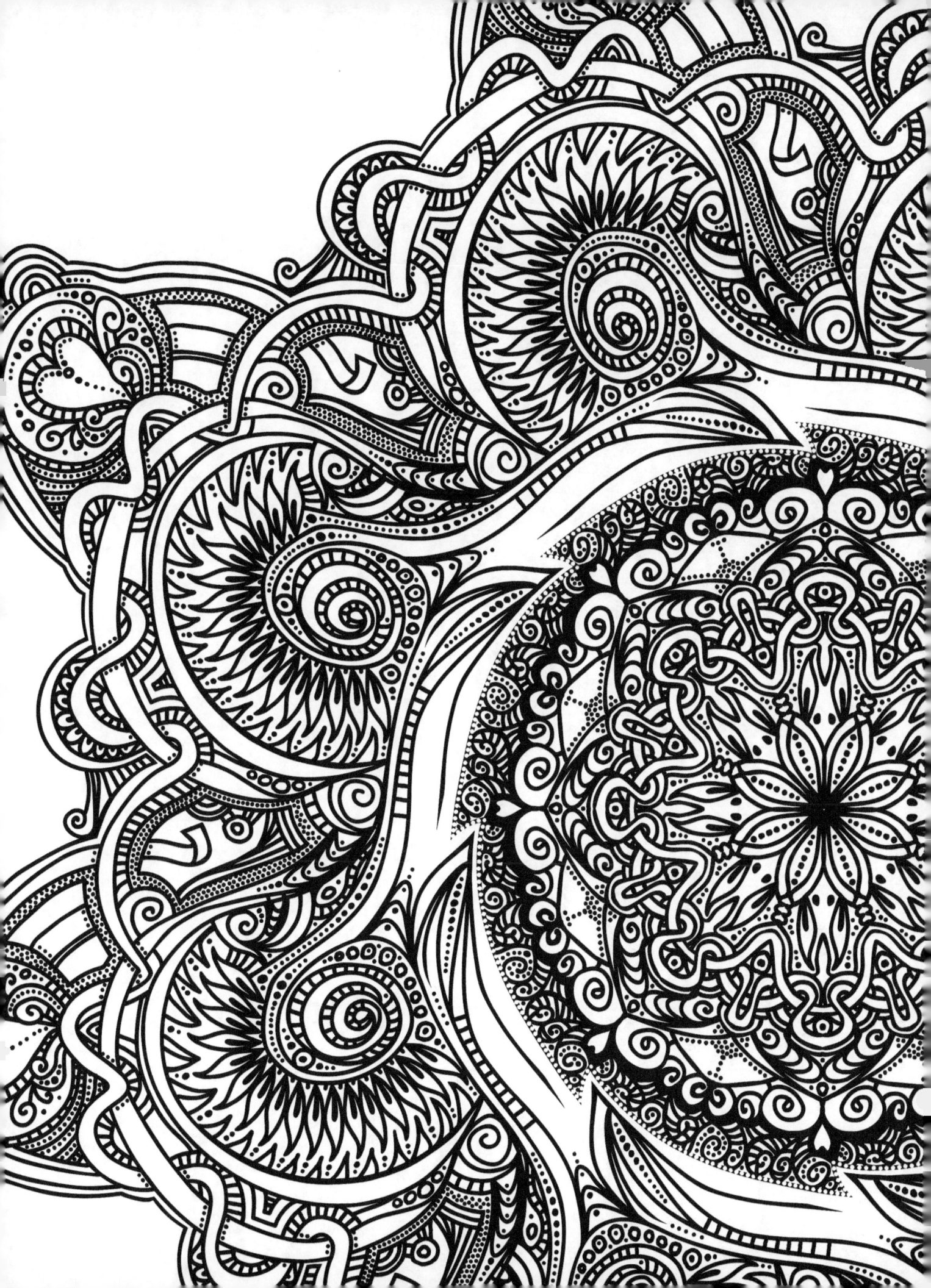

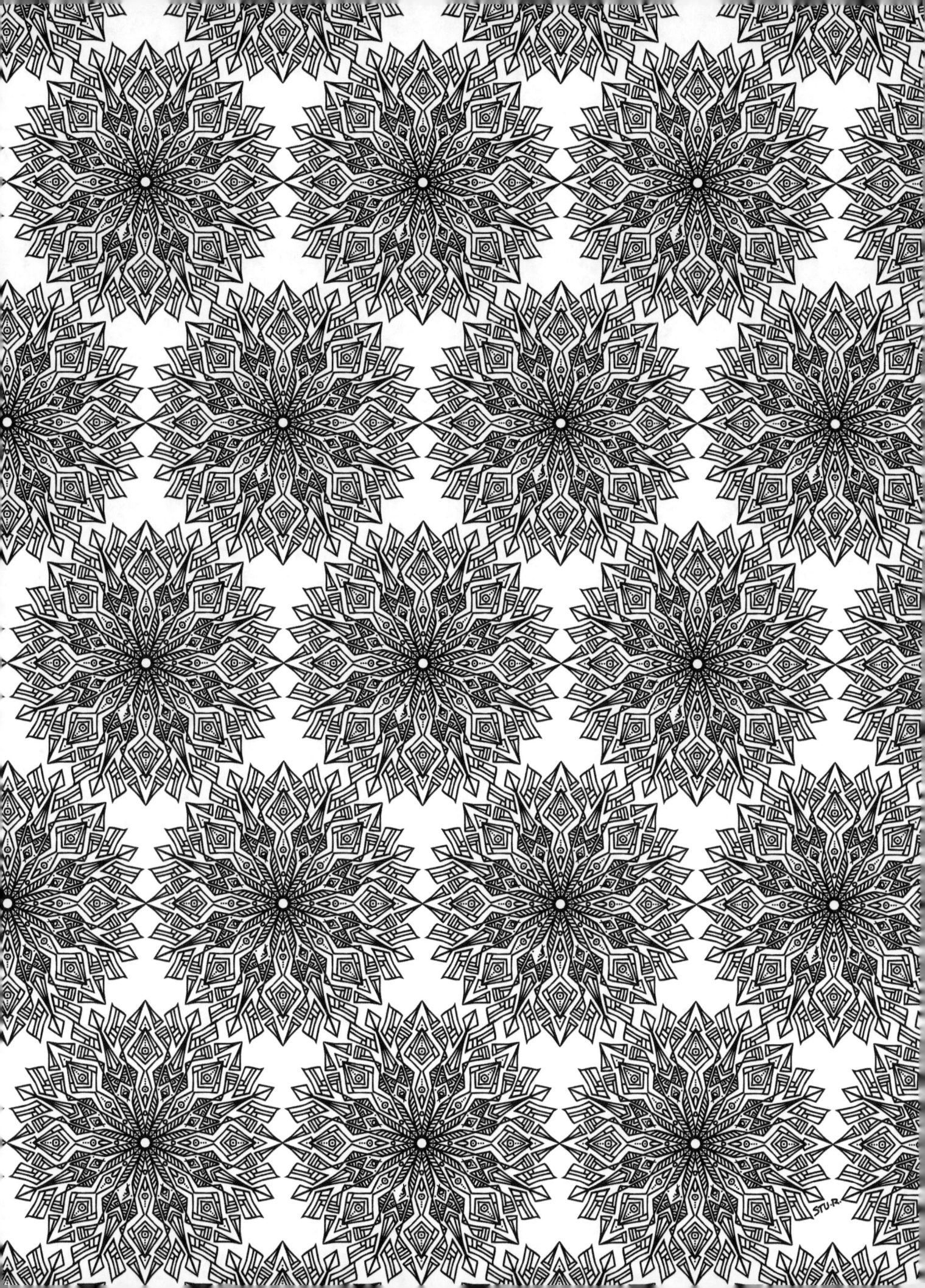

1

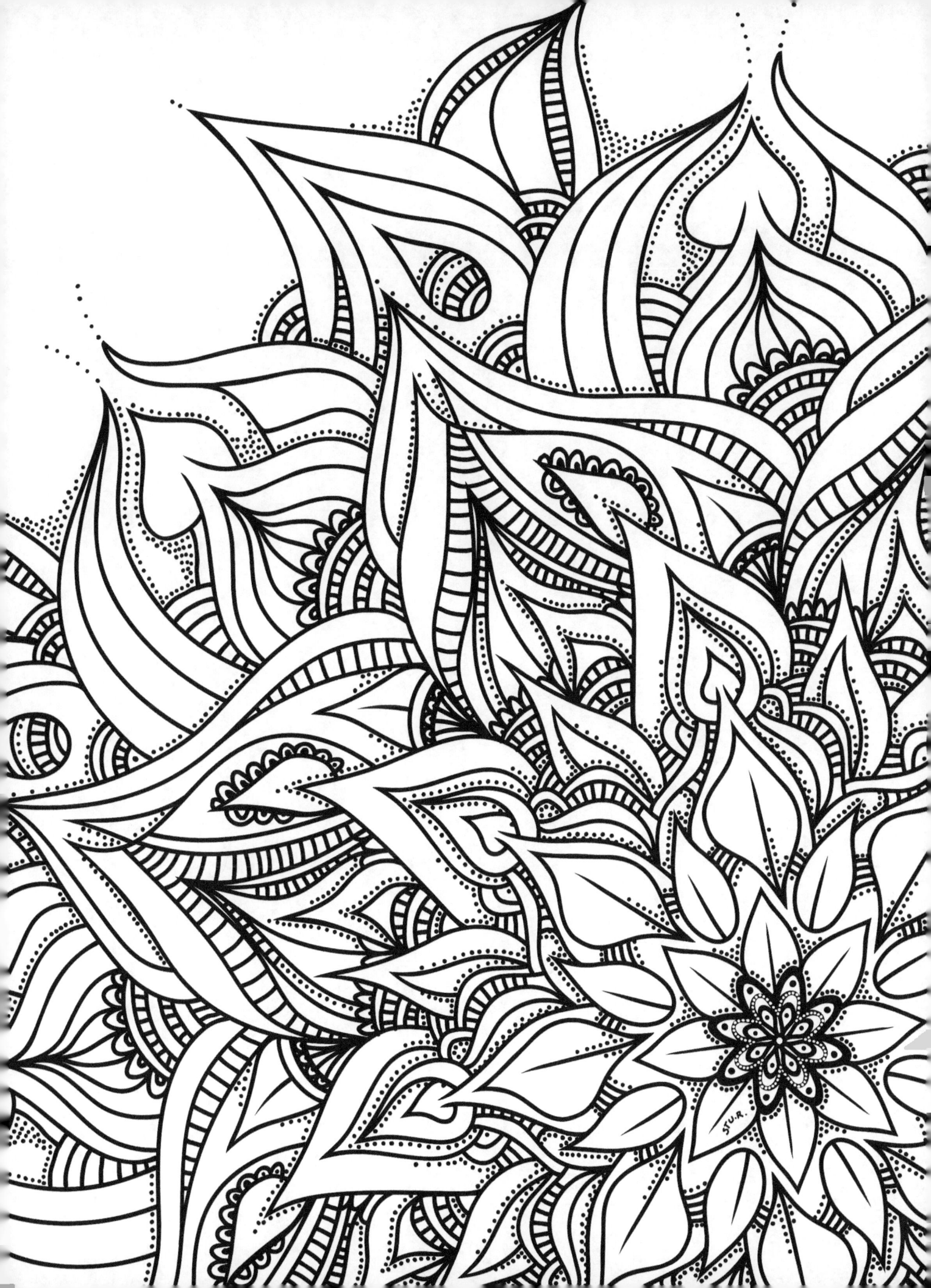

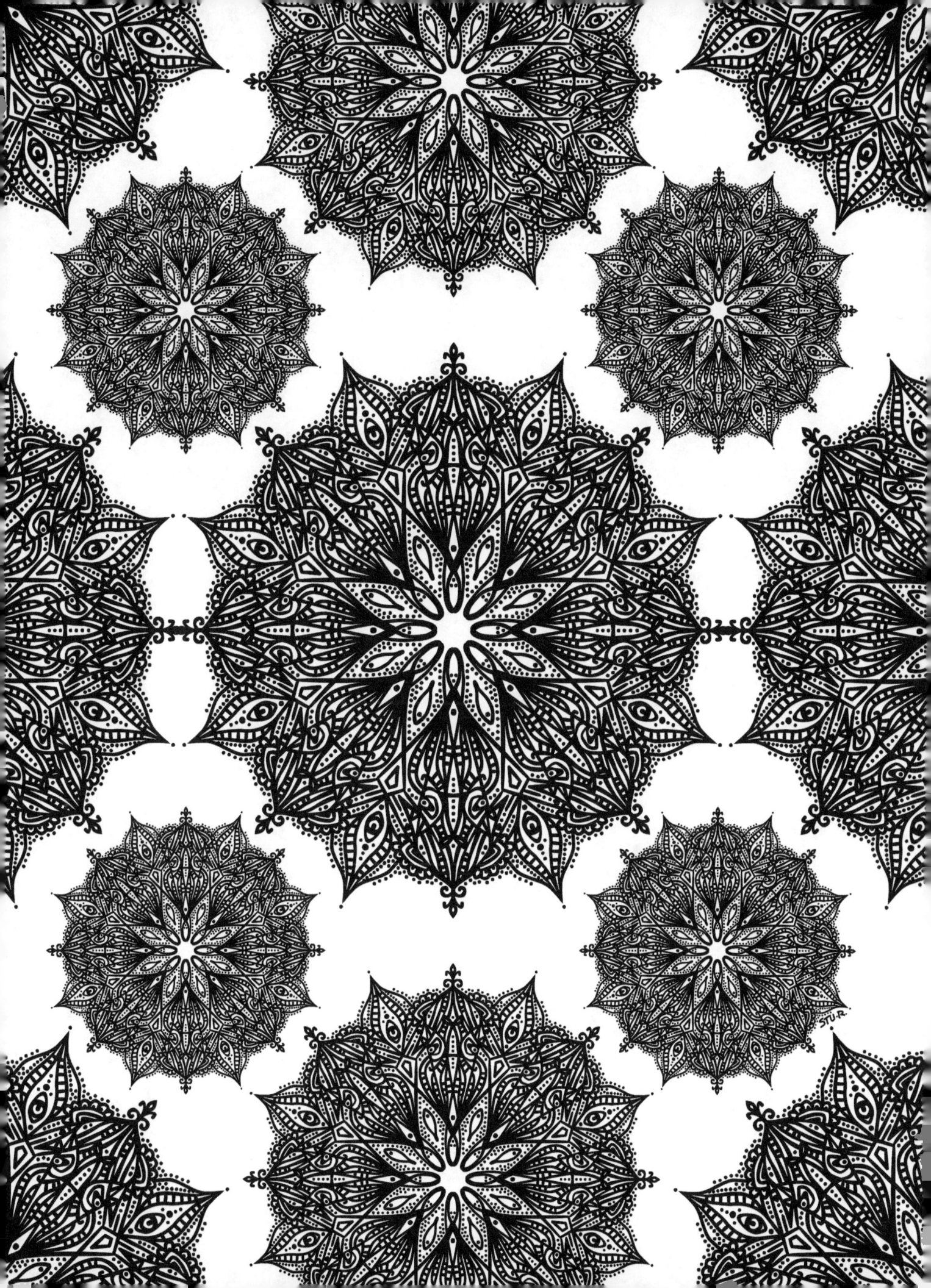

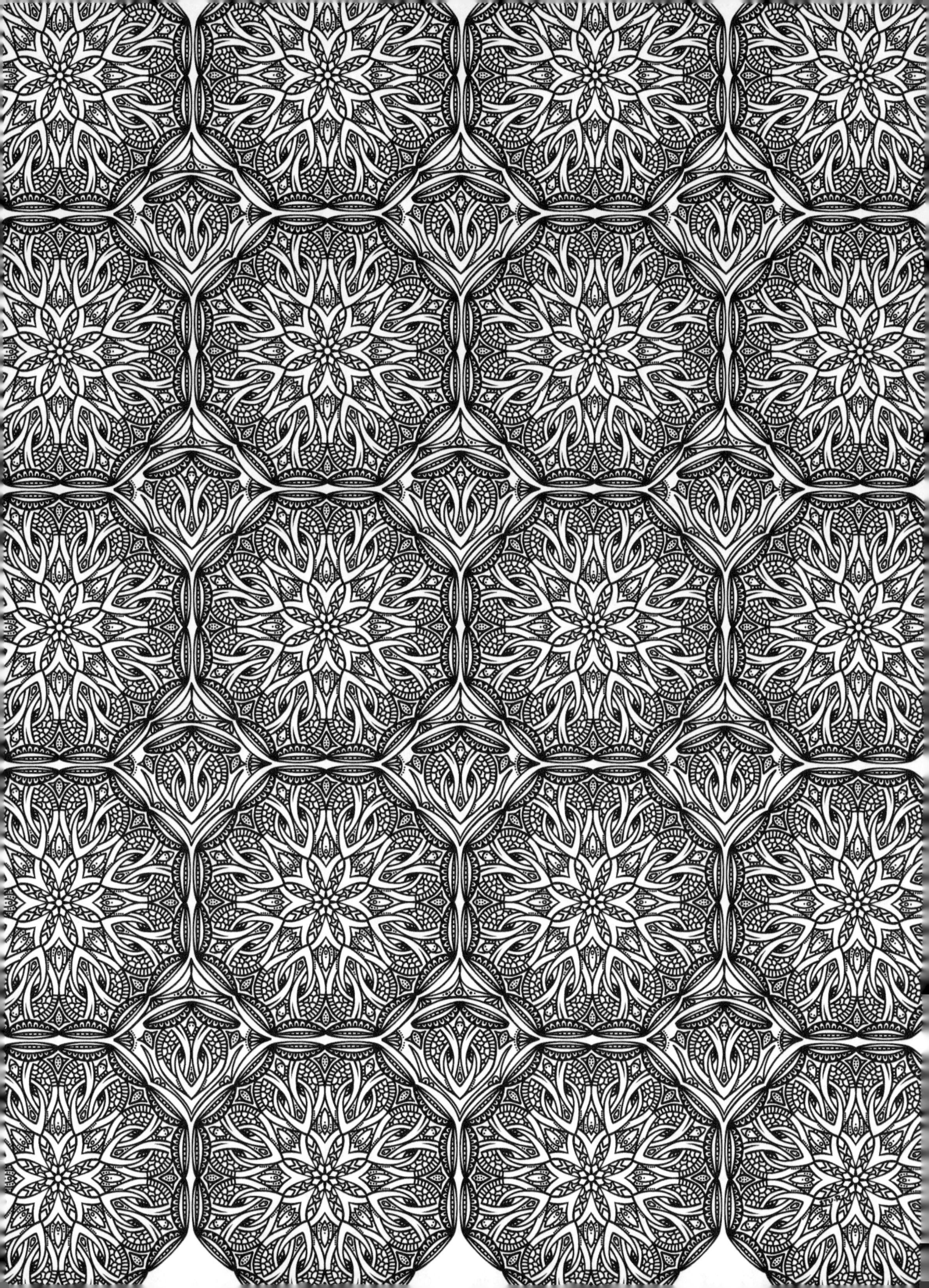

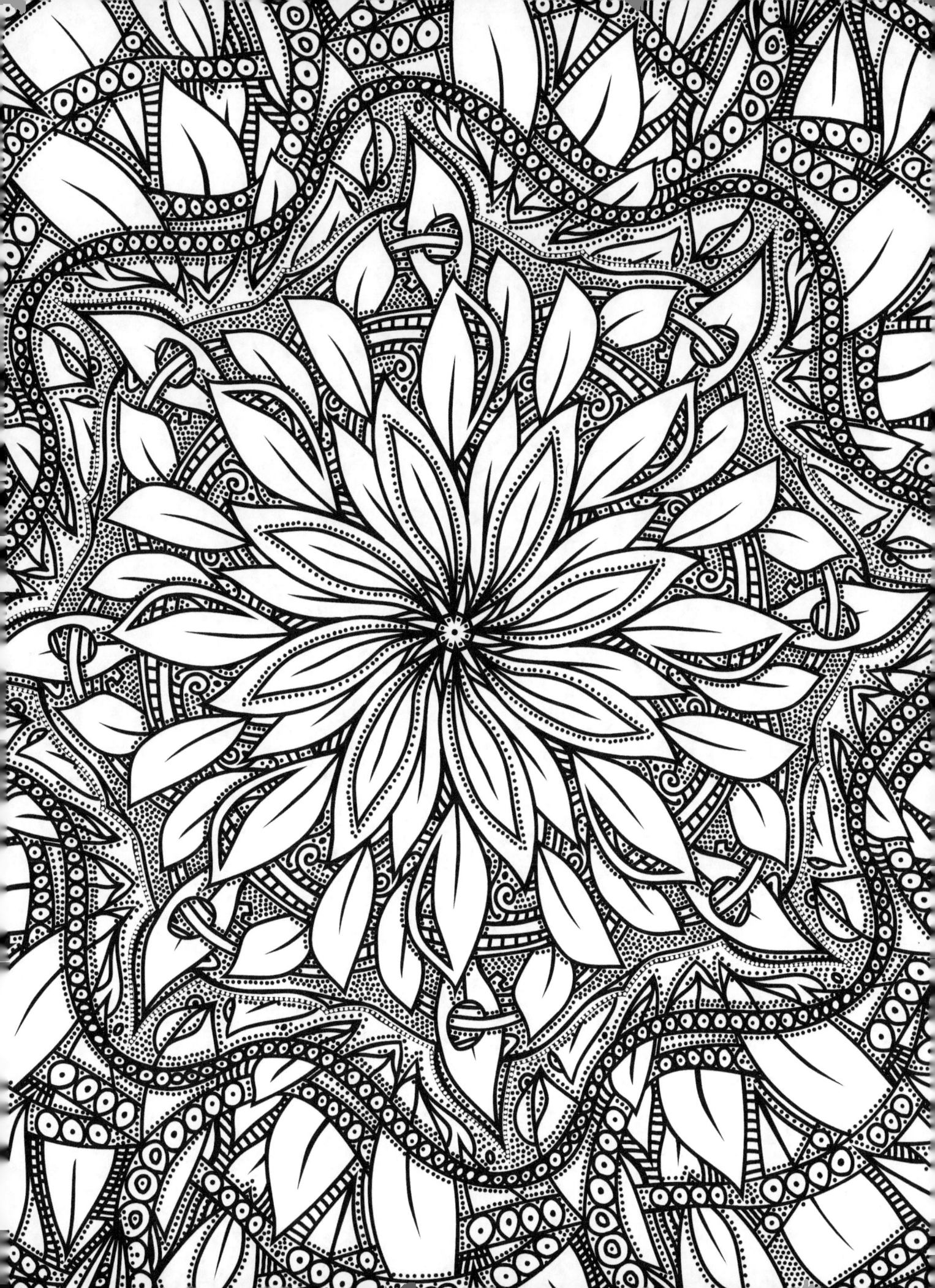

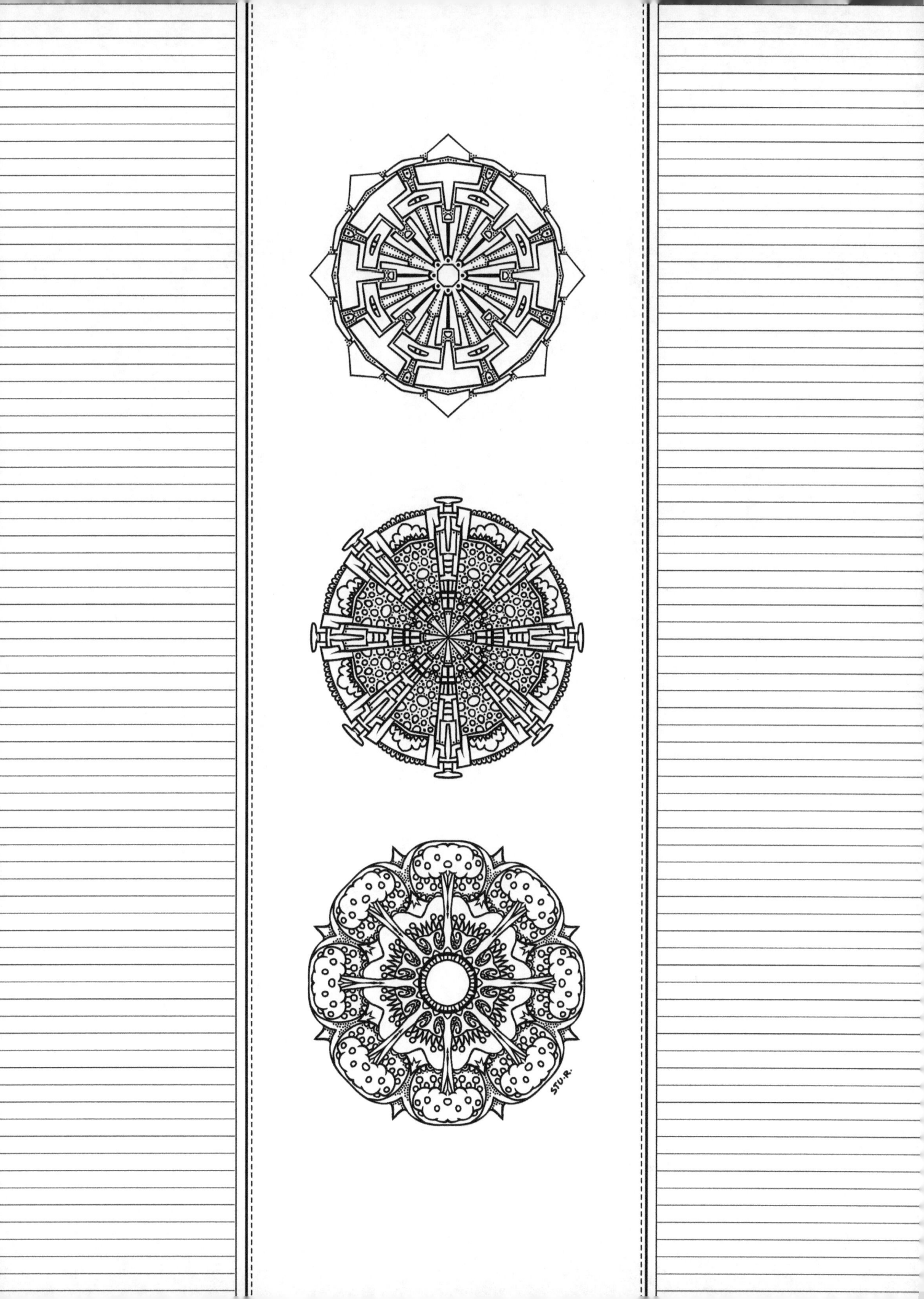

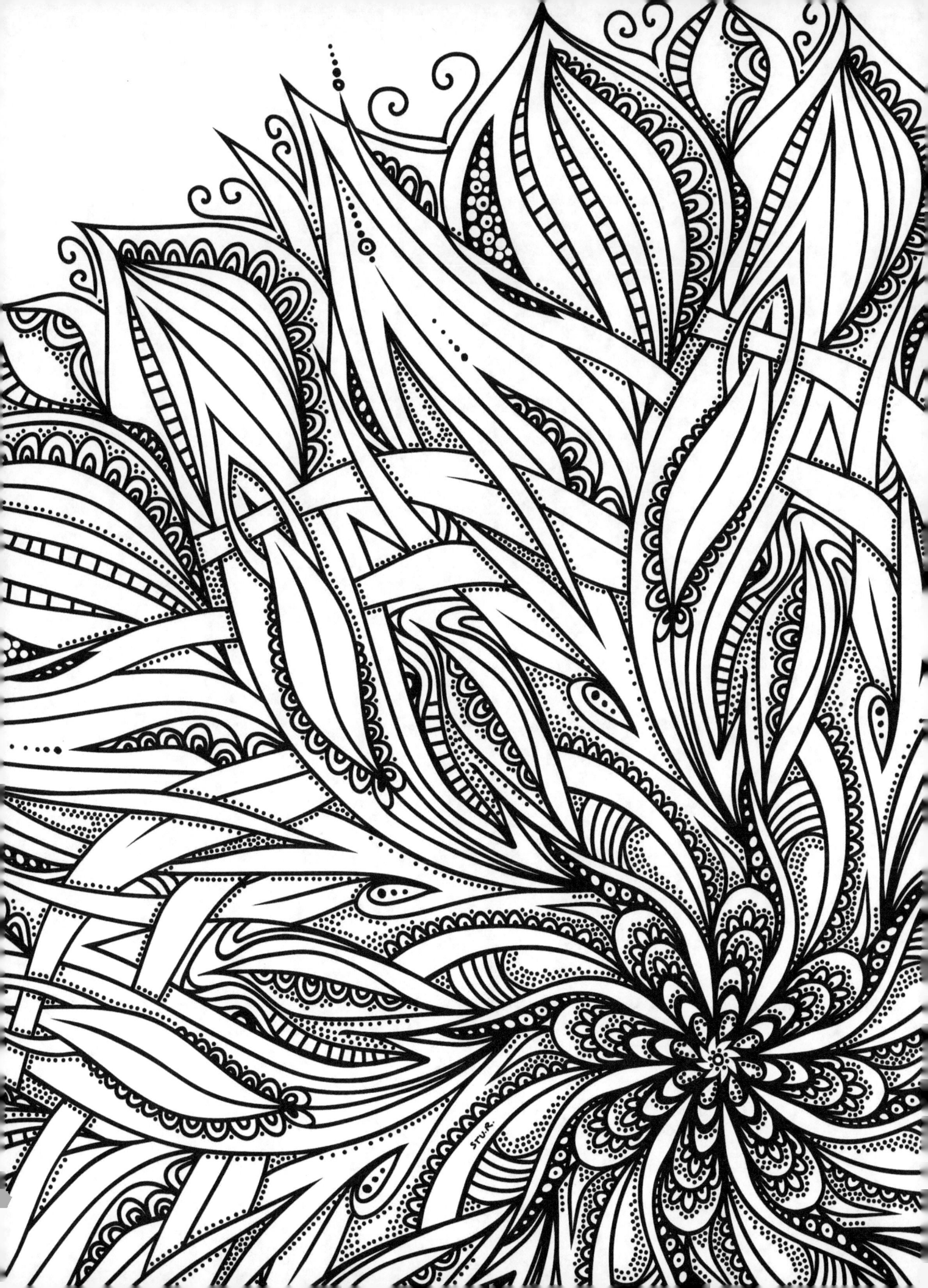

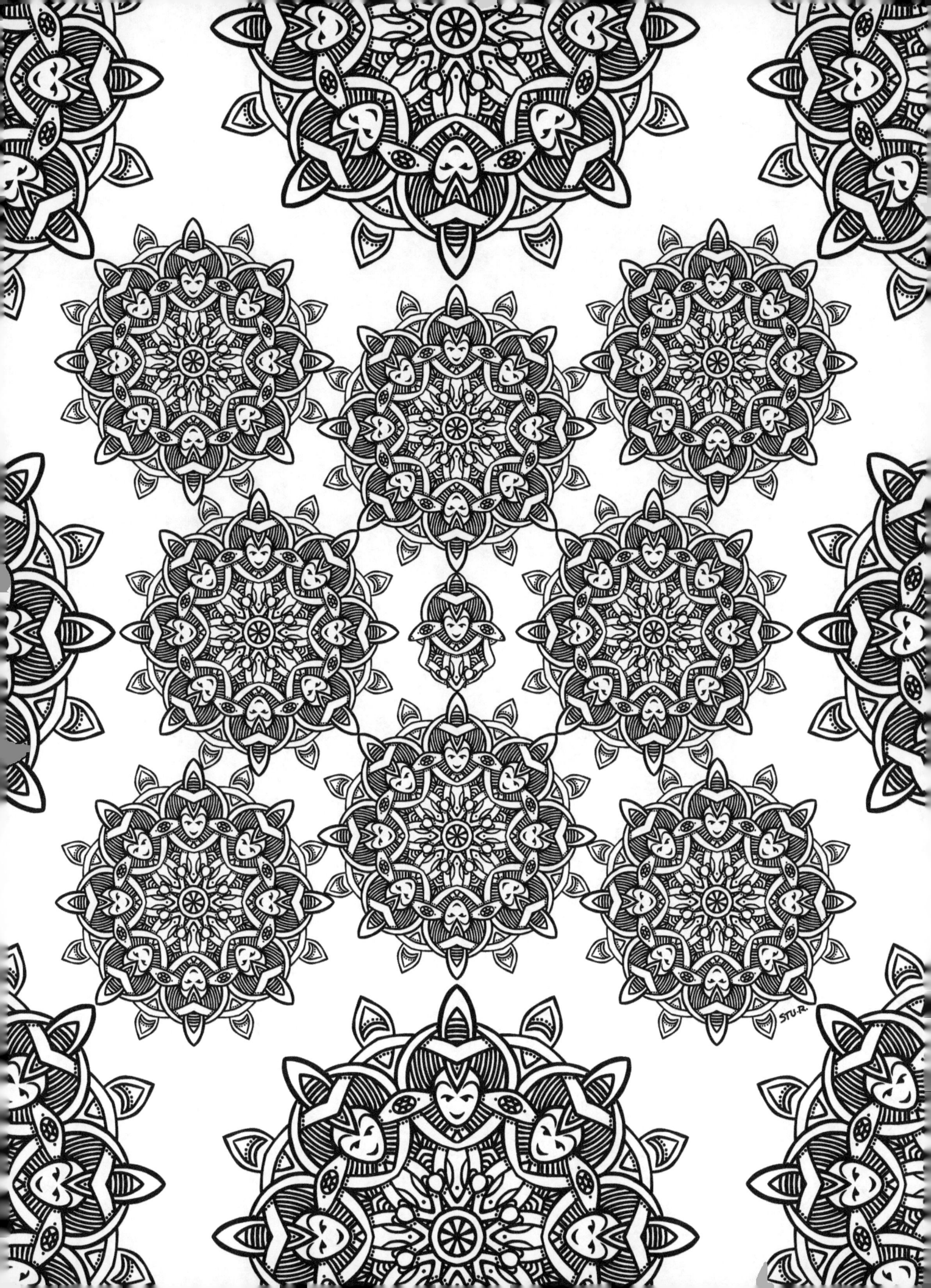

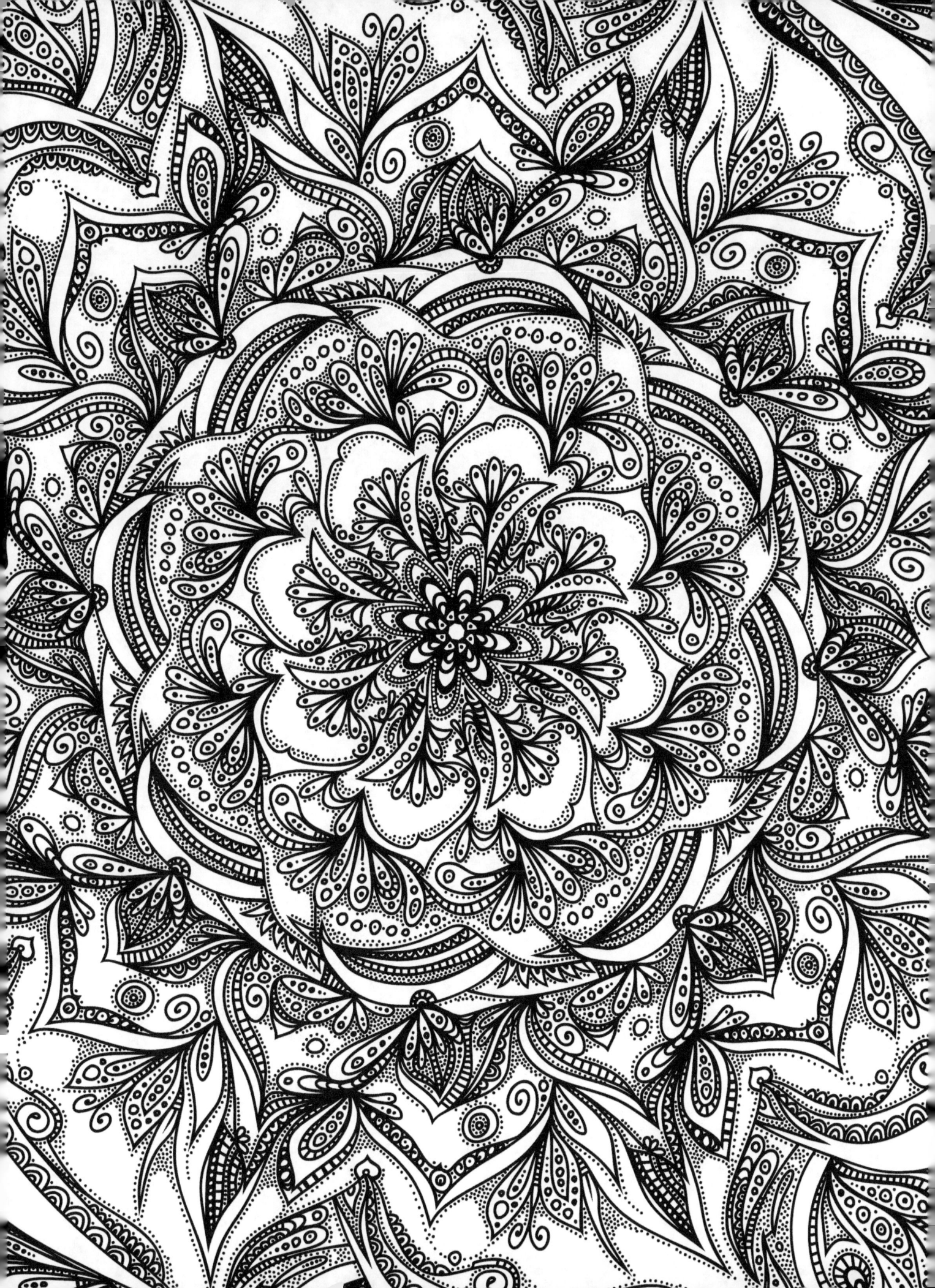

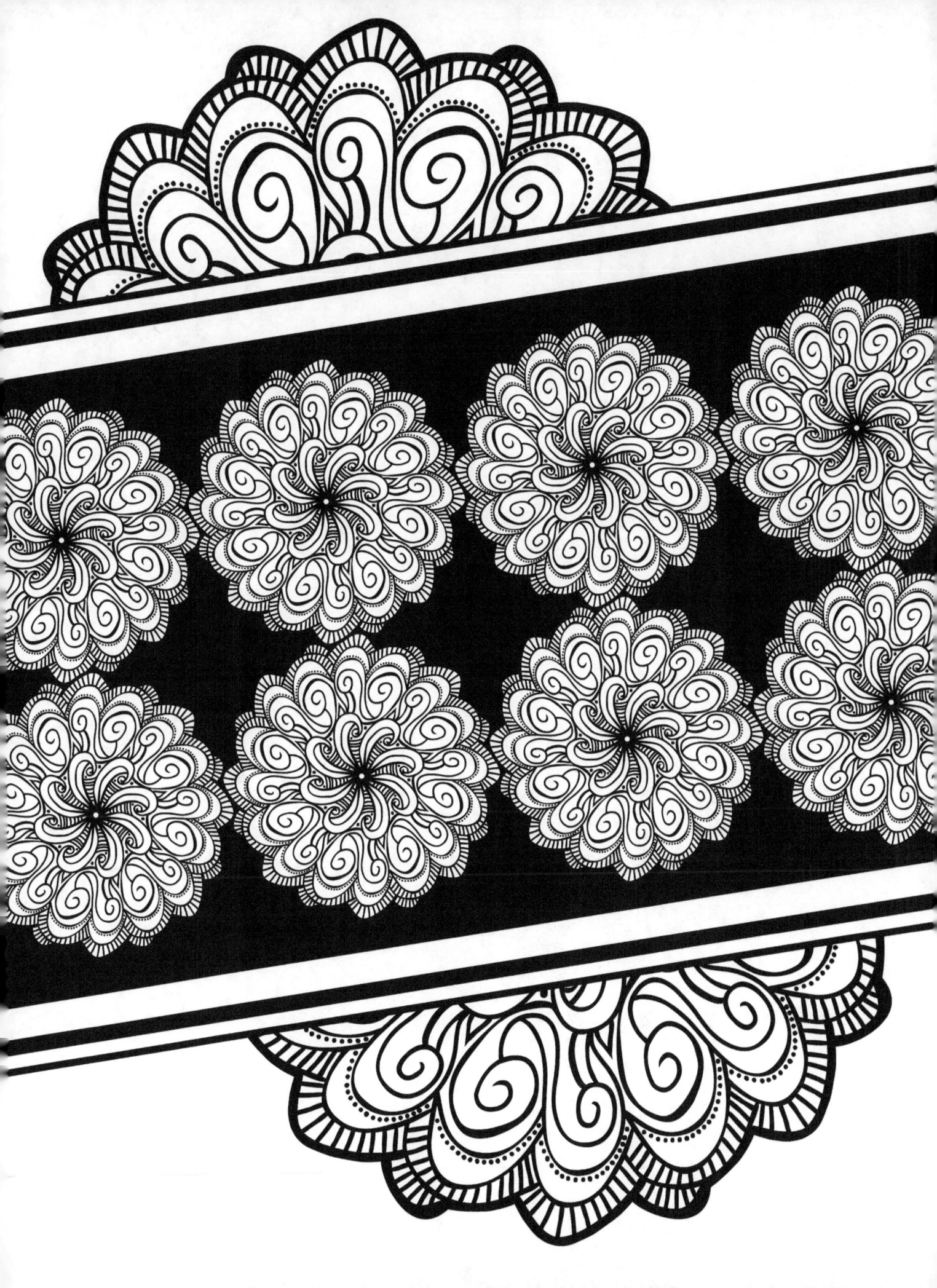

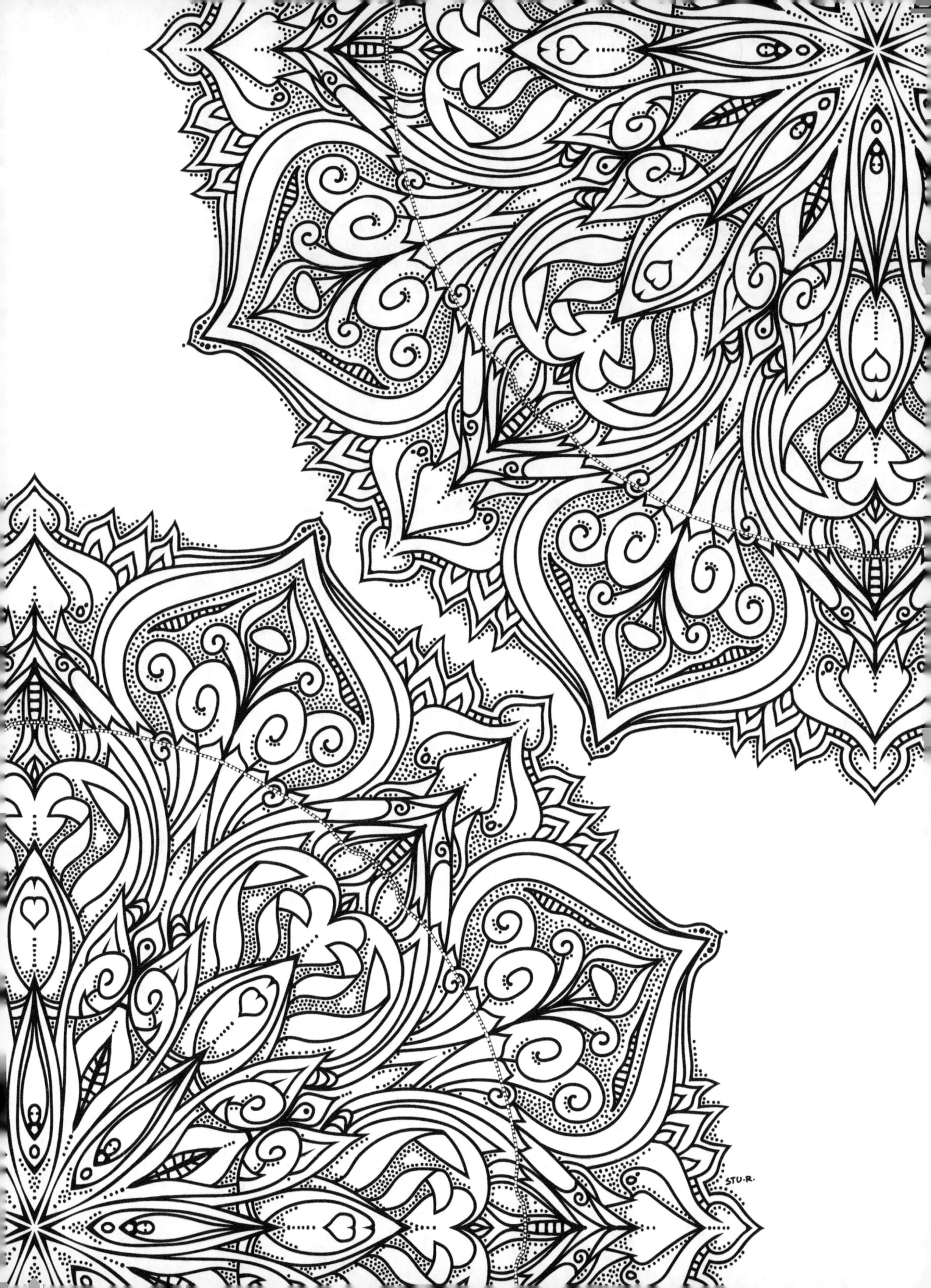

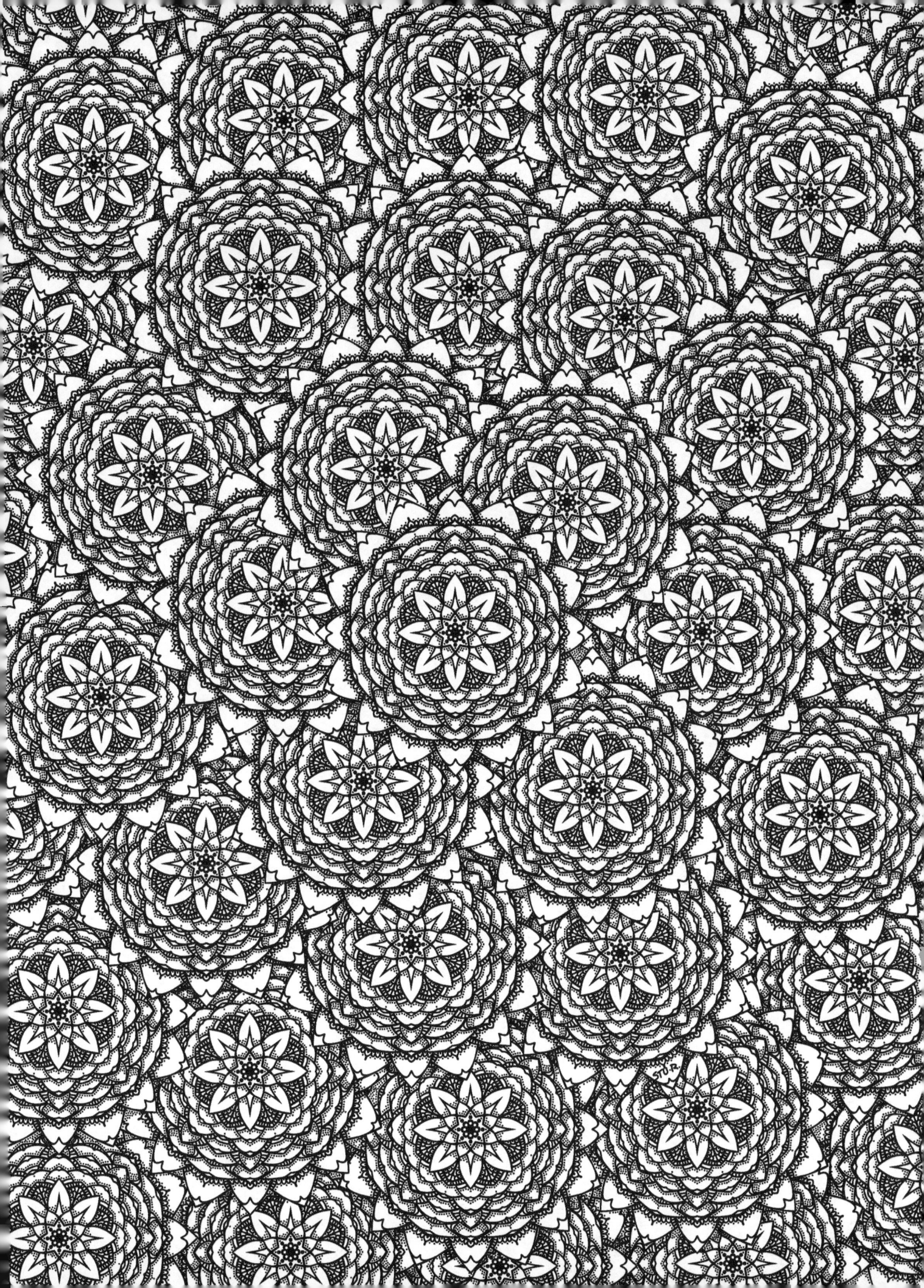

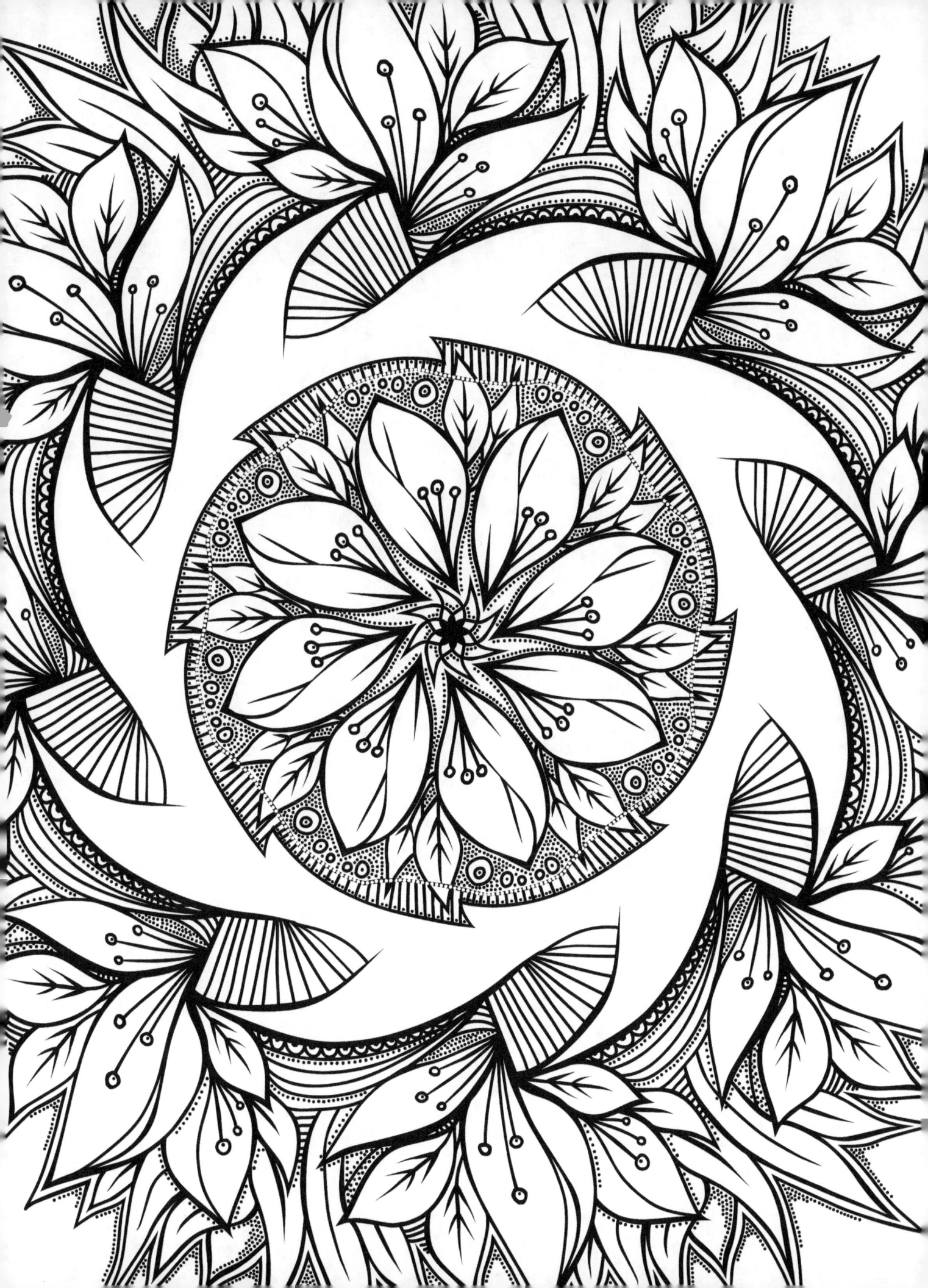

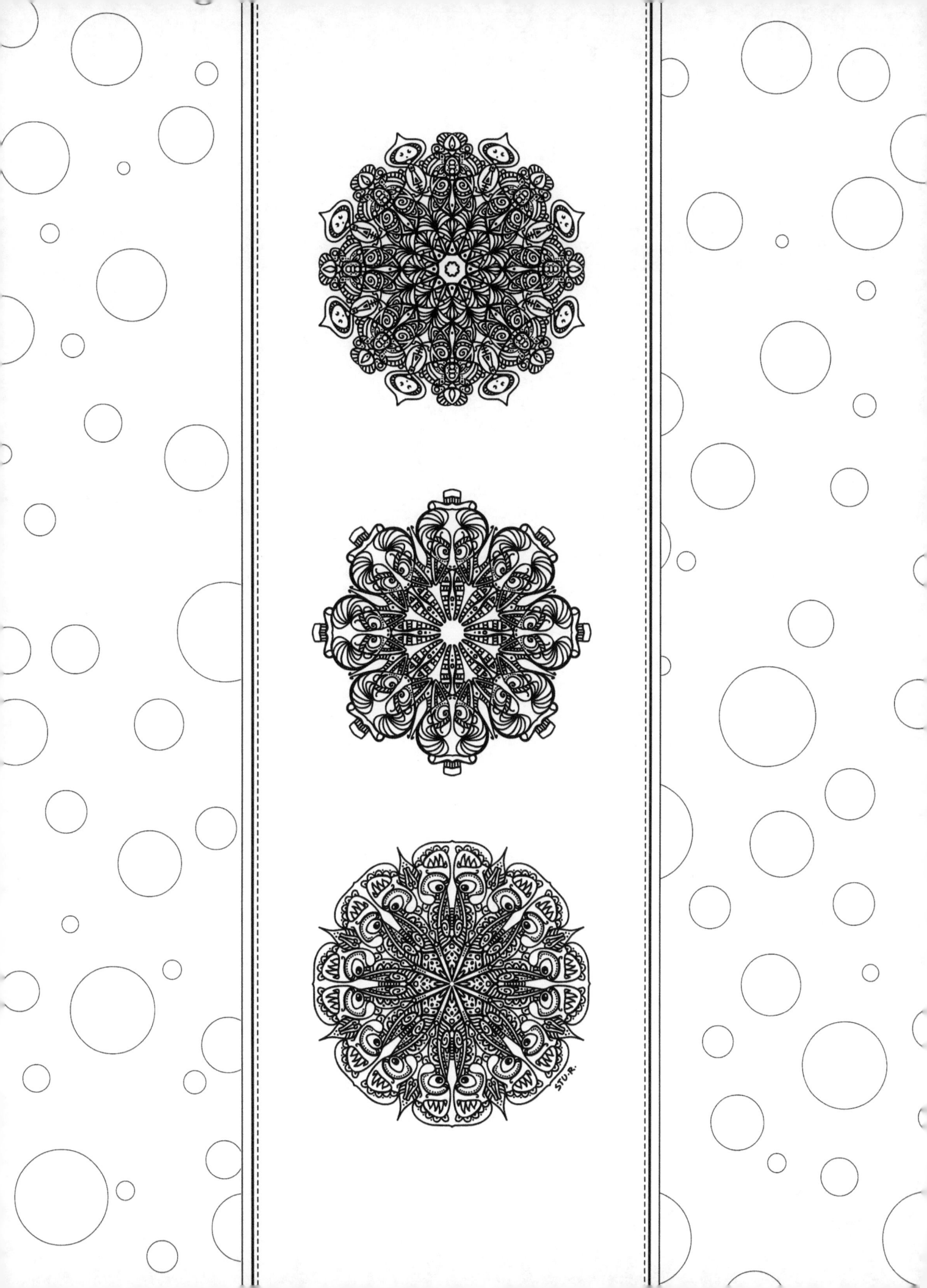

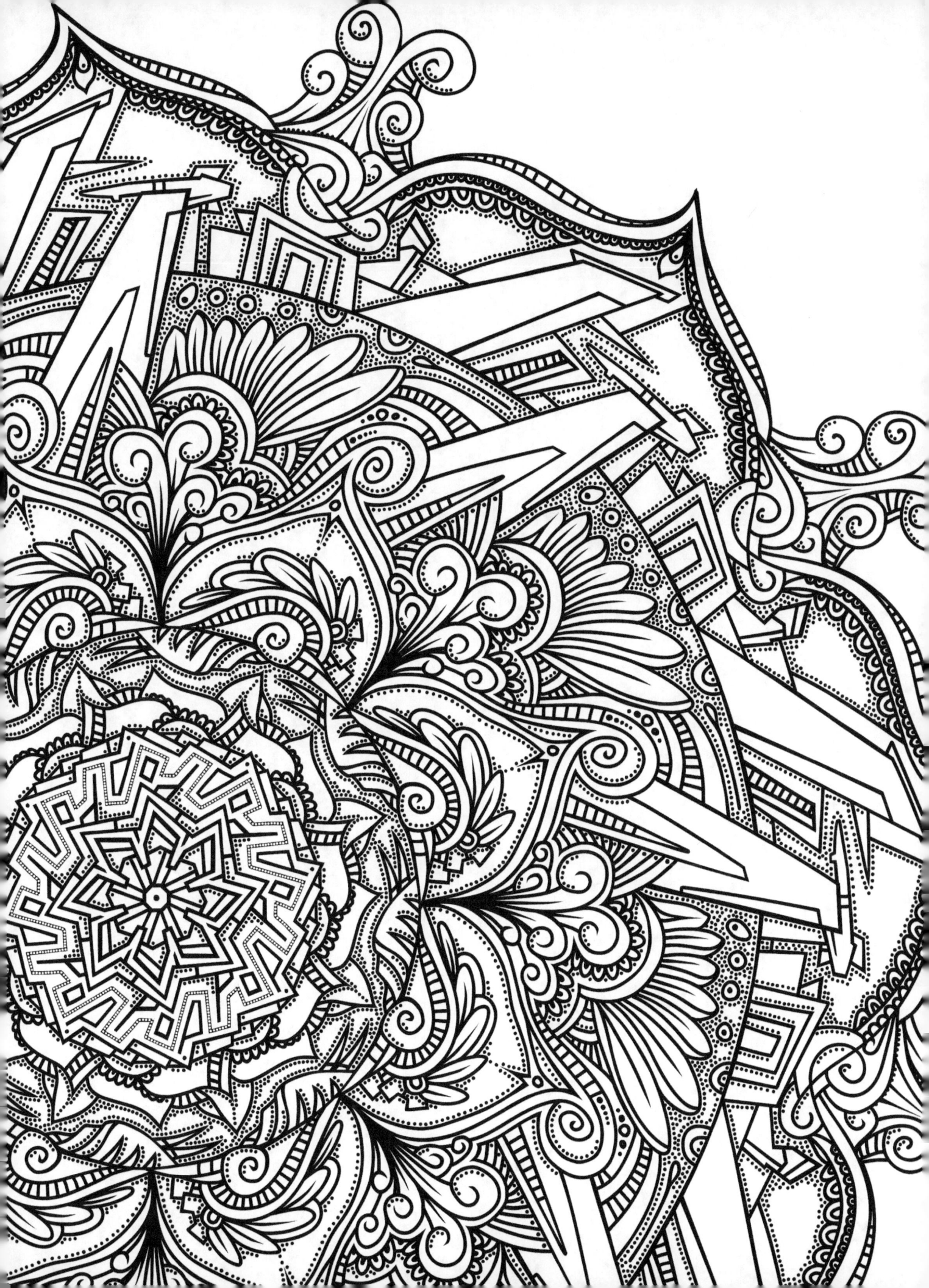

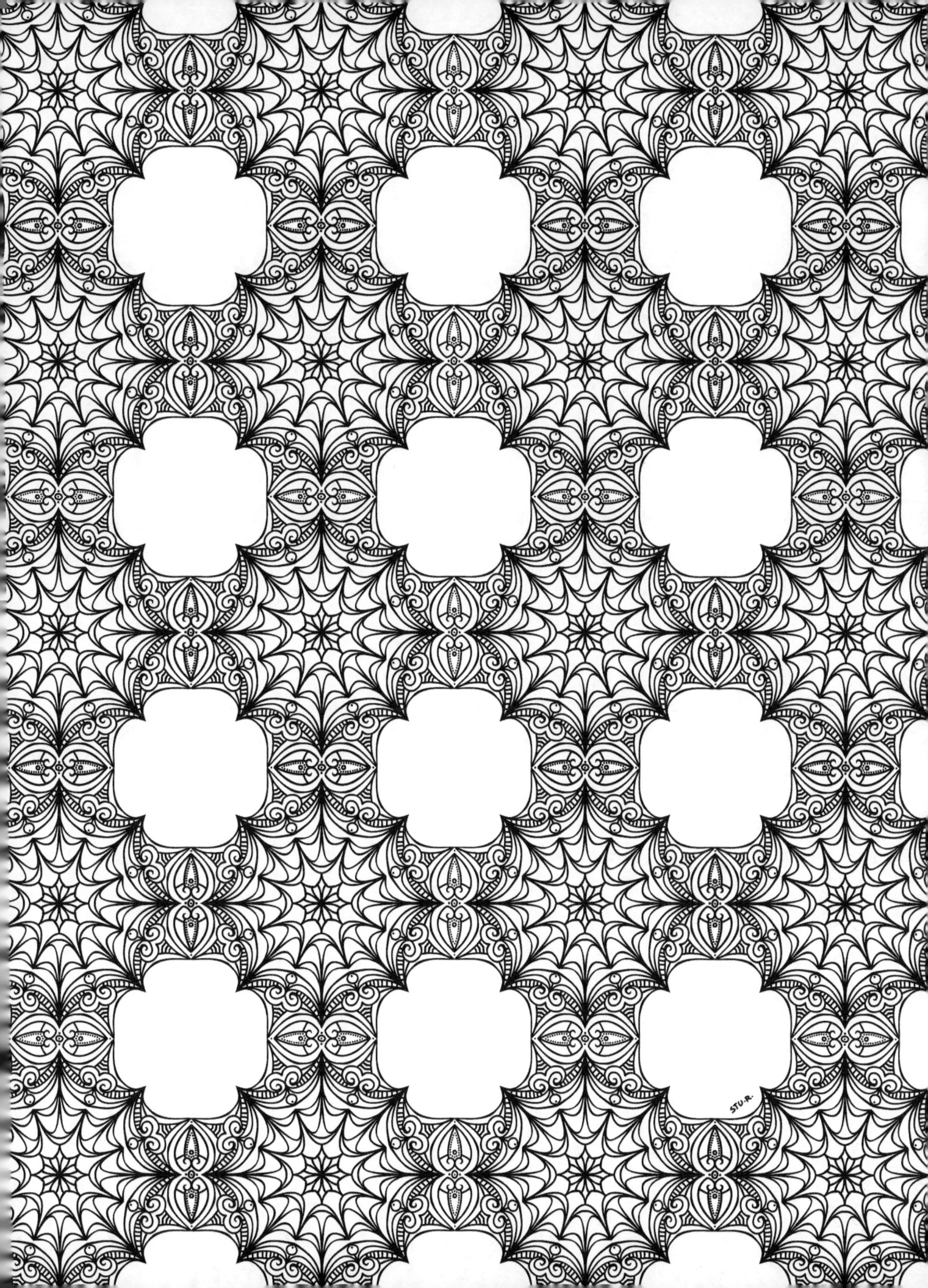

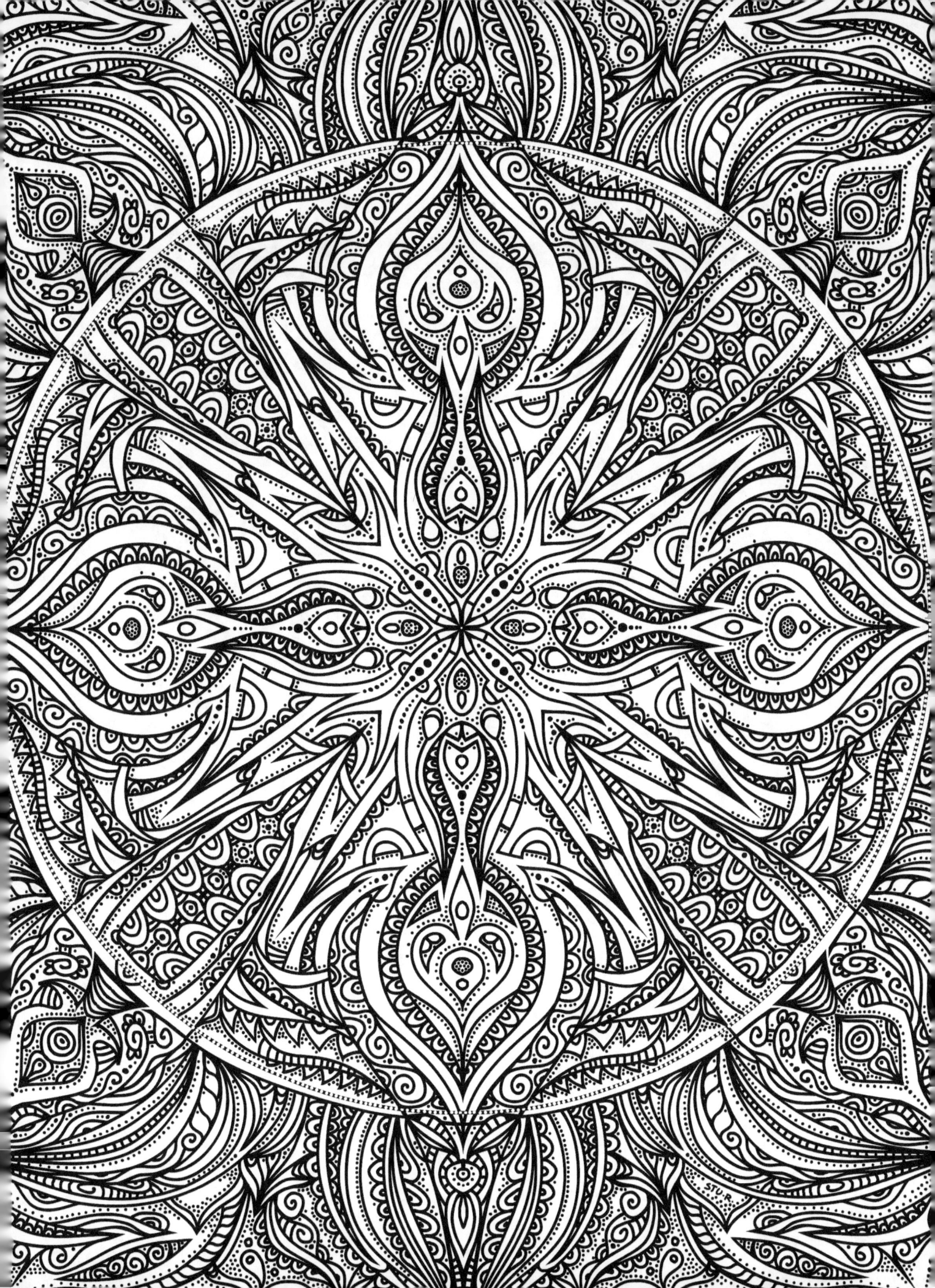

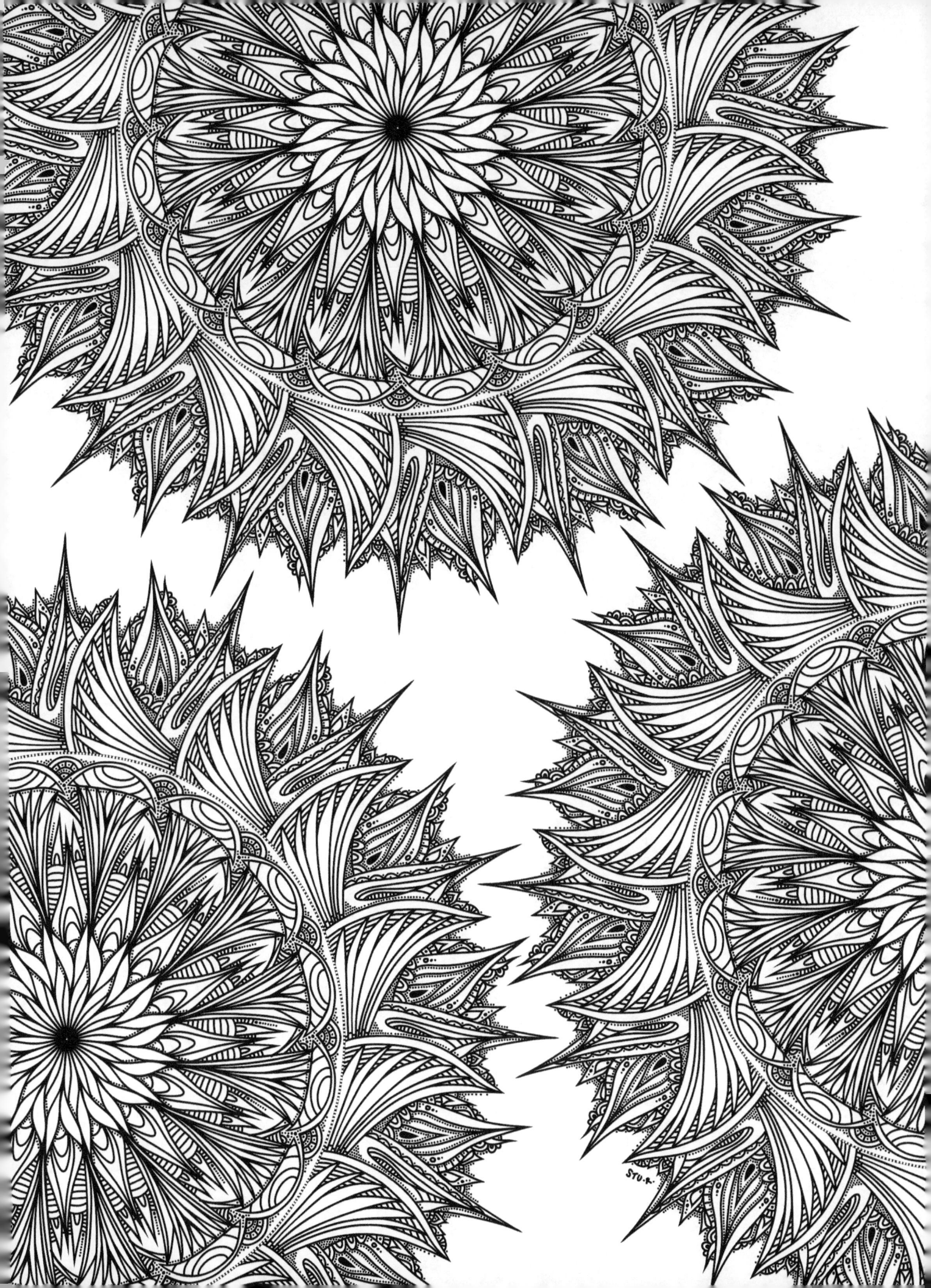

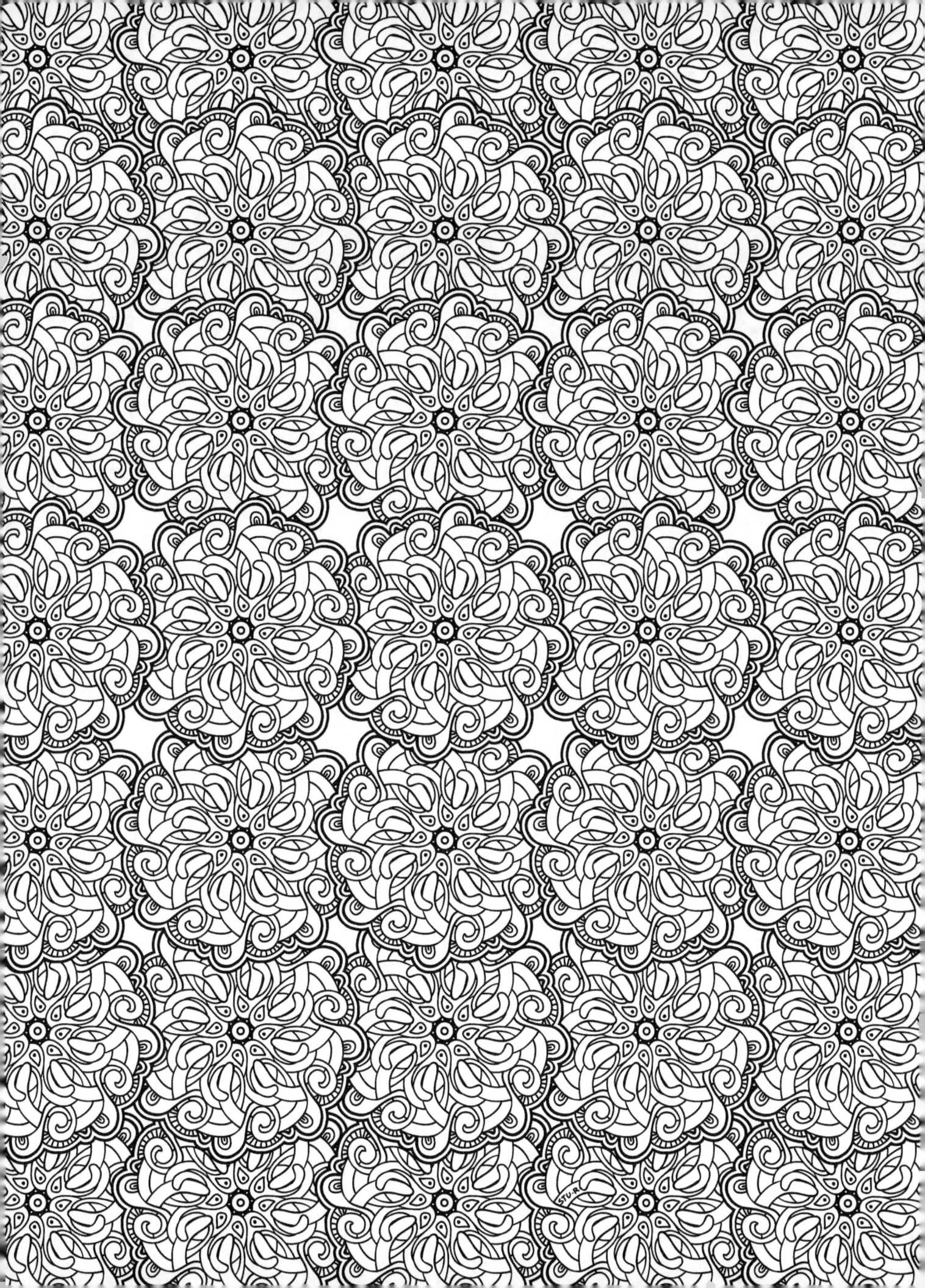

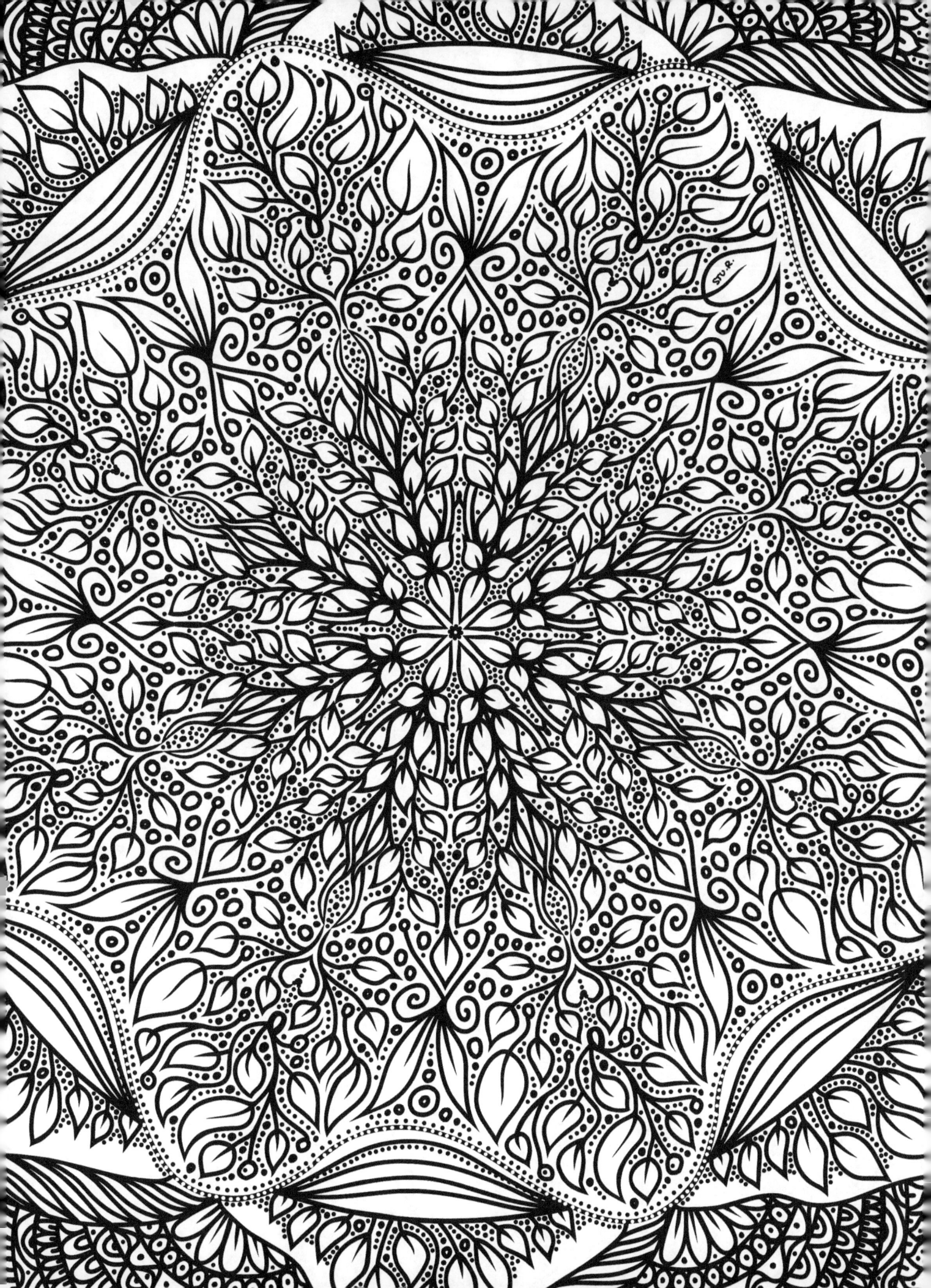

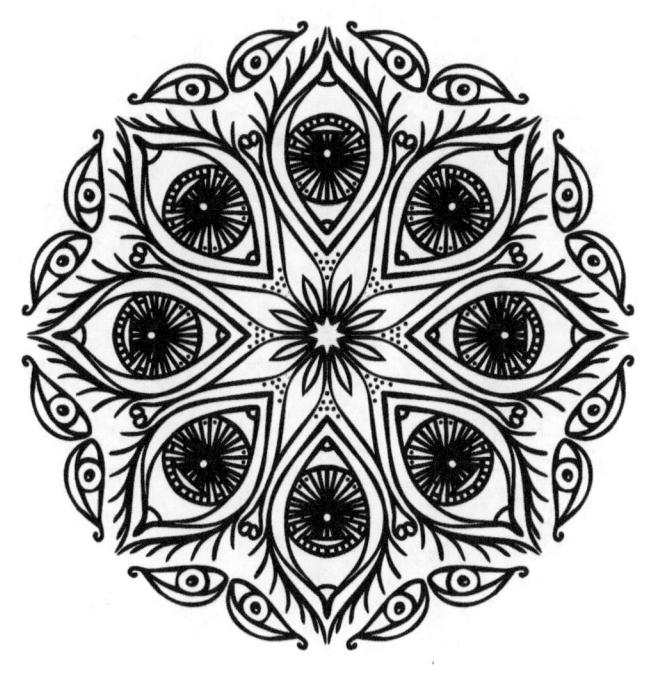
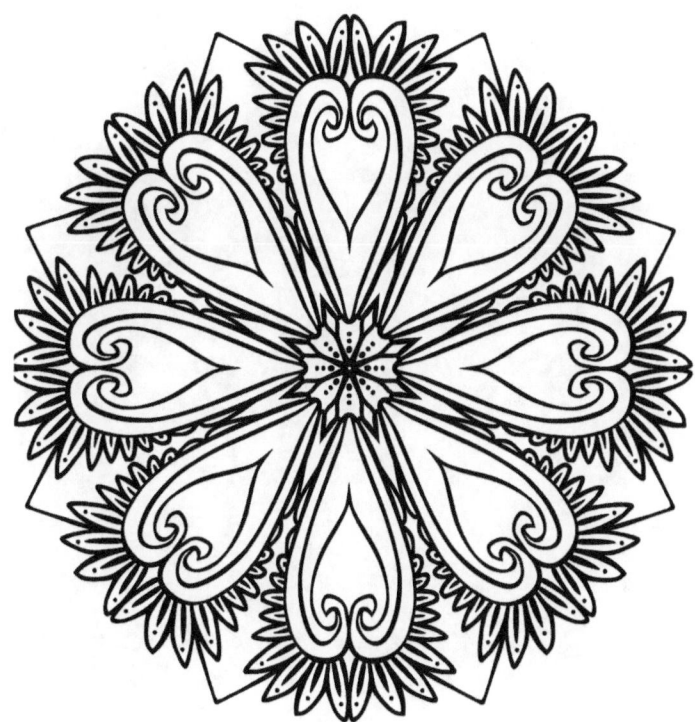
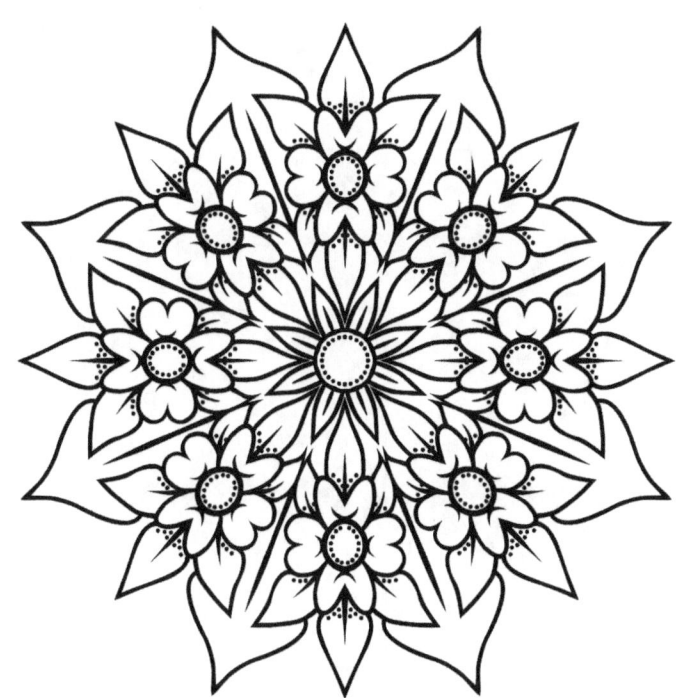
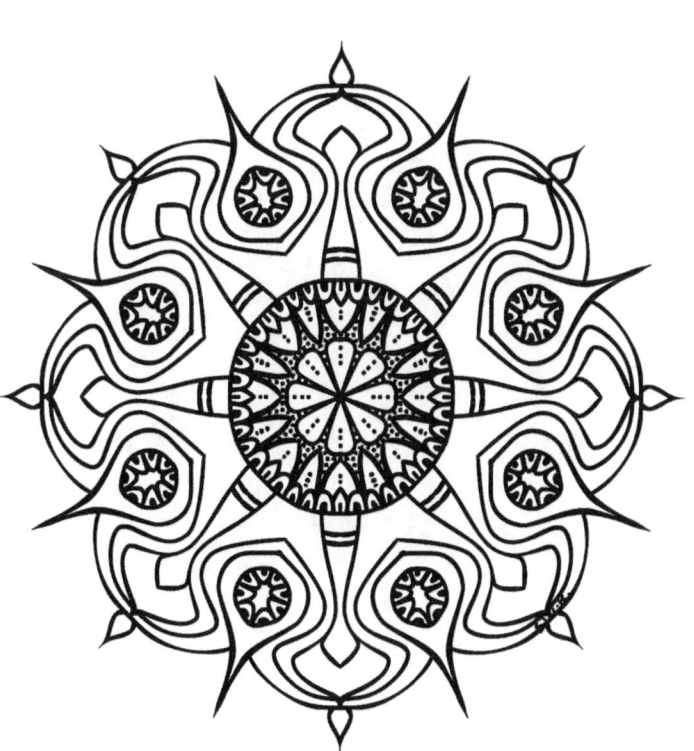

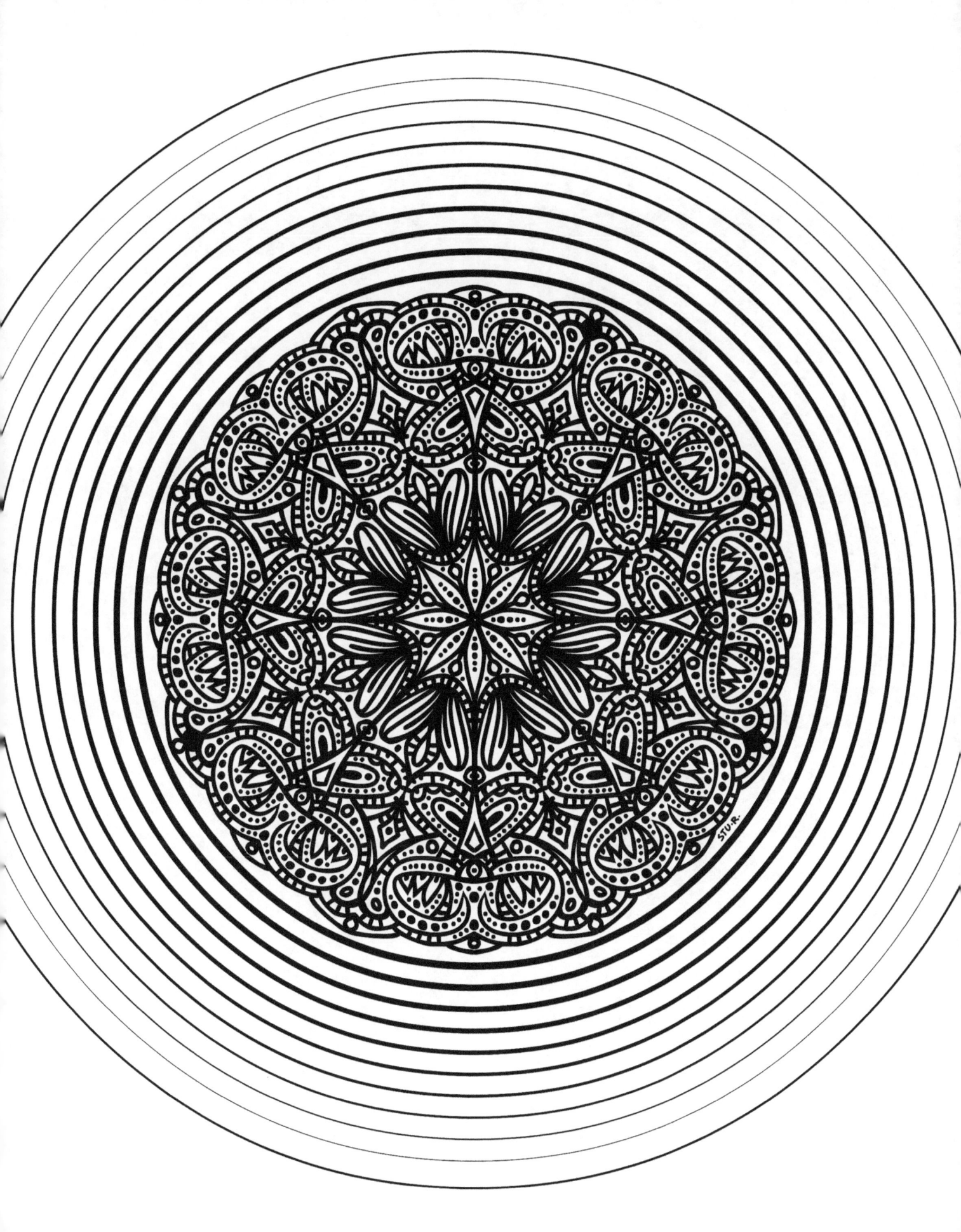

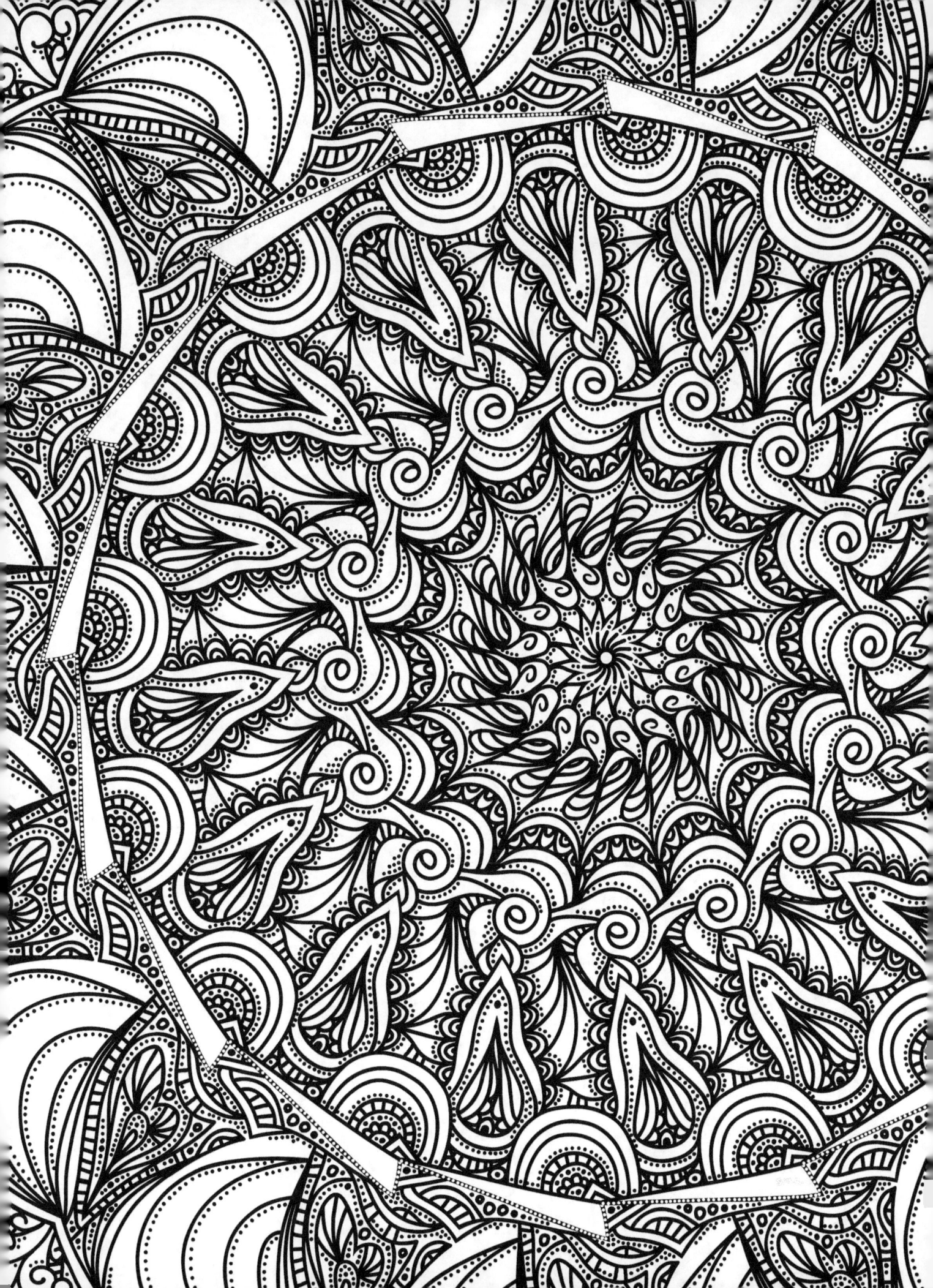

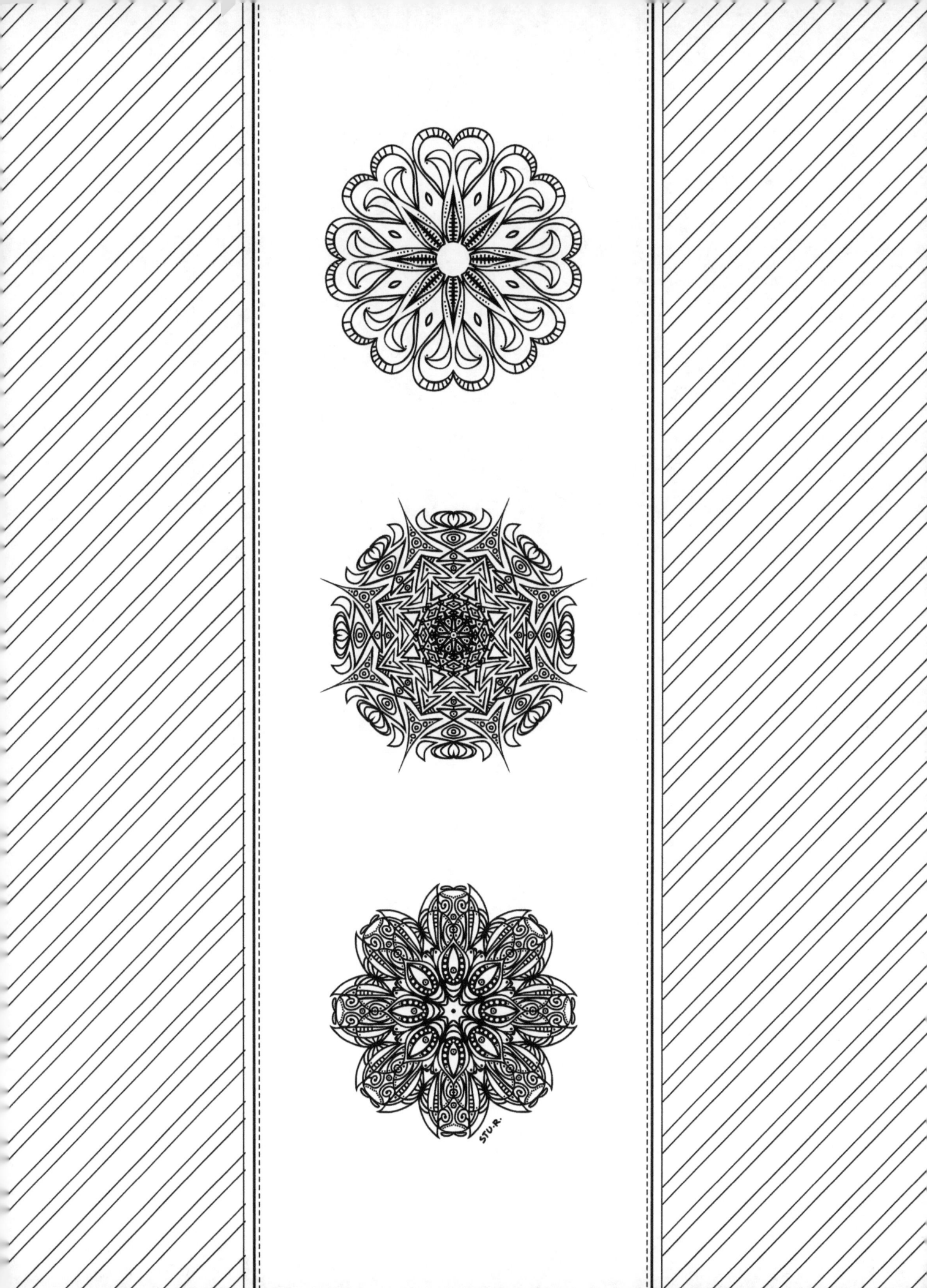

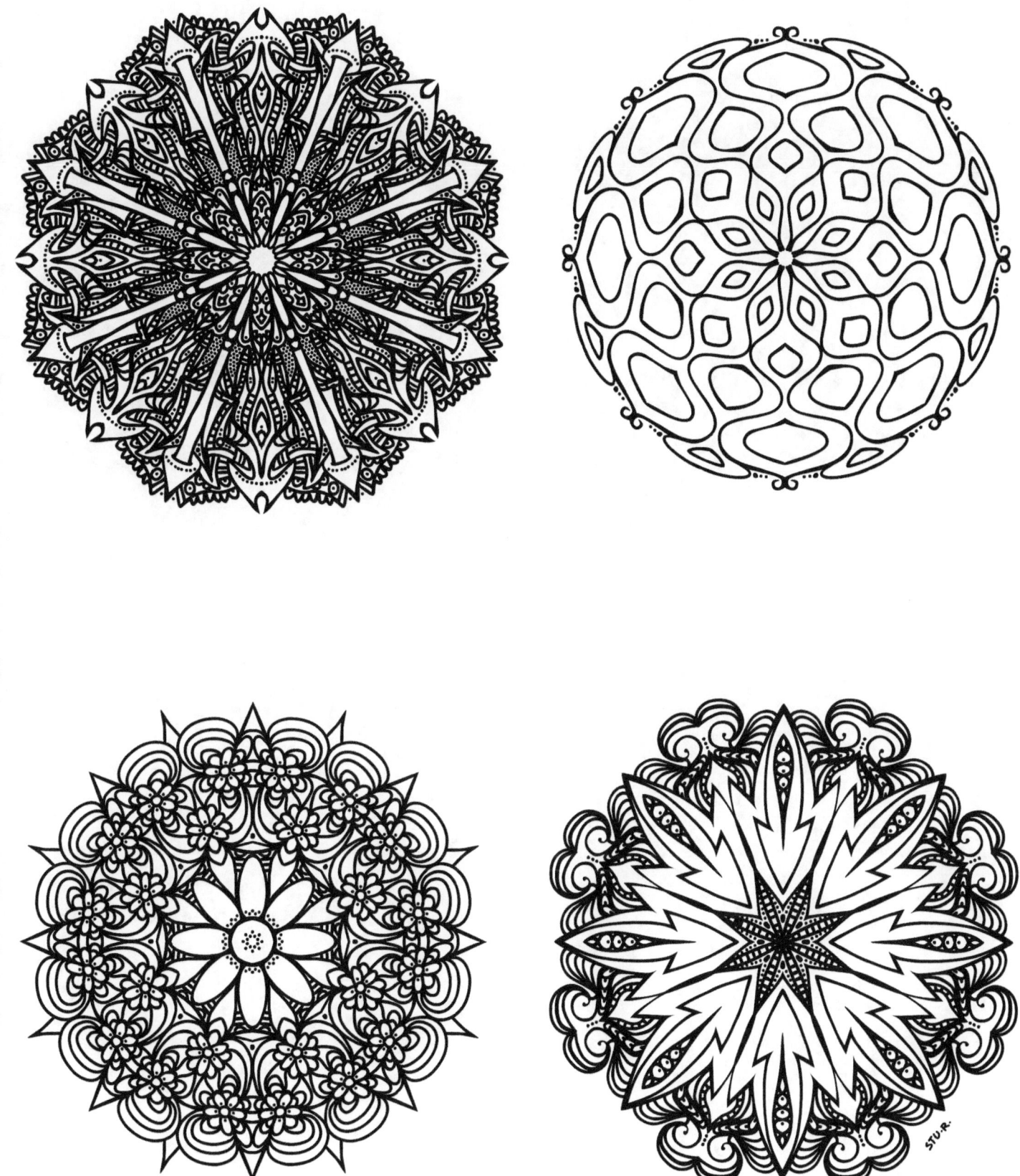

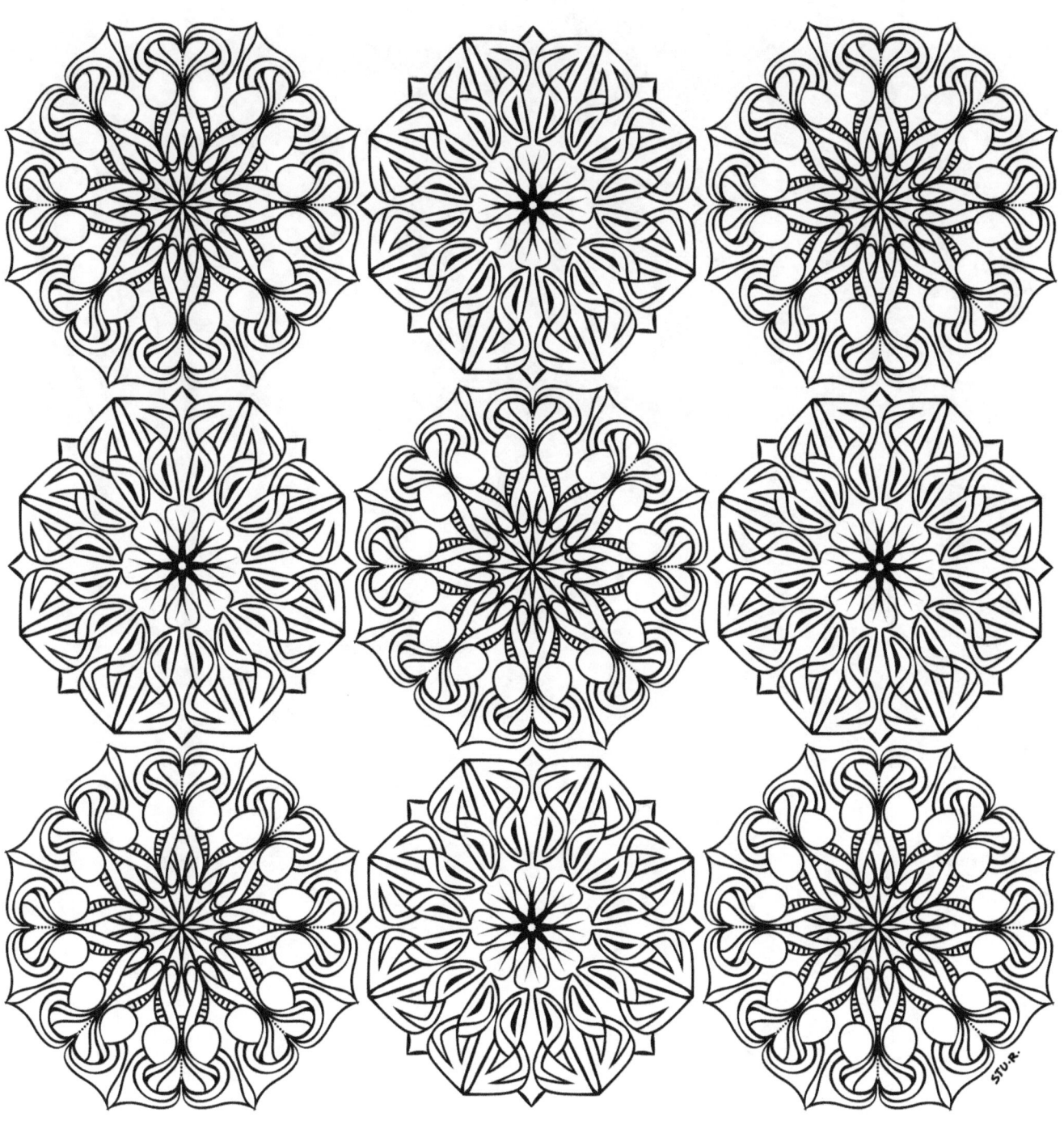

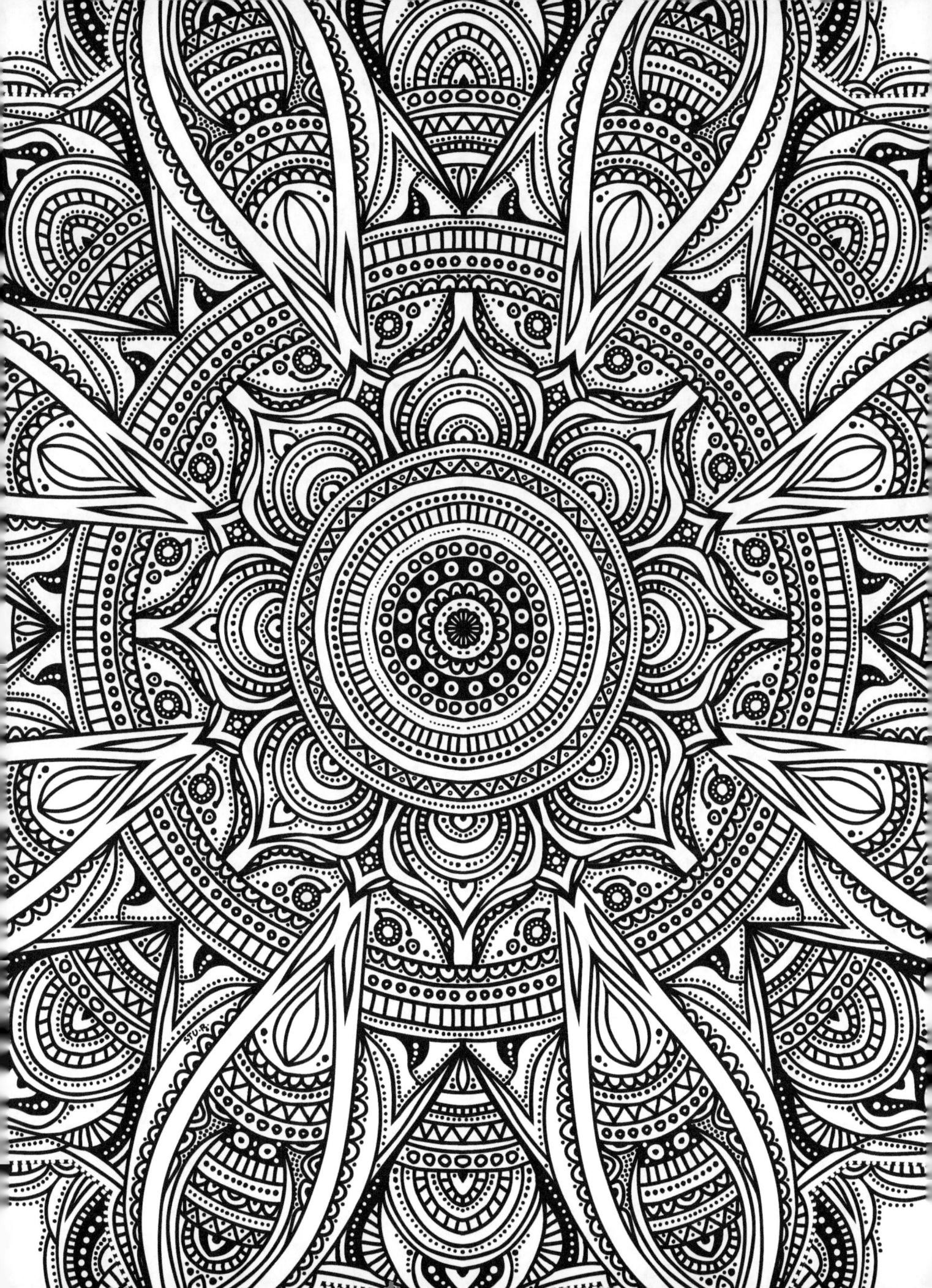

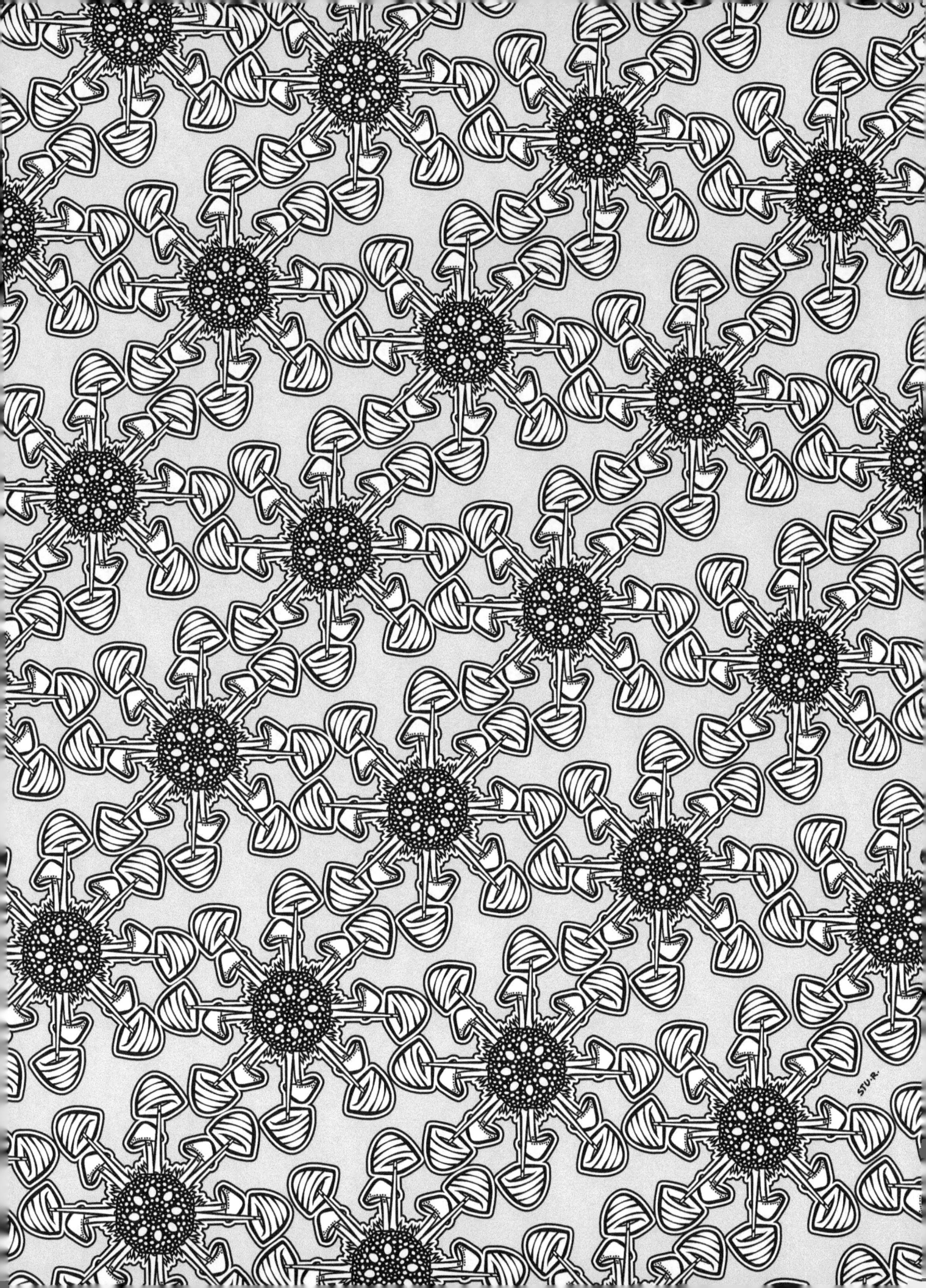

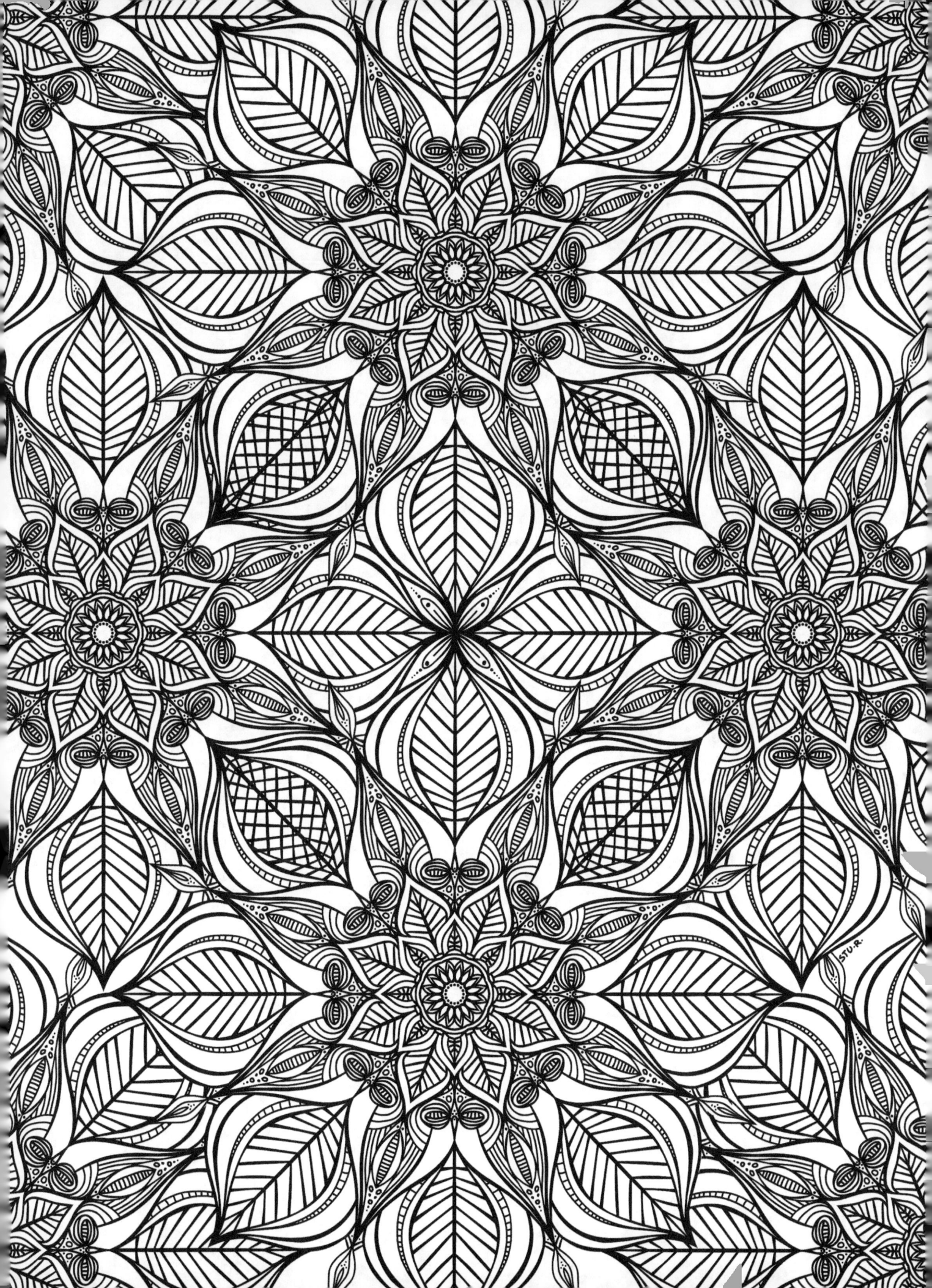

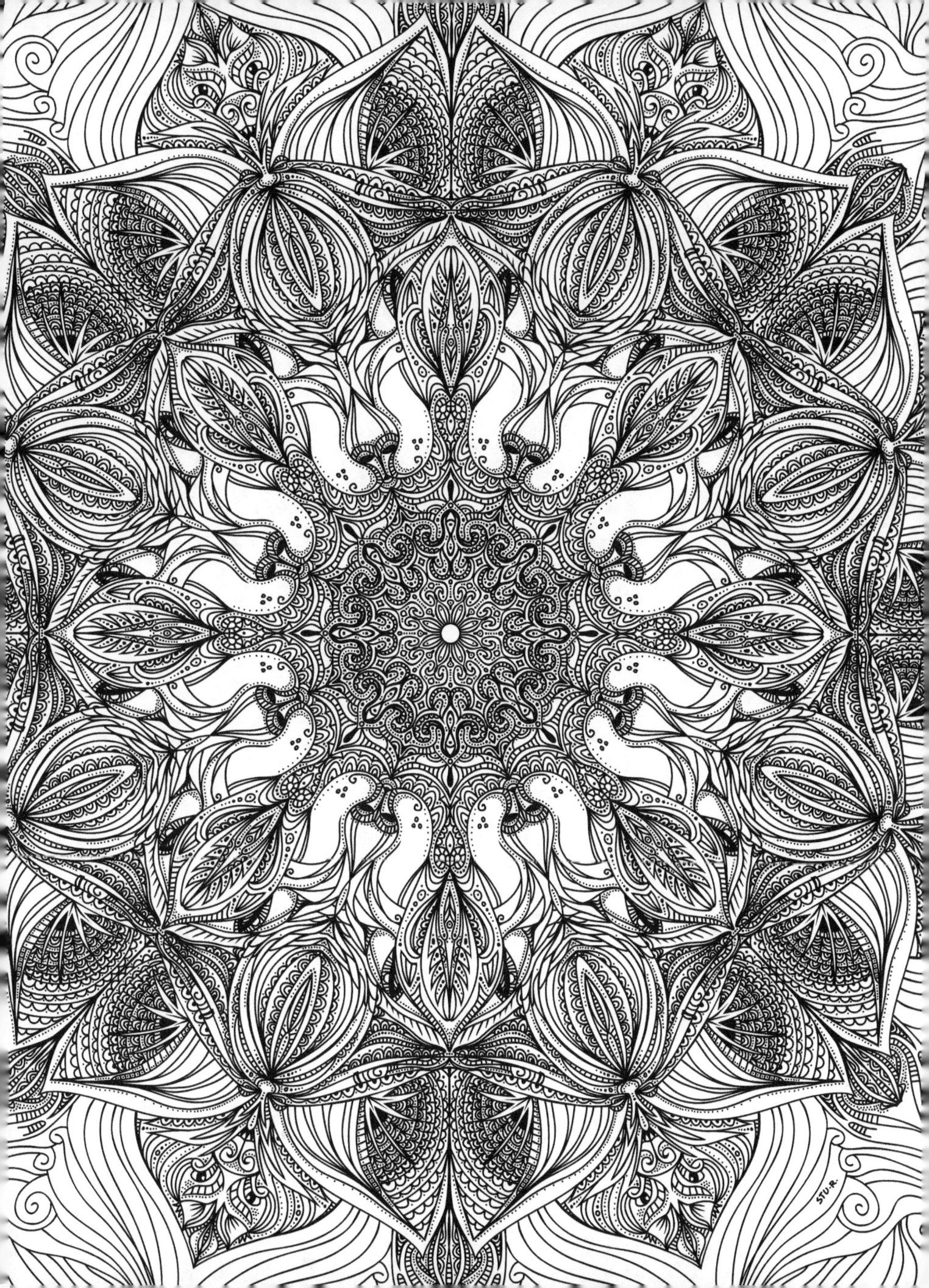

Other Colouring Books by Stuart Royce:

Eclectica
(Absent-Minded Art Volume 1)

Circolour
(Absent-Minded Art Volume 2)

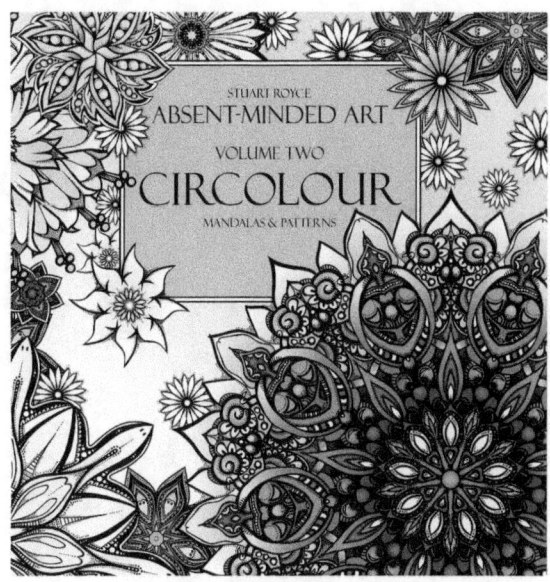

Colourful Christmas
(Absent-Minded Art special)

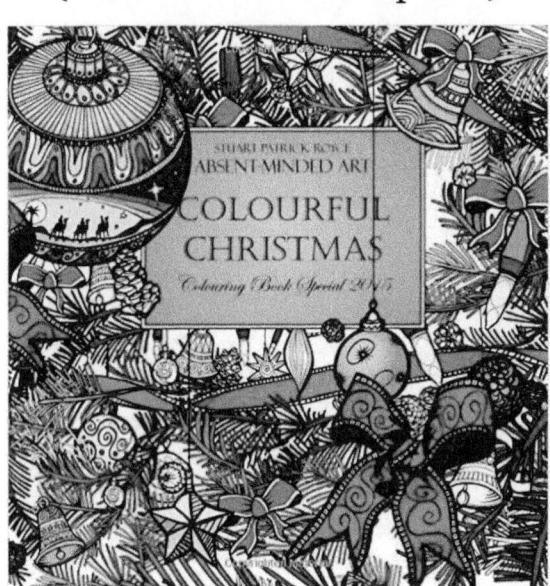

Diversity
(Absent-Minded Art Volume 3)

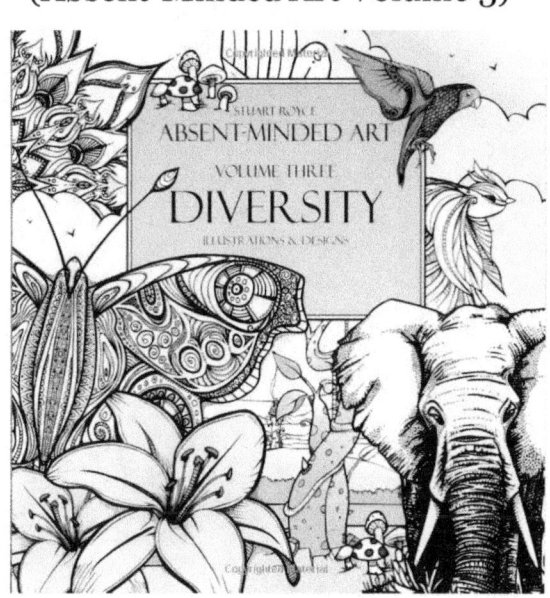

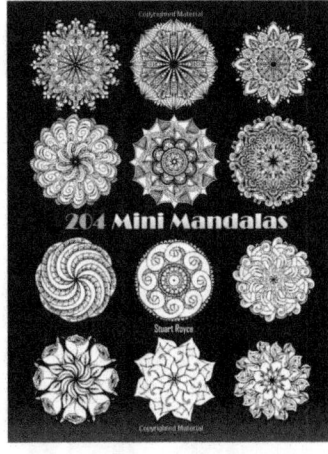

204 Mini Mandalas
(Features all of the small "page garnish" mandalas from this book.)

For more info please visit:
http://www.stuartroyce.com
https://www.facebook.com/StuRoyce
https://www.instagram.com/sturoyce
https://twitter.com/StuartRoyce
https://www.youtube.com/channel/UCRqQFO1BJpKe_iAVZ8Xt7hg
https://www.amazon.com/Stuart-Royce/e/B00X8BS7D0

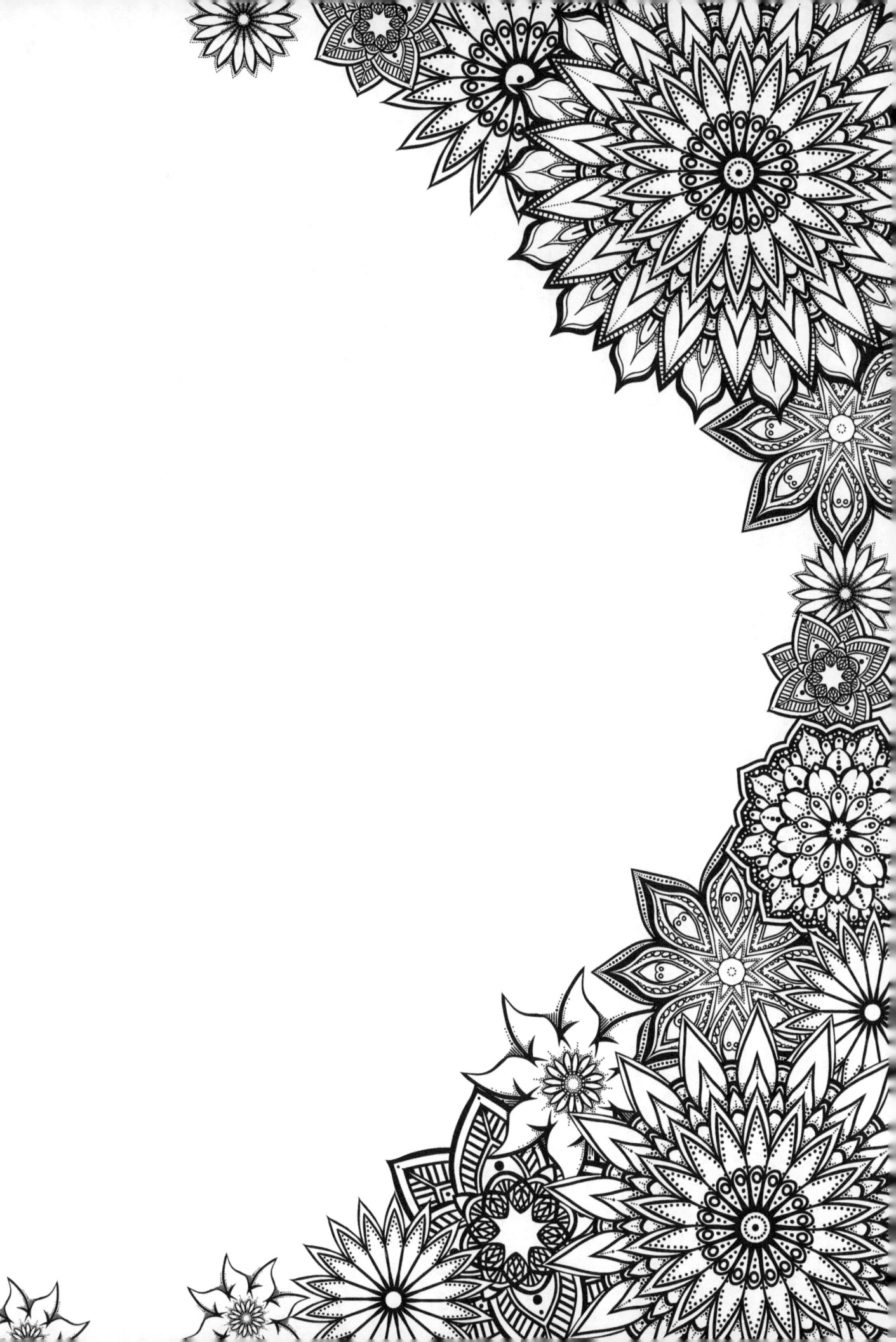

EXTRACT AND USE ME BETWEEN PAGES IF USING INK :)

EXTRACT AND USE ME BETWEEN PAGES IF USING INK :)

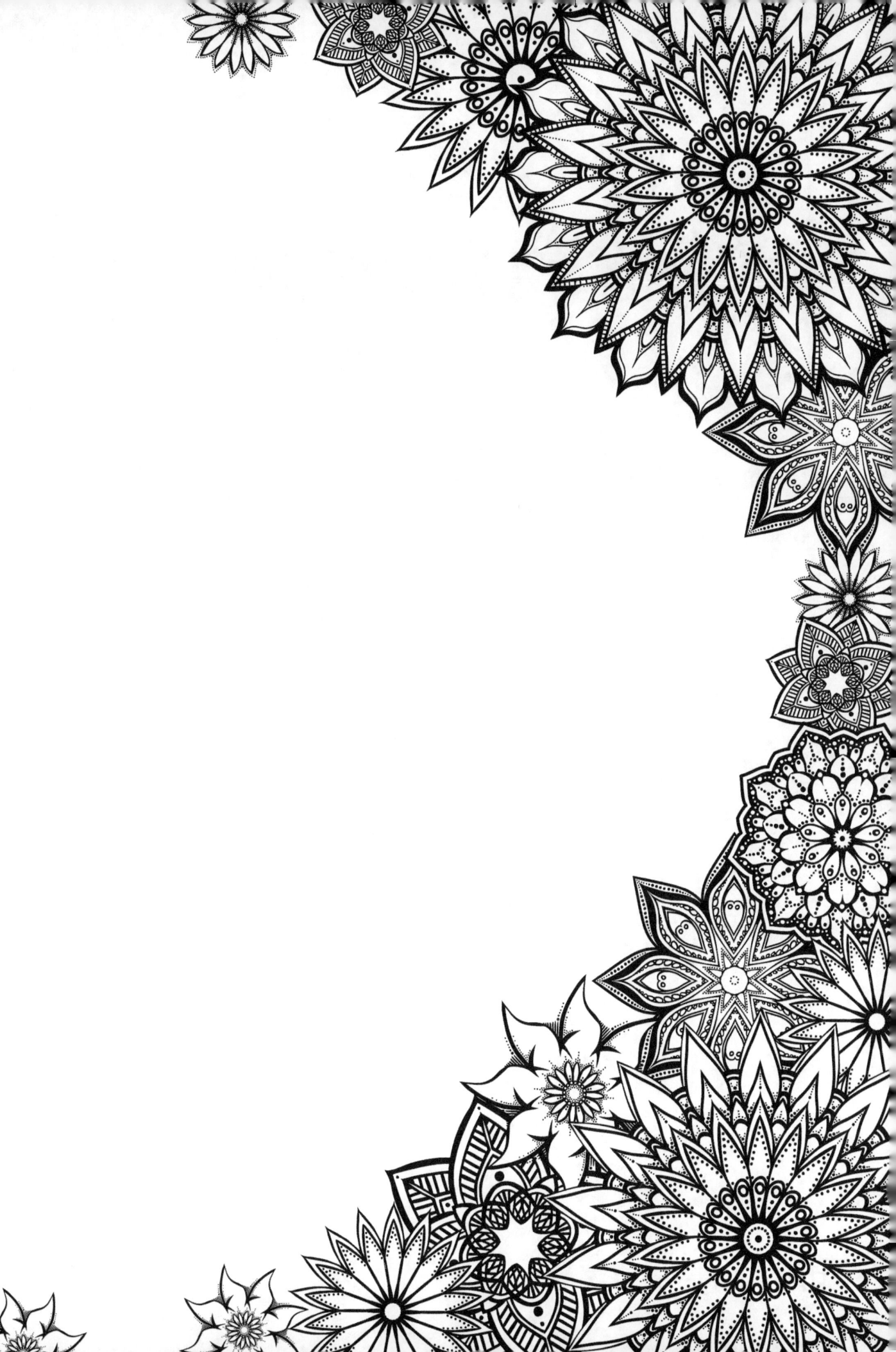

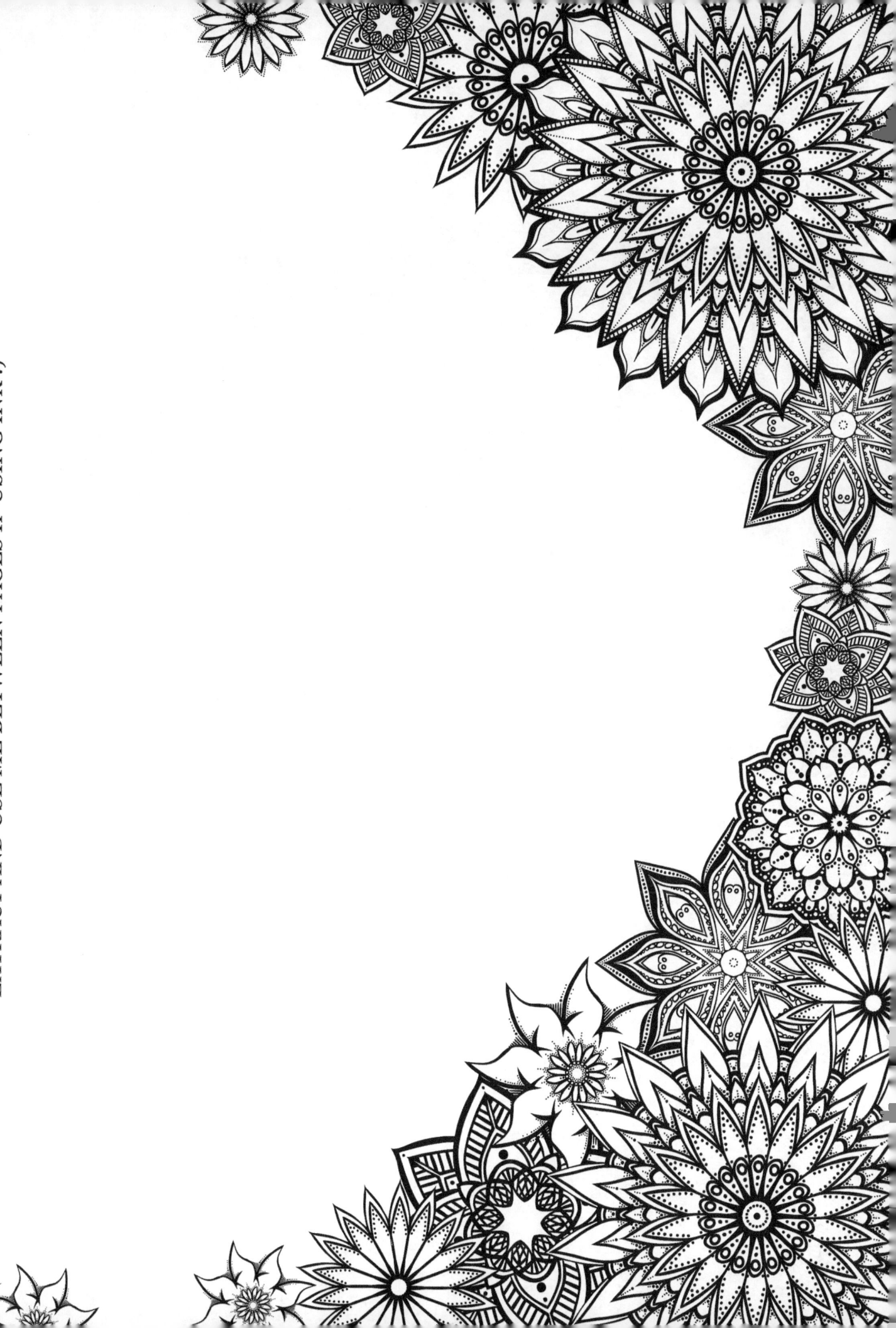

EXTRACT AND USE ME BETWEEN PAGES IF USING INK :)

www.ingramcontent.com/pod-product-compliance
Lightning Source LLC
Chambersburg PA
CBHW080651190526
45169CB00006B/2077